Painting and Sculpture
at The Museum of Modern Art

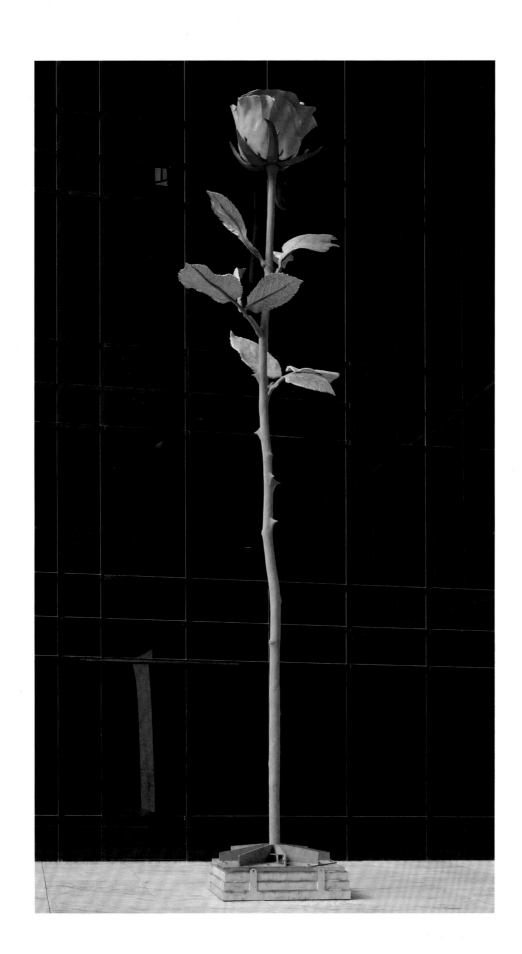

Painting and Sculpture
at The Museum of Modern Art

Ann Temkin

The Museum of Modern Art, New York

Produced by the Department of Publications
The Museum of Modern Art, New York
Christopher Hudson, Publisher
Chul R. Kim, Associate Publisher
David Frankel, Editorial Director
Marc Sapir, Production Director

Edited by Sarah Resnick
Designed by Miko McGinty
Production by Marc Sapir
Printed and bound by OGI/1010
Printing Group Ltd., China

This book is typeset in Fakt.
The paper is 157gsm Kinmari Matt.

Library of Congress Control Number: 2015930565
ISBN: 978-0-87070-967-8

Published by The Museum of Modern Art
11 West 53 Street
New York, New York 10019
www.moma.org

Distributed in the United States and Canada by
ARTBOOK | D.A.P.
155 Sixth Avenue
New York, New York 10013
www.artbook.com

Distributed outside the United States and Canada by
Thames & Hudson Ltd.
181A High Holborn
London, WC1V 7QX
www.thamesandhudson.com

Front cover: Vincent van Gogh. *The Starry Night*. 1889.
See p. 23. Back cover: Yayoi Kusama. *Accumulation No.
1*. 1962. See p. 139. Title page: Isa Genzken (German,
born 1948). *Rose II*. 2007. Stainless steel, aluminum,
and lacquer, 36' x 9' 6" x 42" (1,097.3 x 289.6 x 106.7
cm). Gift of Alfred H. Barr, Jr., and gift of the Advisory
Committee (both by exchange), 2014

Printed in China

CONTENTS

Foreword

It is with great pleasure that we present this new volume surveying the paintings and sculptures housed in The Museum of Modern Art. The book includes works made from the late nineteenth century to the present day, tracing the full span of our collection. Having marked its eighty-fifth anniversary in 2014, the Museum is no longer the young upstart it was during its first decades. But the development of the collection continues, at its best, with the same spirit of discerning openness that characterized its founding.

The paintings and sculptures illustrated herein represent just one aspect of the collecting activities of The Museum of Modern Art. The Museum's holdings also include drawings, prints, photography, architecture, design, media, performance, and film. Within the Museum's galleries, the displays resonate across the respective fields, providing visitors the opportunity to study, question, and enjoy the achievements of one of the most extraordinary eras within the history of Western culture.

We extend profound thanks to Ann Temkin, The Marie-Josée and Henry Kravis Chief Curator of Painting and Sculpture, who has written the essay that follows, selected the works to be included, and arranged the sequence of plates. In so doing, she profited from the generous advice of her curatorial colleagues in the Department of Painting and Sculpture, with special assistance from Talia Kwartler, Cara Manes, and Paulina Pobocha. We are grateful to our colleagues in the Department of Publications, in particular Marc Sapir, who oversaw the production of this book, and to Miko McGinty, its designer.

Most important, we acknowledge the remarkable generosity of the members of our Board of Trustees and the many other donors who are responsible for the ongoing development of this collection. The entirety of our holdings comes as gifts, either through works of art given directly or endowments and donations of funds enabling the purchases. It is only due to our Trustees' and donors' unparalleled efforts on behalf of the Museum that this collection has come into being, and that it continues its vigorous growth into the twenty-first century.

—Glenn D. Lowry
Director, The Museum of Modern Art

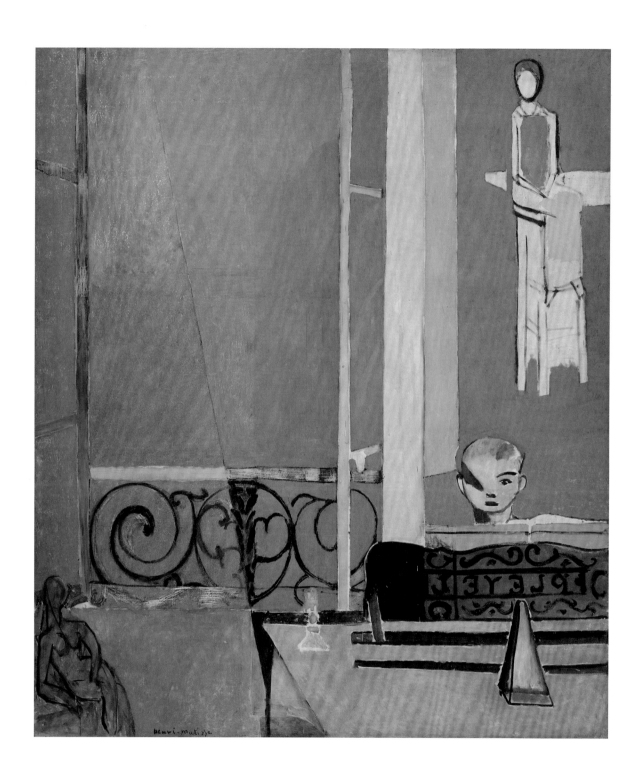

Henri Matisse (French, 1869–1954). *The Piano Lesson*. 1916.
Oil on canvas, 8' ½" x 6' 11¾" (245.1 x 212.7 cm). Mrs. Simon Guggenheim Fund, 1946

Introduction
Ann Temkin

This book offers an overview of The Museum of Modern Art's collection of painting and sculpture as it stands in 2014. Our present holdings are the result of nearly ninety years of choices accumulating only gradually to form what constitutes the collection today. The small portion represented in this book—about five percent of more than four thousand paintings and sculptures—amply makes the case, as the Museum's founders believed in 1929, that the art of our time rivals in its greatness that of any previous era.

Perhaps the key distinction that sets modern art apart from that of earlier periods is the sheer multiplicity of visual languages that fall within it. The common goal of modern artists has been to invent individual styles unique to themselves: creative originality takes precedence over faithfulness to external reality or to tradition. Artistic selfhood emerges through innovation. Thus, the diversity of artistic styles and vocabularies within the pages of this book—even among works made in the same year, in the same city—defies generalization, beyond the collective vow of each successive generation not to repeat the achievements of the former.

Many of the works of art in this book are now fixtures of any textbook of modern art history. Every day at the Museum, visitors arrive and grapple with the realization that they are in front of the *Starry Night*, or the *Gold Marilyn Monroe* (pp. 23 and 135). There are no other such objects anywhere in the world, although infinite numbers of reproductions of them are available everywhere. Other works that we have chosen to include are much less familiar and represent artists who are far from household names. For most visitors, seeing these in the Museum's galleries is an experience of discovery rather than confirmation and may incite more puzzlement than awe. Nevertheless all are works of art that have played key roles in the evolution of painting and sculpture over the last 125 years, and that join together to form the character of MoMA's holdings.

Is this a book of favorites? In a way, yes—although hardly comprehensively so. Some of the favorites here are objects for which that term is almost beside the point, given their iconic status. Would someone say that Pablo Picasso's *Les Demoiselles d'Avignon* (p. 34) is his or her favorite picture? Perhaps not, but *Les Demoiselles* is surely essential, as is any painting or sculpture that profoundly changed the course of the artist who made it and that of countless

others. Alfred H. Barr, Jr., the Museum's founding director, aptly described *Les Demoiselles* as a "battlefield," and, more than a hundred years after its making, it may well strike viewers as ugly rather than beautiful.[1] Picasso left visible in the finished painting the harsh stylistic disjunctions among its different areas, leaving it as a vivid document of the conflict between the nineteenth-century legacy he was abandoning and the soon-to-be revolution that would be called Cubism. The artist kept the painting in his studio until finally selling it to the couturier Jacques Doucet in 1924. The Museum managed to purchase *Les Demoiselles* in 1939 and to showcase it that same year in the galleries of its brand-new International Style building.

Claude Monet's *Water Lilies* paintings (p. 64) are favorites in the more usual sense. These became landmarks of the collection as soon as they were acquired at the end of the 1950s. Monet devoted the final decade of his long life to this series (he died in 1926 at age eighty-six). At that time, most people considered these vast paintings illegible nonsense, the woeful efforts of a once-great artist whose eyesight was failing. The richly textured and loosely articulated passages of blues, greens, and purples seemed to bear no relation to the plants, water, and sky they were meant to document. In a dramatic example of the evolution of taste, by midcentury the *Water Lilies* attracted the admiration of curators and collectors such as Barr and his colleague Dorothy Miller. By that time, large-scale abstractions by artists such as Jackson Pollock had prepared their eyes to see anew what Monet had dared to explore thirty years prior. The *Water Lilies* paintings have provided a beloved oasis in the Museum's galleries ever since.

The eventual triumph of work that was initially scorned is one of the fundamental paradigms of modern art. The Museum of Modern Art itself embodies that premise: its founders in large part conceived their idea for the Museum in response to the cold shoulder shown to modern art uptown at the Metropolitan Museum of Art. The by-then mythic tragedy of Vincent van Gogh stood as a stark warning: without support, more modern artists might die without having been able to imagine in their wildest dreams their ultimate renown. A museum to showcase their work could lead the way not only for scholars and collectors but also for general audiences—and, most important, for the artists of the future whose work would be generated by the art of the present.

Because in the 1920s modern art still was embattled, the roots of the Museum had a strongly evangelical tinge. During the early decades of its existence especially, the taste of Barr and his colleagues was often far ahead of the public's. The Museum was founded as an educational institution and took as its mission the conversion of skeptics into believers. The challenge was considerable, as proven by a rich corpus of *New Yorker* cartoons over the decades that

testify to the bafflement with which viewers responded to what they saw at The Museum of Modern Art. Whether it was the radical simplicity of a sculpture by Constantin Brancusi or the dense tangles of paint skeins in a work by Pollock, the Museum proved a reliable target of ridicule. The inscrutability of pure abstraction—Kazimir Malevich's *Suprematist Composition: White on White*, a white square on a white background, for example (p. 59)—put to the harshest test the willingness of audiences to understand that, in modern art, naturalistic resemblance was rarely the artist's goal, and that often an artist's conceptual ideas or theoretical convictions motivated the visual image he or she produced. Conventional expectations regarding the demonstration of artistic skill were often thwarted.

Occasionally, Barr's foresight outpaced even that of many of his Trustees. In these cases, he needed to take circuitous routes to bring into the collection the works he wanted. This was true on the occasion of the 1936 exhibition *Fantastic Art, Dada, Surrealism*. Barr successfully managed the purchase of signature works in the exhibition by artists such as Joan Miró, Max Ernst, and René Magritte (pp. 68, 69, and 70). But one proposal was firmly resisted by the Museum's Trustees: the so-called Fur-covered Teacup by Meret Oppenheim, simply titled *Object* (p. 86). Barr was convinced of the Teacup's merit, so he purchased it from the artist for the lofty sum of fifty dollars and placed it on extended loan to the Museum. Ten years later, he entered it in the study collection, a subsidiary category not subject to Trustee approval. Finally, in 1963, when Surrealism was more classic than incendiary (and a relevant ancestor to new works of Pop art), *Object* was voted into the Museum collection. It was designated a "purchase" thanks to Barr's fifty-dollar check sent twenty-seven years earlier.

On many occasions, the Museum staff has relied upon Trustees to partner with the Museum in a similar way. When Barr saw Jasper Johns's painting *Flag* (p. 120) in 1958, he felt certain that the Museum should have it, together with three other paintings also on view in the twenty-seven-year-old artist's first solo show. But while the three were approved, the Trustees could not bring themselves to accept a painting that appeared to be a mere "facsimile" of a flag. Its stars and stripes congruent with the full field of the painting, the flag seems to behave more as an object than a representation. Collaged sheets of newspaper show through the oil and wax surface, disrupting the purity of the symbol with the mess of current events. Disappointed, but not defeated, Barr persuaded the reliably adventurous Trustee Philip Johnson to purchase *Flag* with the understanding that it would become a gift several years later, once its importance was indisputable. The painting entered the collection in 1973. This elegant duet was

performed with Johnson several times over the years, to the great benefit of the Museum's public.

Equivalent acts of generosity on the part of untold numbers of prescient individuals are responsible for the existence of the painting and sculpture collection. Among the more remarkable stories in this category is that of collector Ben Heller, a staunch champion of the Abstract Expressionist generation of artists since its beginnings. In 1968, Chief Curator William S. Rubin arranged with Heller the purchase of a group of stellar paintings from his collection that would vastly improve the Museum's holdings of Abstract Expressionism. After the acquisitions meeting at which the proposal was presented, Rubin had to inform Heller that the Trustees had approved the works by Arshile Gorky, Pollock (p. 108), and Franz Kline (p. 114), but had refused funds for the eighteen-foot-long expanse of vibrant red that was Barnett Newman's *Vir Heroicus Sublimis* (p. 112). Newman's brushwork was so understated that the unmodulated field of color, interrupted only by four vertical "zips," appeared to skeptics more the work of a housepainter than an artist. But Heller's passion was such that he responded to Rubin's news by making Newman's painting an outright gift to the Museum.

Events such as this inspire both courage and humility in present-day curators. It is also important to remember, however, that the seductive myth of early rejection can be dangerous. Over the years, the Museum has suffered occasionally from its curators' and patrons' suspicion of artists who enjoyed rapid success, or who became media darlings, as if that were an indicator that they are not truly modern artists. Johnson bought for the Museum Andy Warhol's *Gold Marilyn Monroe* from the artist's first exhibition at Stable Gallery in 1962. The painting sets a silkscreened photographic image of Monroe's head, painted with garish colors as clearly artificial as hair dye or makeup, within a towering field of gold that both invokes her stardom and memorializes her suicide three months earlier. Unfortunately, Johnson's bold move was not followed up: for the most part, the Museum kept its distance from Warhol's work until after his death in 1987. In 1989, Senior Curator Kynaston McShine organized a major retrospective exhibition, and in the 1990s, Chief Curator Kirk Varnedoe strengthened the collection with several grand additions including *Campbell's Soup Cans* of 1962. Warhol's case, among several others, proves that work that becomes quickly and widely popular does not necessarily lack historic significance.

Whether we are judging art that is largely ignored or widely appreciated, one thing holds true: it is much easier to assess a work of art with years of hindsight than at the moment it first appears. With this fact in mind, the acquisition program in each of the Museum's curatorial departments has always been two-

pronged: looking back at previous decades, on the one hand, and tackling the present moment, on the other.[2] In general, curators and Trustees have understood that most objects acquired after a considerable time lag—for example, the breathtaking parade of works from the century's beginnings purchased in the 1930s and 1940s—would be lasting treasures. Works bought at the moment of their making are far less certain propositions. The institutional assumption has been that although scores of works would enter the collection but fail to hold long-term interest, these mistakes would be justified by brilliant choices that would have been missed if such adventurousness on the part of the curators and Trustees were not encouraged. This dual track requires of those involved the ability to accept a certain level of cognitive dissonance as they simultaneously usher into the collection untested discoveries and validated icons.

A particular duo in the pages of this book concisely illustrates these two extremes on the acquisitions spectrum: Claes Oldenburg's *Two Cheeseburgers, with Everything (Dual Hamburgers)* and Yayoi Kusama's *Accumulation No. 1* (pp. 138 and 139). Oldenburg remembers learning that Barr had come to the 1962 exhibition of his sculpture at the Green Gallery on West Fifty-seventh Street and had happily walked out the door with the newly created *Two Cheeseburgers* in his arms, personally couriering them four blocks south to the Museum. What could be more deliciously Pop than America's favorite food, enhanced by cheerfully erotic overtones? The eroticism is far more explicit, and unsettling, in *Accumulation* by Kusama (Oldenburg's neighbor in an East Fourteenth Street loft). That work was also first shown by Richard Bellamy of the Green Gallery, but was bought by another bold gallerist, Beatrice Perry, who proudly displayed it in her home for nearly a half-century. By the time Kusama achieved worldwide acclaim, and a later generation of curators decided that the Museum should own *Accumulation No. 1*, decades had elapsed; despite repeated entreaties, Perry would not part with her treasure. Only after she had passed away and left the sculpture to her son was the Museum finally able to purchase it, fifty years after the work was made. Such delayed gratification is a staple at the Museum and provides rewards no less exhilarating than the instances of love at first sight.

While it is difficult to generalize, consensus on the art of a given moment seems to take shape after a period of two or three decades. Thus, much of the Museum's acquisition program seems to have operated on such a schedule, whether focusing on Cubism in the 1930s and 1940s or Abstract Expressionism in the 1960s and 1970s. The 1990s brought a critical eye to the Museum's holdings of the 1960s in American Pop art and Minimalism, as well as parallel tendencies internationally. Varnedoe championed in 1993 the purchase of

James Rosenquist's *F-111* (p. 142), an eighty-six-foot-long painting created to fill the four walls of Leo Castelli Gallery in 1965. At that time it would have been virtually unthinkable for the Museum to purchase an entire gallery's worth of art by a thirty-one-year-old artist (that was done by the collector Robert Scull); by 1993, not only was the landmark status of the painting self-evident, but the concept of a single work of art consuming an entire room was a commonplace of what by then was called "installation art." Today, we are casting a critical eye on the Museum's collection of the art of the 1980s and 1990s, which still lacks the work of several artists who should and will be collected in depth. The 2013 acquisition of Mike Kelley's *Deodorized Central Mass with Satellites* (p. 224), for example, again demonstrates a retrospective admiration for an artist whose works we had acquired only tentatively during his too-short lifetime. While Kelley's choice of secondhand animal plush toys as a sculptural medium may once have seemed suspect, today it prompts scholarly analysis and the attentive care of conservators.

Although the prospect of a collection was merely notional at the time of the Museum's founding, it was brought to reality by the bequest of cofounder Lillie P. Bliss, who upon her death in 1931 left the Museum thirty-three paintings and more than seventy works on paper. The collection centered on work from the late nineteenth century, including *The Bather* by Paul Cézanne (p. 21), the artist whom both Picasso and Henri Matisse acknowledged as the father of their generation. For many decades, *The Bather* has greeted visitors at the entrance to the Painting and Sculpture Galleries, almost as a guardian figure for the scores of artworks to follow. Bliss made her bequest conditional on the raising of the funds necessary for the professional maintenance of a collection, and was also farsighted enough to make it an engine for further growth: she stipulated that less-essential works could be sold in order to finance new purchases. The first such use of her bequest was the sale of a painting by Hilaire-Germain-Edgar Degas for the purchase of *Les Demoiselles d'Avignon*. Bliss's provision for what is called "deaccession" has guided acquisition procedures ever since: works that are eventually judged of lesser importance relative to comparable objects in the collection may be sold in order to provide funds for new purchases. Such decisions are among those to which curators and Trustees give the most serious thought, and although sometimes contentious, they have been instrumental to the progressive growth of the collection.[3]

The list of Bliss's peers and successors is long and inspiring. Many of the early acquisitions were the gifts of cofounder Mrs. John D. (Abby Aldrich) Rockefeller, Jr. Besides donating 185 works in 1935, the following

year Rockefeller provided Barr with his first purchase funds: an (at that time) far-reaching one thousand dollars to spend during a summer research trip in Europe. Rockefeller's firsthand support focused particularly on American art. It is she who facilitated Mexican artist Diego Rivera's visit to New York for his 1931 exhibition at the Museum, and funded the acquisition of one of the eight frescoes he painted on-site for the show (p. 78). Blanchette Hooker Rockefeller, Abby's daughter-in-law and a later president of the Museum, also provided support to important American art. Her gifts include Romare Bearden's *Patchwork Quilt* (p. 167), a painting that features the artist's signature technique of collage. With this choice of subject, Bearden linked modern collage, with its sophisticated European roots, to a venerable American folk art.

Abby's sons Nelson and David continued the family tradition with long service as Museum officers and magnificent gifts that include, respectively, Henri Rousseau's *The Dream* (p. 37) and Paul Signac's *Opus 217. Against the Enamel of a Background Rhythmic with Beats and Angles, Tones and Tints, Portrait of M. Félix Fénéon in 1890* (p. 25). In both cases, these were paintings that the curators (Barr, in the former instance, and Rubin in the latter) identified as musts for the Museum. *The Dream*, which sets a female nude on a sofa in a lush jungle, is one of the last and greatest works by the self-taught customs agent who was celebrated as a hero by the artists of the Paris avant-garde. *Opus 217* is the portrait of an art critic who eloquently championed the Post-Impressionists. Like its overwrought title, the painting's astonishing background both invokes the contemporary color theories that guided those artists' work and instantly conveys the flamboyant persona of the sitter.

The ranks of greatest benefactors of the collection also must include Mrs. Simon (Olga) Guggenheim. Her name is far less well known than that of her brother-in-law Solomon R. Guggenheim, founder of the eponymous museum, but her contribution to The Museum of Modern Art was comparably fundamental. Guggenheim provided ongoing financial support that enabled the Museum to purchase a dazzling array of some seventy paintings and sculptures between the years 1935 and 1973. This book includes no fewer than fifteen of her gifts, among them Marc Chagall's *I and the Village* (p. 38), Matisse's *The Red Studio* (p. 39), and Picasso's *Girl before a Mirror* (p. 77). She also donated funds for American works such as Pavel Tchelitchew's *Hide-and-Seek* (p. 89), a hallucinatory image of children enmeshed in a mighty tree that has fascinated visitors to the Museum since its acquisition in 1942.

Bliss's formative bequest has inspired many instances of an entire collection, or a majority of it, coming into the Museum. Such gifts are especially crucial in the area of contemporary art: whereas the Museum is often quick to recognize

the work of a young artist, it has seldom made relatively speculative commitments in deep quantity. Private collectors—with no encumbrances of committee votes or inhibitions of historical accountability—have let their passions fuel purchases with more alacrity than that of the Museum. Exemplary among several such transformative gifts within the last twenty years is the 1996 bequest of Elaine and Werner Dannheisser, which instantly brought to the Museum a group of landmark works of the 1980s and 1990s by artists such as Jeff Koons, Robert Gober, and Felix Gonzalez-Torres (pp. 191, 209, and 210).

In many cases, artists themselves have made gifts to the Museum's collection, as donors of their own works and those of their peers. One such instance is Ellsworth Kelly's painting *Colors for a Large Wall* (p. 107), created in Paris in 1951. Composed of sixty-four square panels, each a simple monochrome, *Colors* possessed none of the gestural energy typical of contemporary works made in New York. But Kelly, at the time a young, unknown artist, felt an immediate and concrete conviction that this was a painting destined for The Museum of Modern Art. In 1969, as a respected figure with two paintings, one sculpture, and many works on paper already in the collection, he took it upon himself to ensure that his dream of its being here was realized.

Artists also partner with the Museum in refining our holdings of their work. In 2014, Richard Serra gave the Museum *Circuit* (p. 171), a sculpture he had created in 1972 for Documenta 5, an exhibition in Kassel, Germany. The Museum owned a second version of that sculpture, *Circuit II*, made for a solo exhibition of Serra's work at MoMA in 1986; its dimensions differed from those of *Circuit* because the original work could not fit inside the Museum's elevators. Nearly thirty years later, Serra's desire for the sculpture to be seen in its initial form led him to purchase *Circuit* from its owner and donate it to the Museum (now with ample elevator space) to replace *Circuit II*.

Ultimately the cumulative efforts of successive generations of collection builders enables the tremendous depth that defines the painting and sculpture collection. A book such as this one cannot represent the Museum's commitment to tracing important careers from beginning to end in all mediums, or demonstrate the fact that for many artists we can mount concise retrospectives from our holdings alone. We have included here several objects by Picasso and Matisse, as their magisterial bodies of work form what can be considered the spine of the collection. But otherwise we have chosen to include a maximum number of artists by representing most with just one painting or sculpture, even if our holdings include ten, twenty, or more. In most cases we have selected a work from the transformative moment in the artist's career when his or her mature vocabulary first emerged in full form. But it needs to be said that many

artists have so deeply taken to heart the modern mantra of originality that they strive even to reinvent their own work and to adopt entirely new approaches more than once during the course of their lives. Thus, especially during the modern era, one work of art can scarcely sum up an artist's full corpus.

For that reason and many others, a volume such as this represents a mere fraction of what one experiences at the Museum. Indeed, it may well be that your favorite painting or sculpture at MoMA is not reproduced in this book. A visit to the Museum is the ideal tonic for that, whether one revisits that object or is captivated by a new one. One thing we can promise: that on no two occasions will a visitor find the contents of the Painting and Sculpture Galleries entirely the same. Today's fluid program of gallery reinstallations constantly balances the presence of works that are rarely or never off view with fresh presentations that explore the collection's depth and variety. The display of the collection is a perpetual work in progress, not only because new works enter at a rate of more than fifty per year but because a contemporary perspective continually reshapes our view of works of art made decades ago.

Inevitably, objects from the most recent decades do not yet—and some may never—possess the same iconic status as those in earlier pages of the book, already tested by time. A chronicler of the Museum's collection understands above all that the future course of art history is nothing we can anticipate. At the time of acquisition, works now considered classic or authoritative may well have been courageous choices, or even ambivalent ones. Let us therefore conclude with the thought of a work of art that is already in the collection but absent from this book. Recently acquired, it is something we do not yet suspect will be considered a milestone twenty or fifty years from now. But as times change, and eyes adjust, the work's beauty and intelligence will come to light. As is often the case, we will have been prescient enough to select it without fully understanding or appreciating the historical import it would one day come to have.

NOTES

1. Alfred H. Barr, Jr., *Picasso: Forty Years of His Art* (New York: The Museum of Modern Art, 1939), p. 60.
2. To discover whether a certain acquisition was the former or the latter, notice the final piece of information in the work's caption—the year of its acquisition—and compare it to the date the work was made.
3. The credit line accompanying a work of art purchased with deaccession funds cites the donor of the work sold to enable its purchase, followed by the phrase "by exchange" in parentheses.

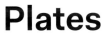

Plates

Paul Cézanne (French, 1839–1906). *The Bather*. c. 1885. Oil on canvas, 50 x 38⅛" (127 x 96.8 cm). Lillie P. Bliss Collection, 1934

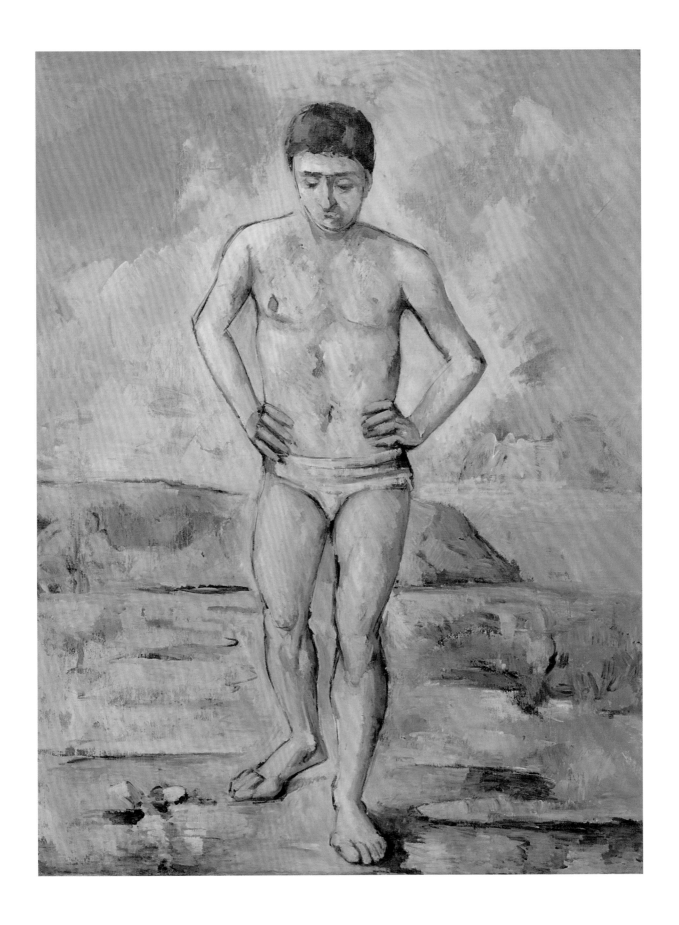

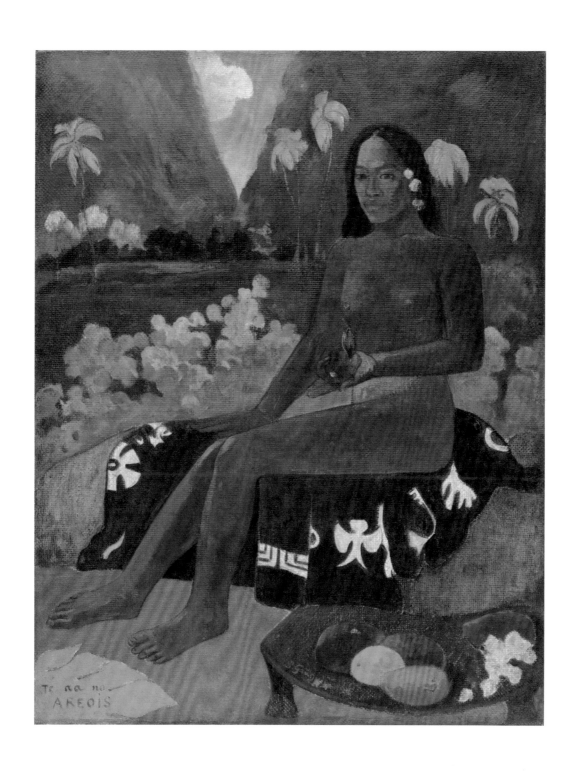

Paul Gauguin (French, 1848–1903). *The Seed of the Areoi*. 1892. Oil on burlap,
36¼ x 28⅜" (92.1 x 72.1 cm). The William S. Paley Collection, 1990

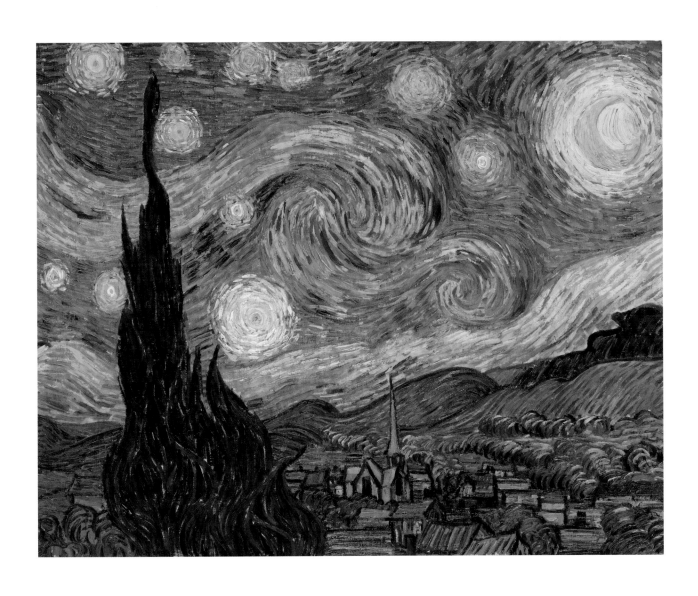

Vincent van Gogh (Dutch, 1853–1890). *The Starry Night*. 1889. Oil on canvas,
29 x 36¼" (73.7 x 92.1 cm). Acquired through the Lillie P. Bliss Bequest, 1941

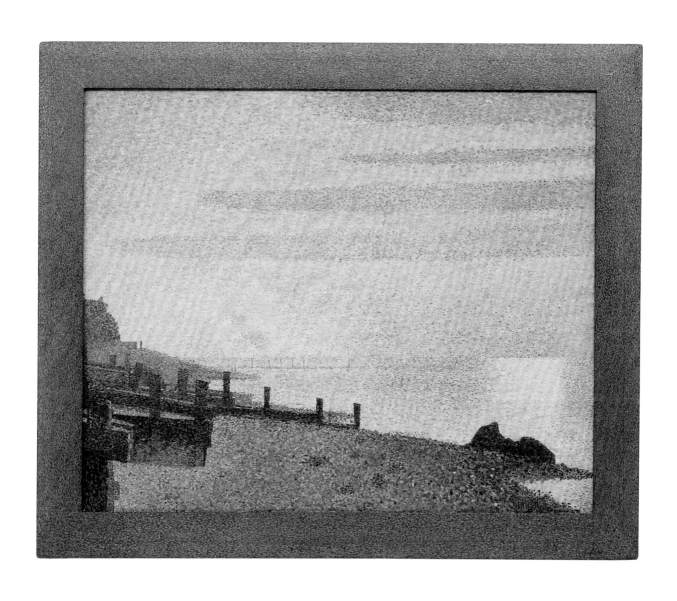

Georges-Pierre Seurat (French, 1859–1891). *Evening, Honfleur*. 1886. Oil on canvas with painted wood frame, 30¾ x 37" (78.3 x 94 cm) including frame. Gift of Mrs. David M. Levy, 1957

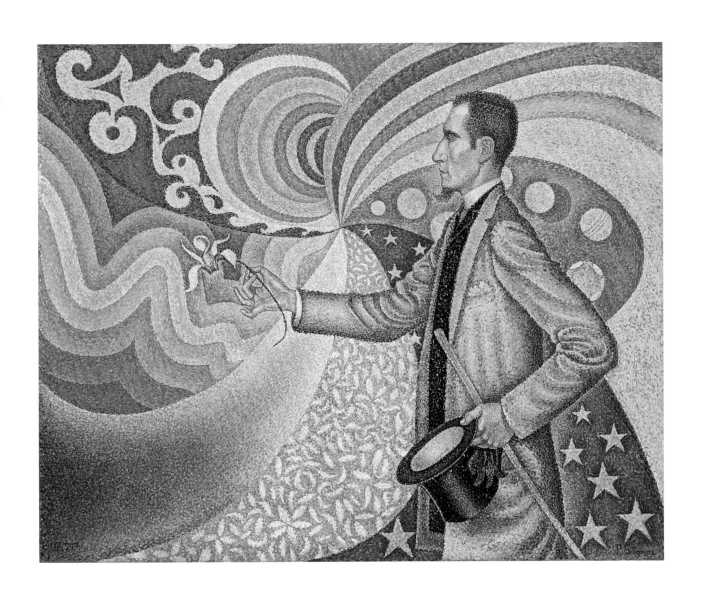

Paul Signac (French, 1863–1935). *Opus 217. Against the Enamel of a Background Rhythmic with Beats and Angles, Tones and Tints, Portrait of M. Félix Fénéon in 1890*. 1890. Oil on canvas, 29 x 36½" (73.5 x 92.5 cm). Fractional gift of Mr. and Mrs. David Rockefeller, 1991

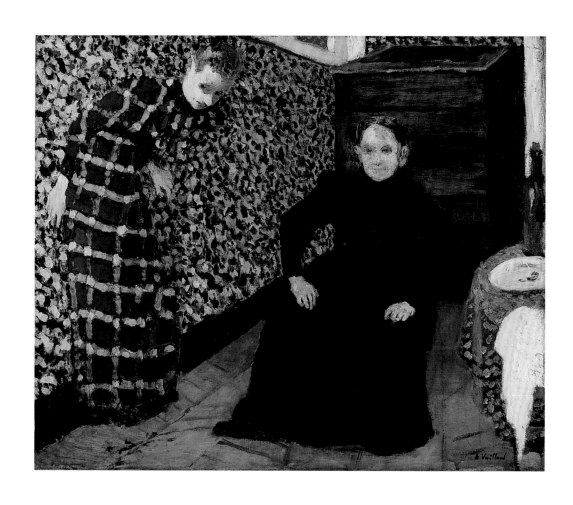

Édouard Vuillard (French, 1868–1940). *Interior, Mother and Sister of the Artist*. 1893.
Oil on canvas, 18¼ x 22¼" (46.3 x 56.5 cm). Gift of Mrs. Saidie A. May, 1934

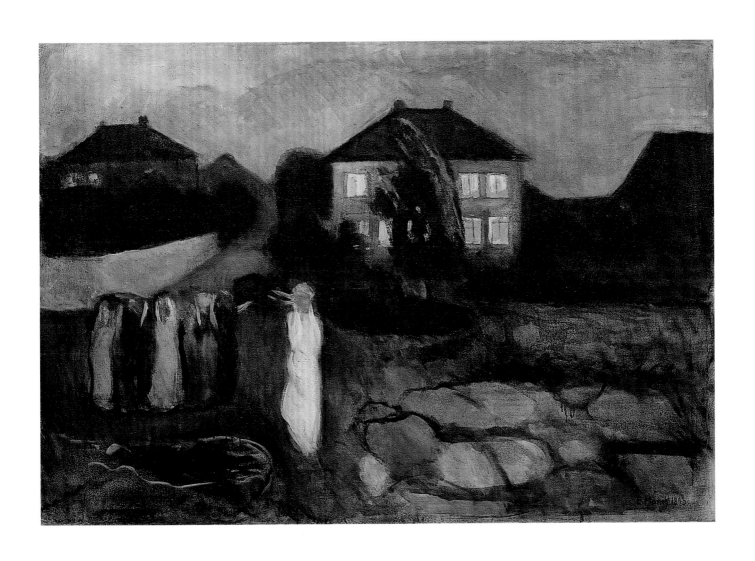

Edvard Munch (Norwegian, 1863–1944). *The Storm*. 1893. Oil on canvas, 36⅛ x 51½" (91.8 x 130.8 cm).
Gift of Mr. and Mrs. H. Irgens Larsen and acquired through the Lillie P. Bliss and Abby Aldrich Rockefeller Funds, 1974

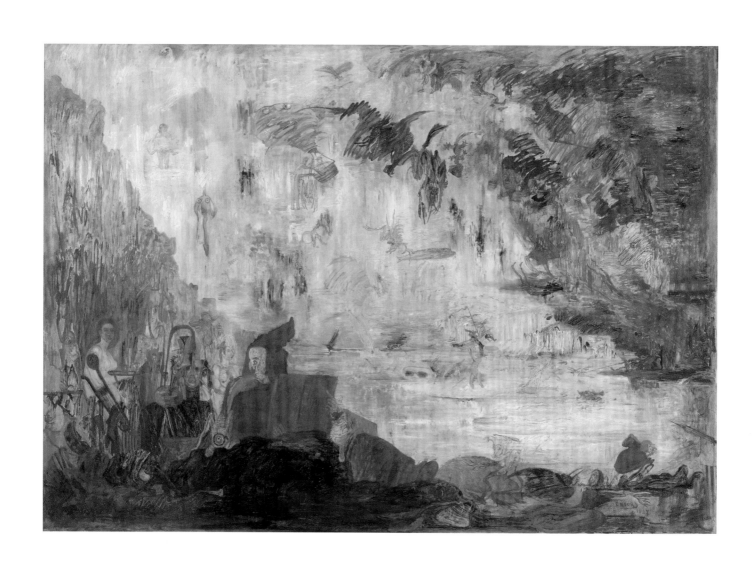

James Ensor (Belgian, 1860–1949). *Tribulations of Saint Anthony*. 1887.
Oil on canvas, 46⅜ x 66" (117.8 x 167.6 cm). Purchase, 1940

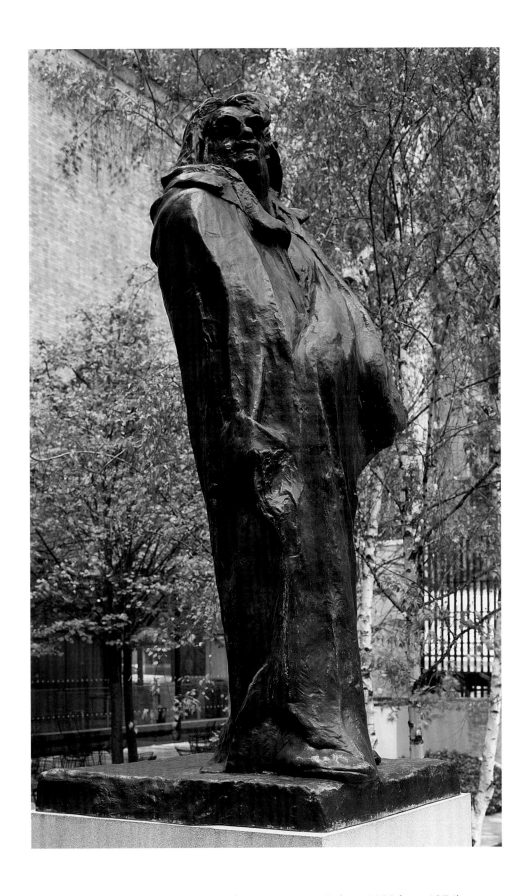

Auguste Rodin (French, 1840–1917). *Monument to Balzac*. 1898 (cast 1954). Bronze, 9' 3" x 48¼" x 41" (282 x 122.5 x 104.2 cm). Presented in memory of Curt Valentin by his friends, 1955

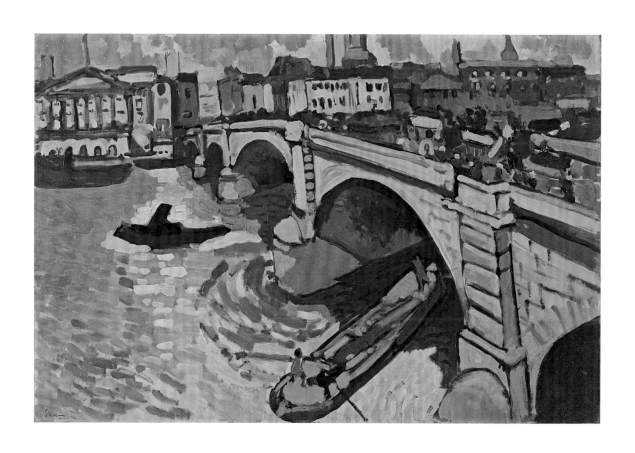

André Derain (French, 1880–1954). *London Bridge.* 1906. Oil on canvas,
26 x 39" (66 x 99.1 cm). Gift of Mr. and Mrs. Charles Zadok, 1952

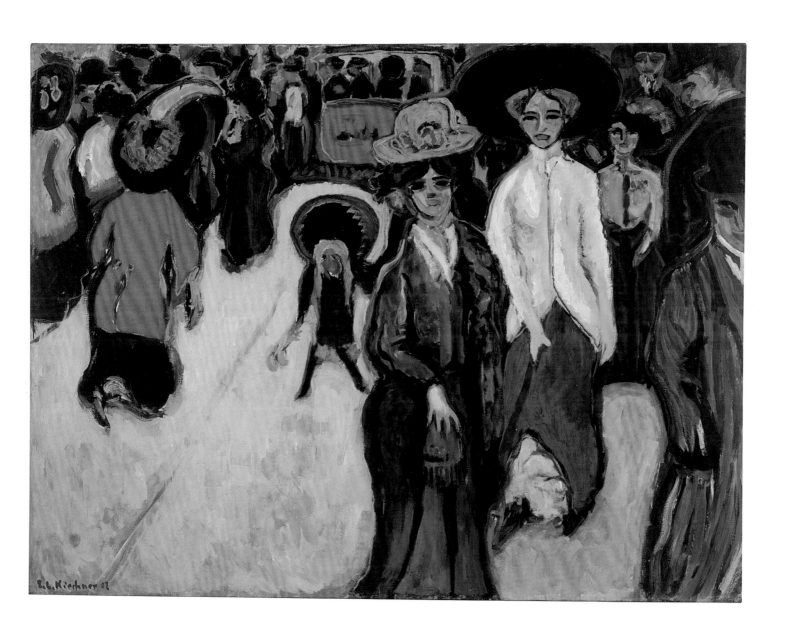

Ernst Ludwig Kirchner (German, 1880–1938). *Street, Dresden*. 1908 (reworked 1919; dated 1907 on painting). Oil on canvas, 59¼" x 6' 6⅞" (150.5 x 200.4 cm). Purchase, 1951

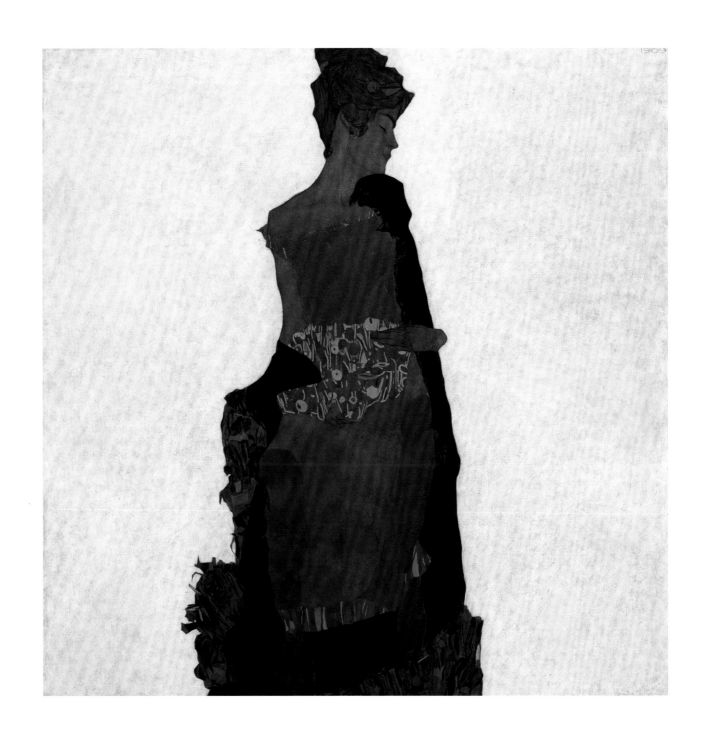

Egon Schiele (Austrian, 1890–1918). *Portrait of Gerti Schiele*. 1909. Oil, silver, gold-bronze paint, and pencil on canvas, 55 x 55¼" (139.5 x 140.5 cm). Purchase and partial gift of the Lauder family and private collection, 1982

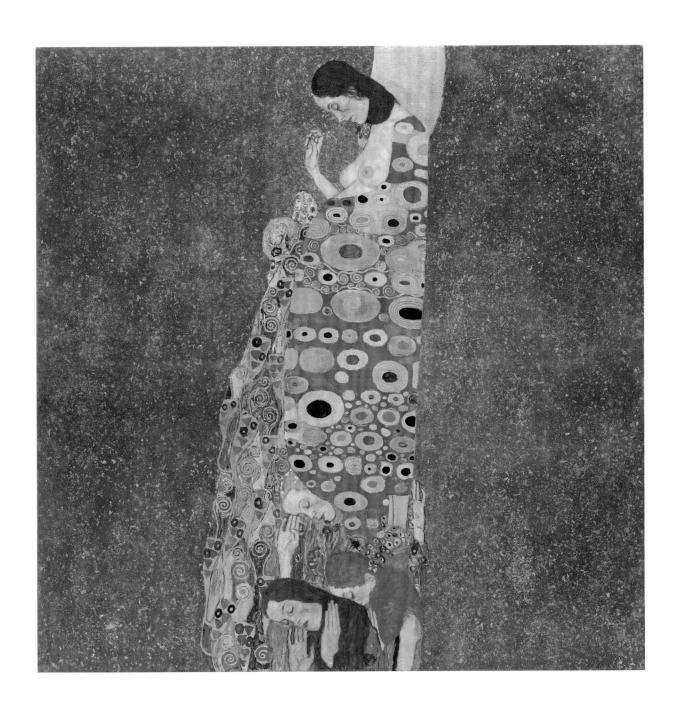

Gustav Klimt (Austrian, 1862–1918). *Hope, II.* 1907–08. Oil, gold, and platinum on canvas, 43½ x 43½"
(110.5 x 110.5 cm). Jo Carole and Ronald S. Lauder and Helen Acheson Funds, and Serge Sabarsky, 1978

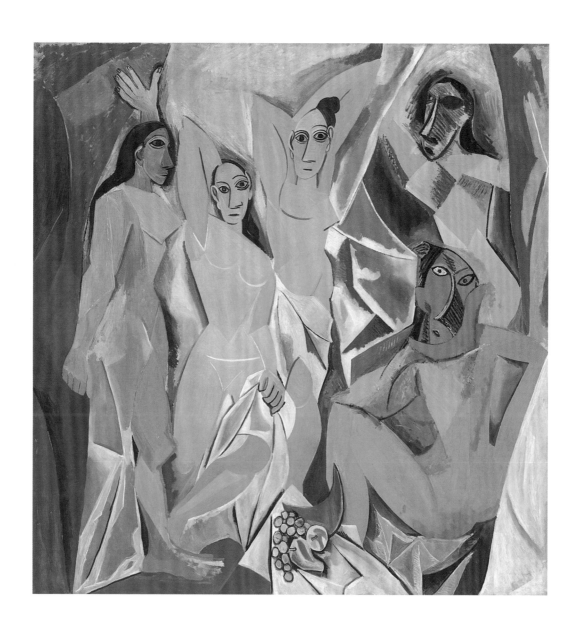

Pablo Picasso (Spanish, 1881–1973). *Les Demoiselles d'Avignon*. 1907. Oil on canvas,
8' x 7' 8" (243.9 x 233.7 cm). Acquired through the Lillie P. Bliss Bequest, 1939

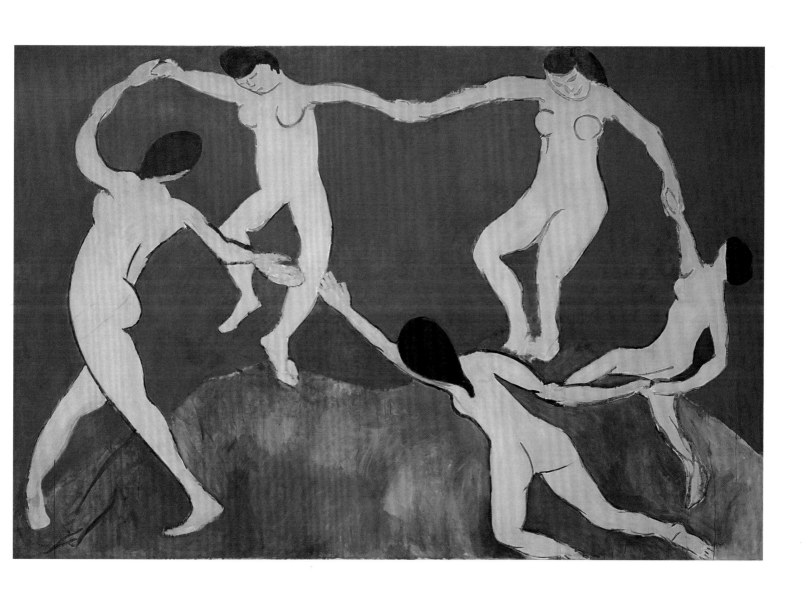

Henri Matisse (French, 1869–1954). *Dance (I)*. 1909. Oil on canvas, 8' 6½" x 12' 9½"
(259.7 x 390.1 cm). Gift of Nelson A. Rockefeller in honor of Alfred H. Barr, Jr., 1963

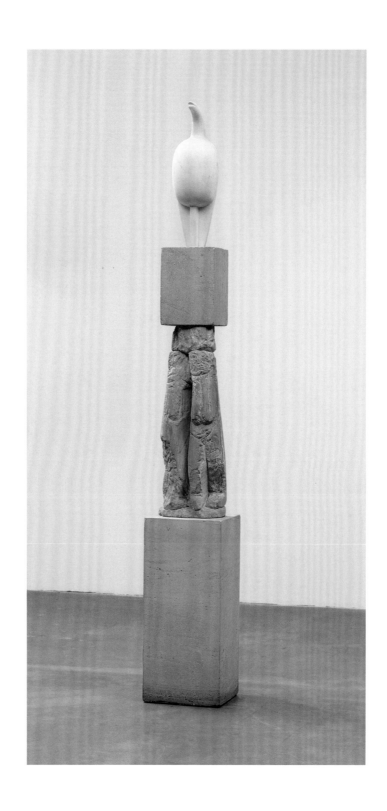

Constantin Brancusi (French, born Romania. 1876–1957). *Maiastra*. 1910–12.
White marble, 22" (55.9 cm) high, and three-part limestone pedestal, 70" (177.8 cm) high, of which
the middle section is *Double Caryatid*, c. 1908. Katherine S. Dreier Bequest, 1953

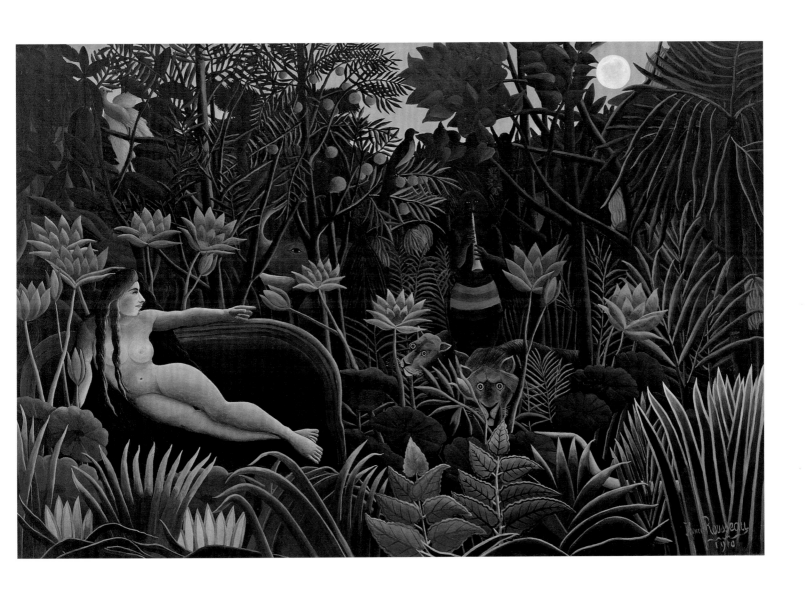

Henri Rousseau (French, 1844–1910). *The Dream*. 1910. Oil on canvas,
6' 8½" x 9' 9½" (204.5 x 298.5 cm). Gift of Nelson A. Rockefeller, 1954

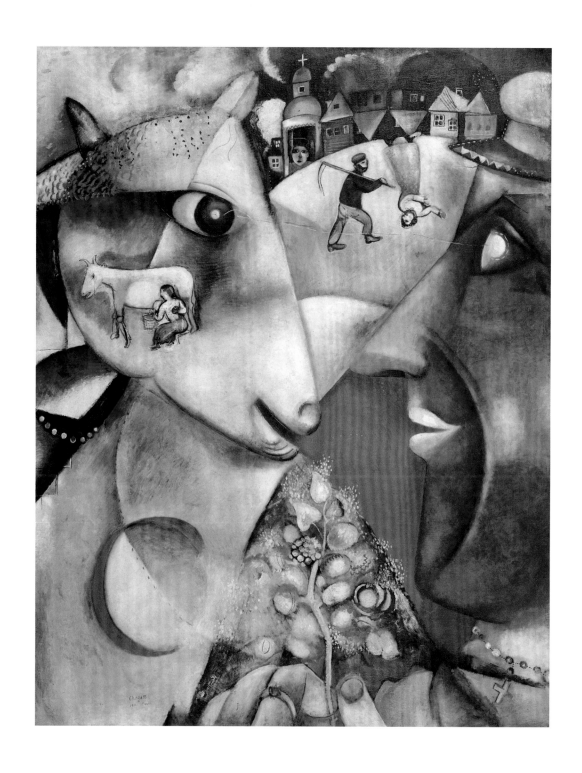

Marc Chagall (French, born Belarus. 1887–1985). *I and the Village*. 1911. Oil on canvas, 6' 3⅝" x 59⅝" (192.1 x 151.4 cm). Mrs. Simon Guggenheim Fund, 1945

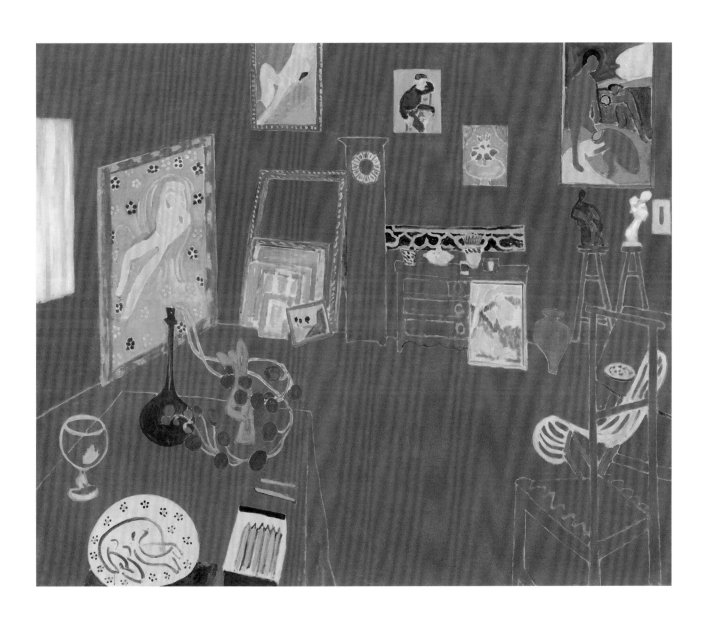

Henri Matisse (French, 1869–1954). *The Red Studio*. 1911. Oil on canvas,
71¼" x 7' 2¼" (181 x 219.1 cm). Mrs. Simon Guggenheim Fund, 1949

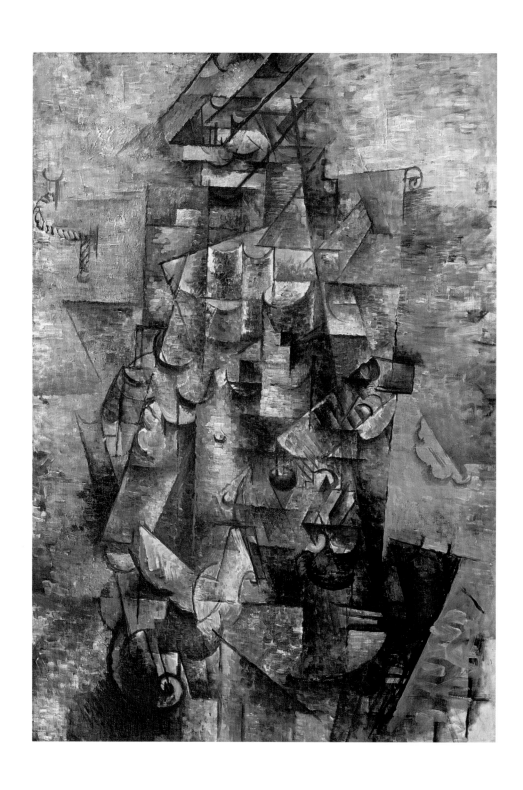

Georges Braque (French, 1882–1963). *Man with a Guitar*. 1911–12. Oil on canvas, 45¾ x 31⅞" (116.2 x 80.9 cm). Acquired through the Lillie P. Bliss Bequest, 1945

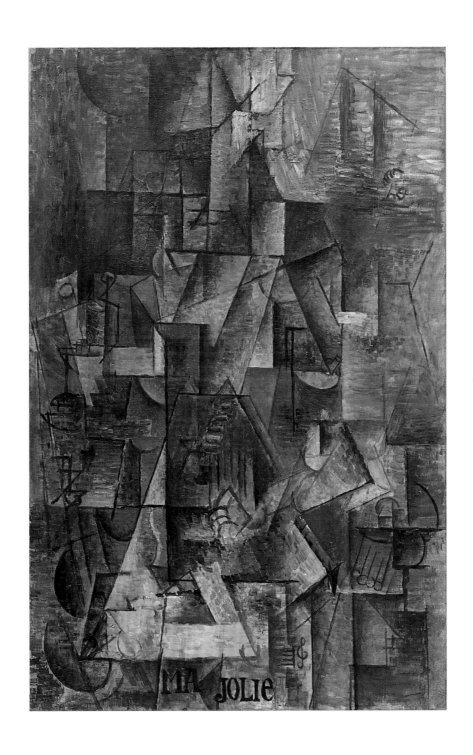

Pablo Picasso (Spanish, 1881–1973). *"Ma Jolie."* 1911–12. Oil on canvas, 39⅜ x 25¾" (100 x 64.5 cm). Acquired through the Lillie P. Bliss Bequest, 1945

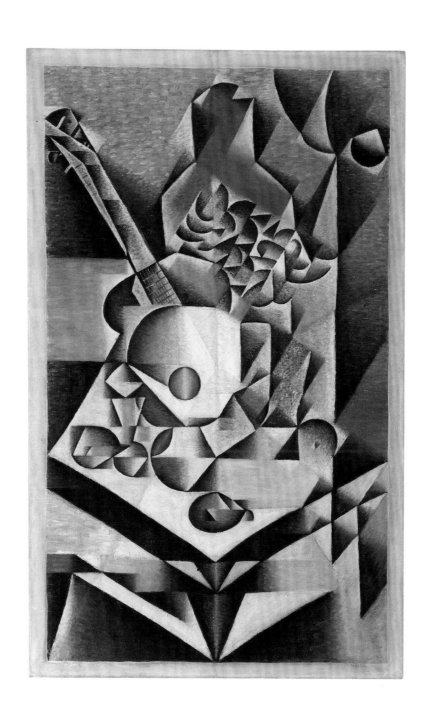

Juan Gris (Spanish, 1887–1927). *Still Life with Flowers*. 1912. Oil on canvas, 44⅛ x 27⅝" (112.1 x 70.2 cm). Bequest of Anna Erickson Levene in memory of her husband, Dr. Phoebus Aaron Theodor Levene, 1947

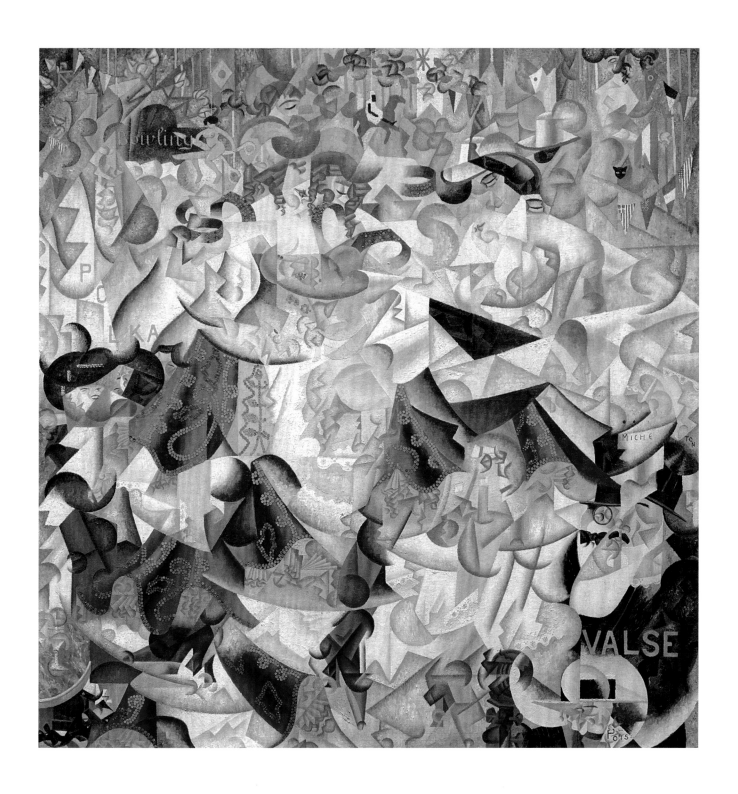

Gino Severini (Italian, 1883–1966). *Dynamic Hieroglyphic of the Bal Tabarin*. 1912. Oil on canvas with sequins, 63⅝ x 61½" (161.6 x 156.2 cm). Acquired through the Lillie P. Bliss Bequest, 1949

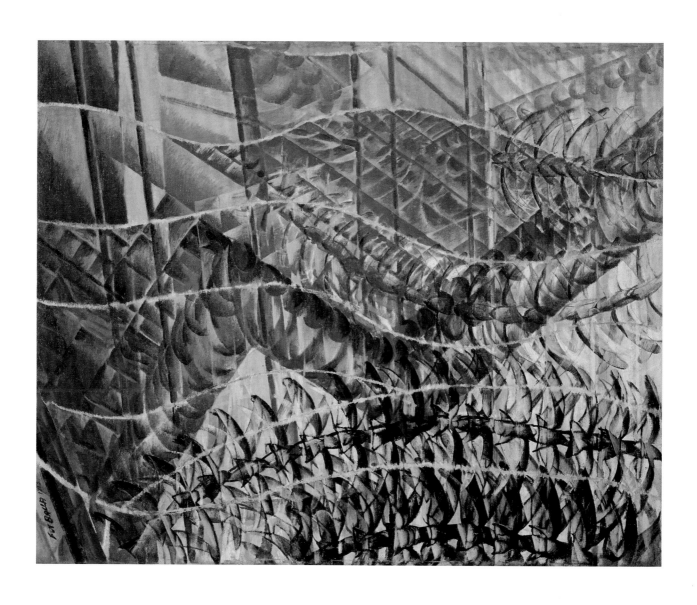

Giacomo Balla (Italian, 1871–1958). *Swifts: Paths of Movement + Dynamic Sequences*. 1913.
Oil on canvas, 38⅛ x 47¼" (96.8 x 120 cm). Purchase, 1949

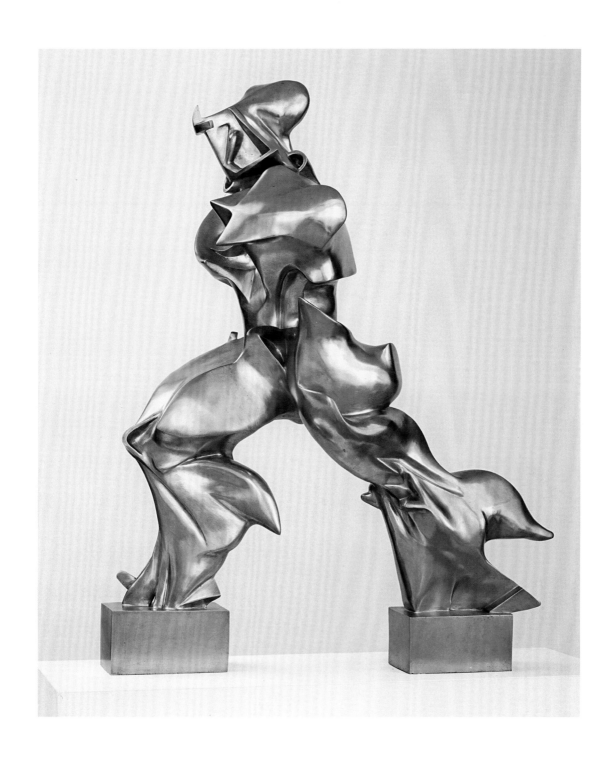

Umberto Boccioni (Italian, 1882–1916). *Unique Forms of Continuity in Space*. 1913 (cast 1931).
Bronze, 43⅞ x 34⅞ x 15¾" (111.2 x 88.5 x 40 cm). Acquired through the Lillie P. Bliss Bequest, 1948

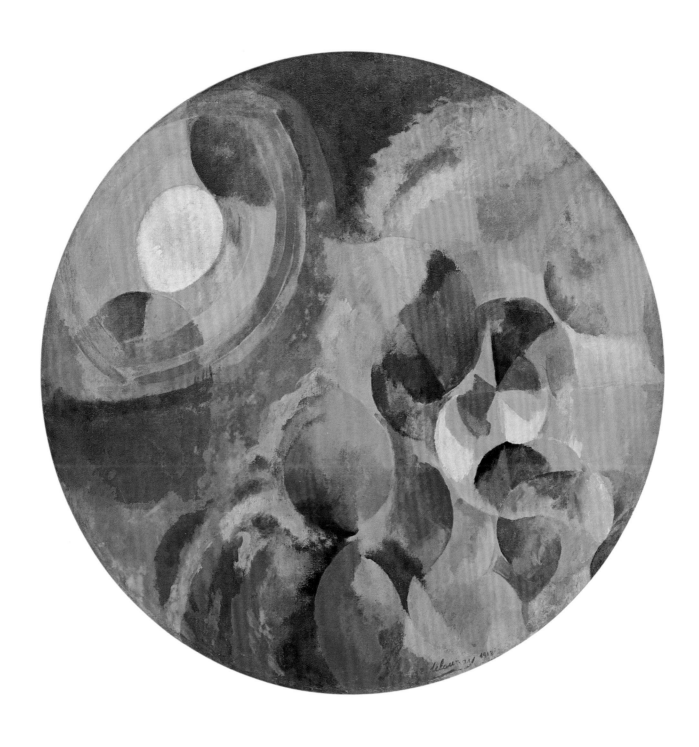

Robert Delaunay (French, 1885–1941). *Simultaneous Contrasts: Sun and Moon*. 1913
(dated 1912 on painting). Oil on canvas, 53" (134.5 cm) diam. Mrs. Simon Guggenheim Fund, 1954

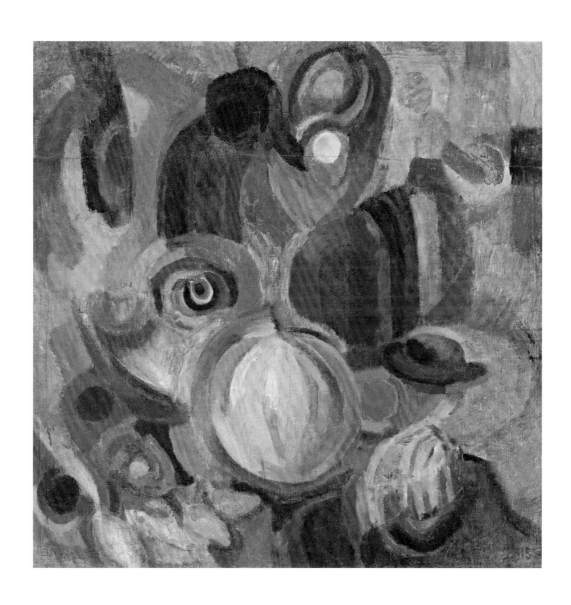

Sonia Delaunay-Terk (French, born Ukraine. 1885–1979). *Portuguese Market*. 1915.
Oil and wax on canvas, 35⅝ x 35⅝" (90.5 x 90.5 cm). Gift of Theodore R. Racoosin, 1955

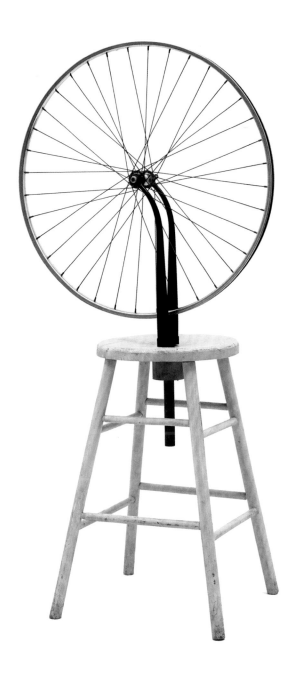

Marcel Duchamp (American, born France. 1887–1968). *Bicycle Wheel*. 1951 (third version, after lost original of 1913). Metal wheel mounted on painted wood stool, 51 x 25 x 16½" (129.5 x 63.5 x 41.9 cm). The Sidney and Harriet Janis Collection, 1967

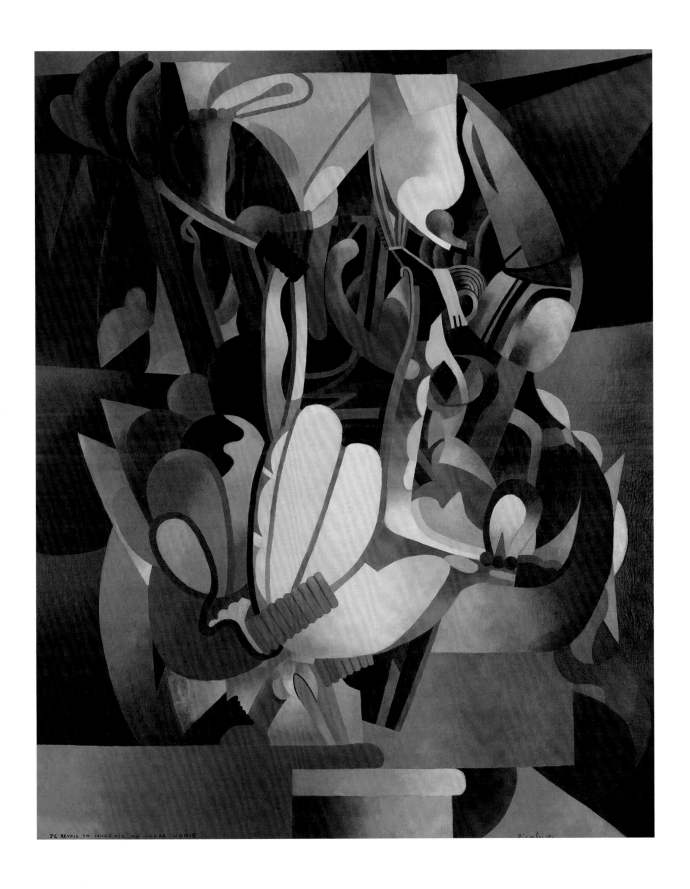

Francis Picabia (French, 1879–1953). *I See Again in Memory My Dear Udnie*. 1914, possibly begun 1913. Oil on canvas, 8' 2½" x 6' 6¼" (250.2 x 198.8 cm). Hillman Periodicals Fund, 1954

Vasily Kandinsky (French, born Russia. 1866–1944). *Panel for Edwin R. Campbell No. 1*. 1914.
Oil on canvas, 64 x 31½" (162.5 x 80 cm). Mrs. Simon Guggenheim Fund, 1954

Vasily Kandinsky. *Panel for Edwin R. Campbell No. 2*. 1914. Oil on canvas, 64⅛ x 48⅜" (162.6 x 122.7 cm).
Nelson A. Rockefeller Fund (by exchange), 1983

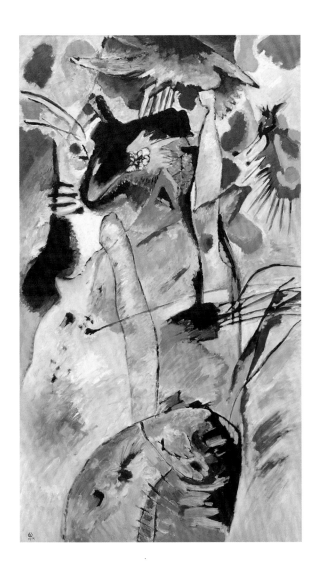

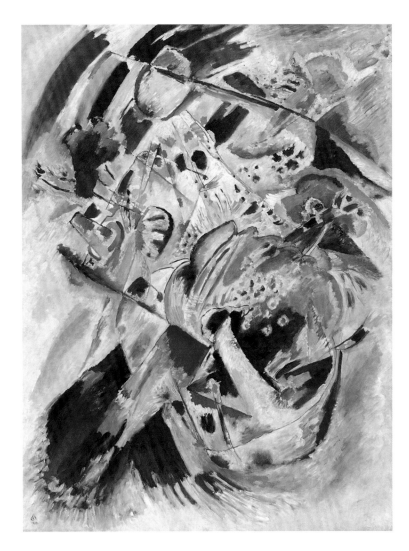

Vasily Kandinsky. *Panel for Edwin R. Campbell No. 3.* 1914. Oil on canvas, 64 x 36¼" (162.5 x 92.1 cm).
Mrs. Simon Guggenheim Fund, 1954

Vasily Kandinsky. *Panel for Edwin R. Campbell No. 4.* 1914. Oil on canvas, 64¼ x 48¼" (163 x 122.5 cm).
Nelson A. Rockefeller Fund (by exchange), 1983

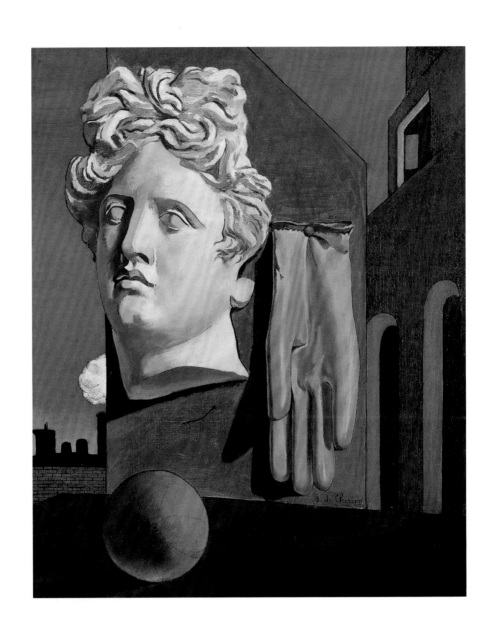

Giorgio de Chirico (Italian, born Greece. 1888–1978). *The Song of Love*. 1914.
Oil on canvas, 28¾ x 23⅜" (73 x 59.1 cm). Nelson A. Rockefeller Bequest, 1979

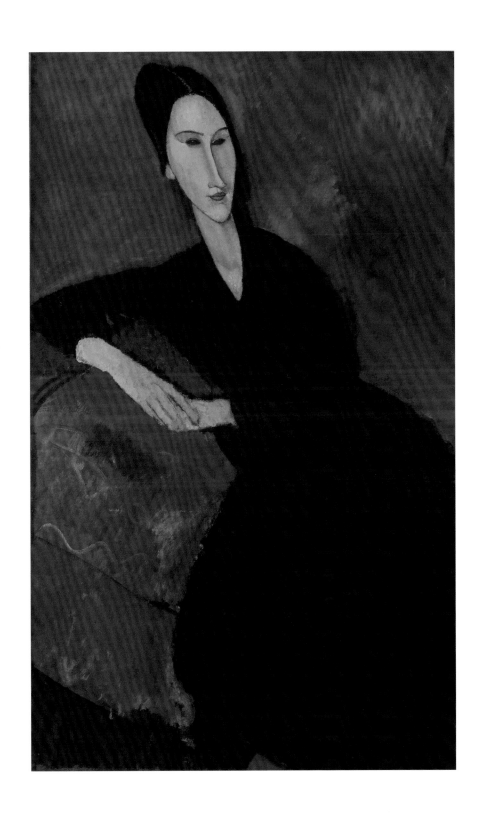

Amedeo Modigliani (Italian, 1884–1920). *Anna Zborowska*. 1917.
Oil on canvas, 51¼ x 32" (130.2 x 81.3 cm). Lillie P. Bliss Collection, 1934

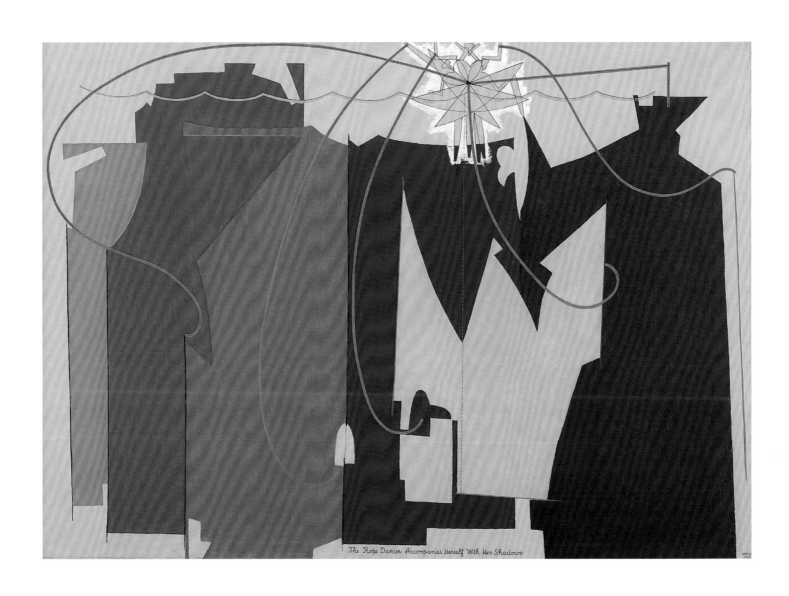

Man Ray (Emmanuel Radnitzky) (American, 1890–1976). *The Rope Dancer Accompanies Herself with Her Shadows*. 1916. Oil on canvas, 52" x 6' 1⅜" (132.1 x 186.4 cm). Gift of G. David Thompson, 1954

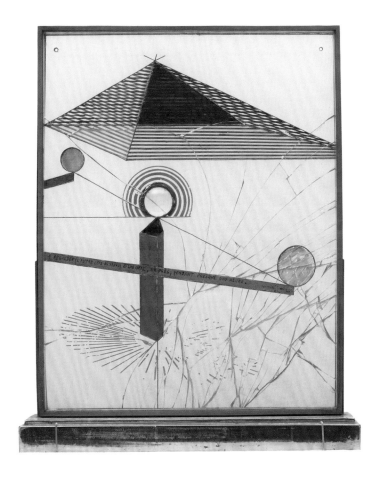

Marcel Duchamp (American, born France. 1887–1968). *To Be Looked at (from the Other Side of the Glass) with One Eye, Close to, for Almost an Hour*. 1918. Oil, silver leaf, lead wire, and magnifying lens on glass (cracked), mounted between panes of glass in a standing metal frame, 20⅛ x 16¼ x 1½" (51 x 41.2 x 3.7 cm), and painted wood base, 1⅞ x 17⅞ x 4½" (4.8 x 45.3 x 11.4 cm); overall 22" (55.8 cm) high. Katherine S. Dreier Bequest, 1953

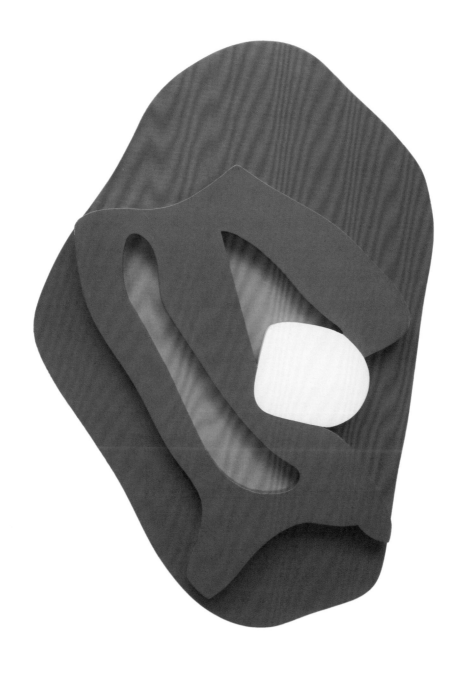

Jean Arp (Hans Arp) (French, born Germany [Alsace]. 1886–1966). *Enak's Tears (Terrestrial Forms)*.
1917. Painted wood, 34 x 23⅛ x 2⅜" (86.2 x 58.5 x 6 cm). Benjamin Scharps and David Scharps Fund and purchase, 1979

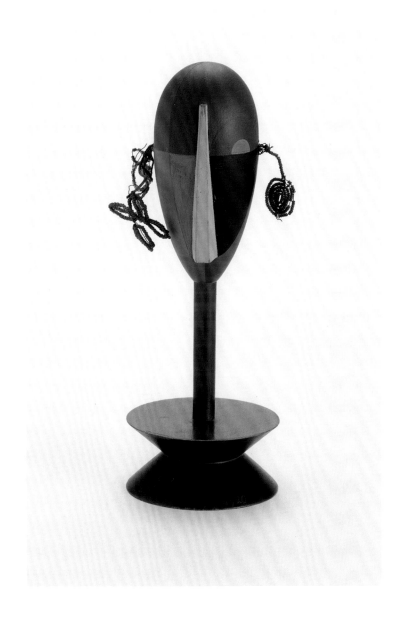

Sophie Taeuber-Arp (Swiss, 1889–1943). *Dada Head*. 1920.
Painted wood with glass beads on wire, 9¼" (23.5 cm) high. Mrs. John Hay Whitney
Bequest (by exchange) and Committee on Painting and Sculpture Funds, 2003

Lyubov Popova (Russian, 1889–1924). *Painterly Architectonic*. 1917.
Oil on canvas, 31½ x 38⅝" (80 x 98 cm). Philip Johnson Fund, 1958

Kazimir Malevich (Russian, born Ukraine. 1878–1935). *Suprematist Composition:*
White on White. 1918. Oil on canvas, 31¼ x 31¼" (79.4 x 79.4 cm). Acquisition confirmed in 1999 by
agreement with the Estate of Kazimir Malevich and made possible with funds from the Mrs. John Hay Whitney
Bequest (by exchange), 1935

Aleksandr Rodchenko (Russian, 1891–1956). *Spatial Construction no. 12*. c. 1920. Plywood, open construction partially painted with aluminum paint, and wire, 24 x 33 x 18½" (61 x 83.7 x 47 cm). Acquisition made possible through the extraordinary efforts of George and Zinaida Costakis and through the Nate B. and Frances Spingold, Matthew H. and Erna Futter, and Enid A. Haupt Funds, 1986

El Lissitzky (Russian, 1890–1941). *Proun 19D*. 1920 or 1921. Gesso, oil, varnish, crayon, colored papers, sandpaper, graph paper, cardboard, metallic paint, and metal foil on plywood, 38⅜ x 38¼" (97.5 x 97.2 cm). Katherine S. Dreier Bequest, 1953

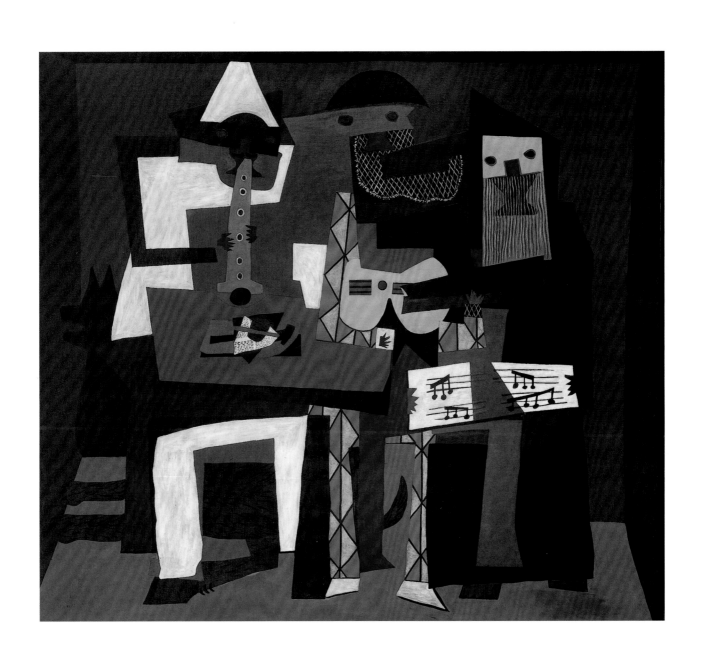

Pablo Picasso (Spanish, 1881–1973). *Three Musicians*. 1921. Oil on canvas,
6' 7" x 7' 3¾" (200.7 x 222.9 cm). Mrs. Simon Guggenheim Fund, 1949

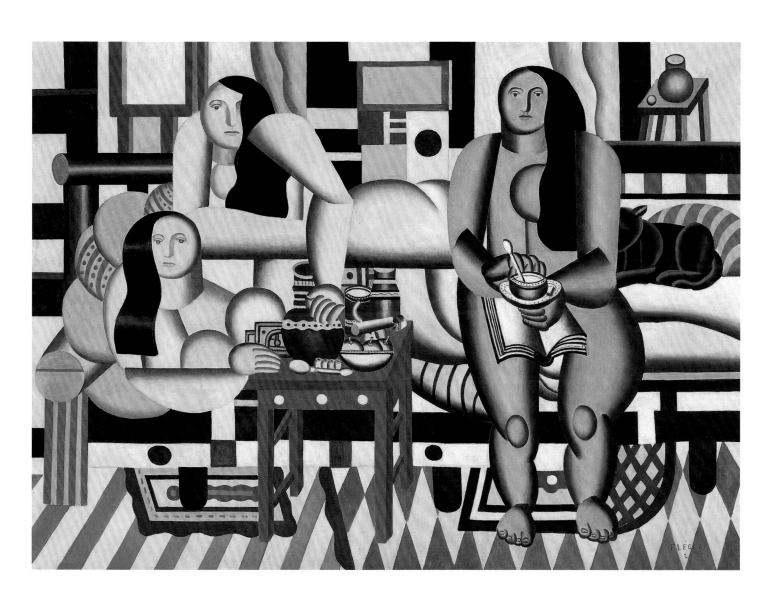

Fernand Léger (French, 1881–1955). *Three Women*. 1921–22. Oil on canvas,
6' ¼" x 8' 3" (183.5 x 251.5 cm). Mrs. Simon Guggenheim Fund, 1942

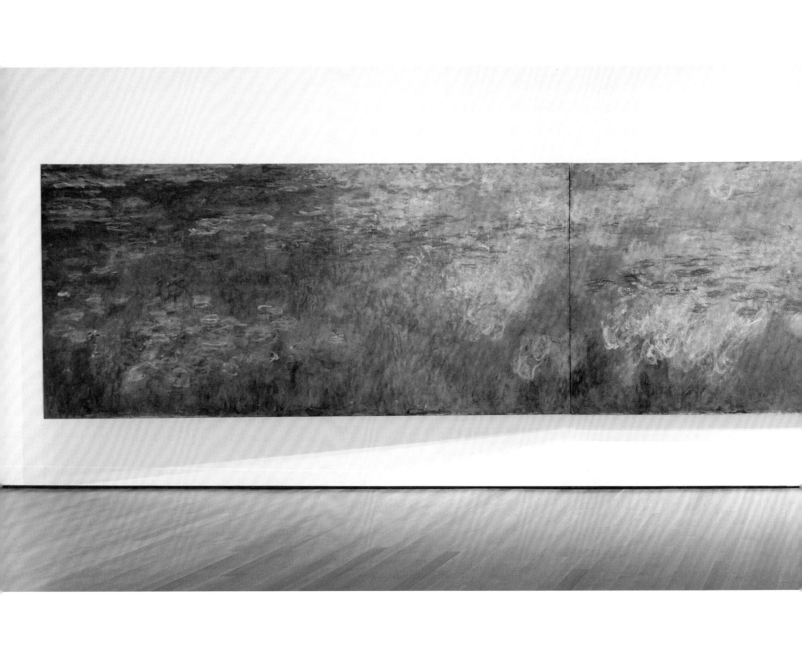

Claude Monet (French, 1840–1926). *Water Lilies*. 1914–26. Oil on canvas, three panels, each 6' 6¾" x 13' 11¼" (200 x 424.8 cm); overall 6' 6¾" x 41' 10⅜" (200 x 1,276 cm). Mrs. Simon Guggenheim Fund, 1959

László Moholy-Nagy (American, born Hungary. 1895–1946). *Construction in Enamel 2*. 1923.
Porcelain enamel on steel, 18¾ x 11⅞" (47.5 x 30.1 cm). Gift of Philip Johnson in memory of Sibyl Moholy-Nagy, 1971

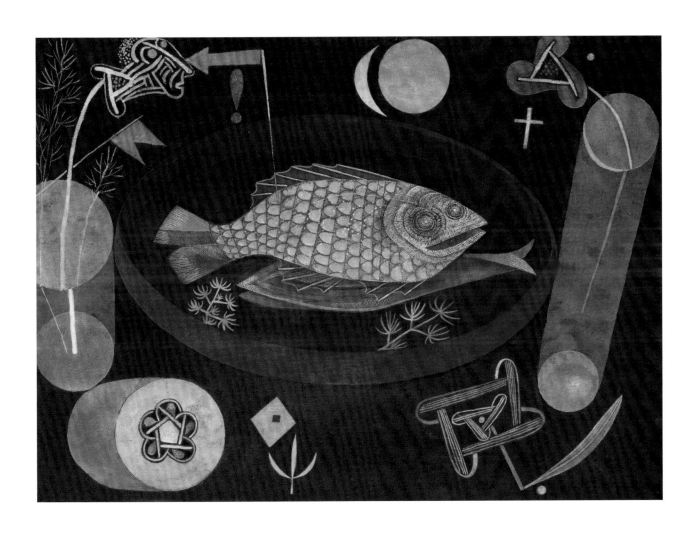

Paul Klee (German, born Switzerland. 1879–1940). *Around the Fish*. 1926. Oil and tempera
on canvas mounted on cardboard, 18⅜ x 25⅛" (46.7 x 63.8 cm). Abby Aldrich Rockefeller Fund, 1939

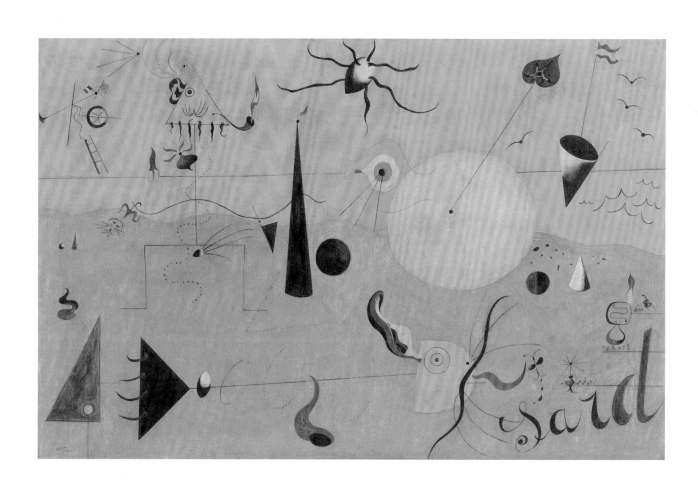

Joan Miró (Spanish, 1893–1983). *The Hunter (Catalan Landscape)*. 1923–24.
Oil on canvas, 25½ x 39½" (64.8 x 100.3 cm). Purchase, 1936

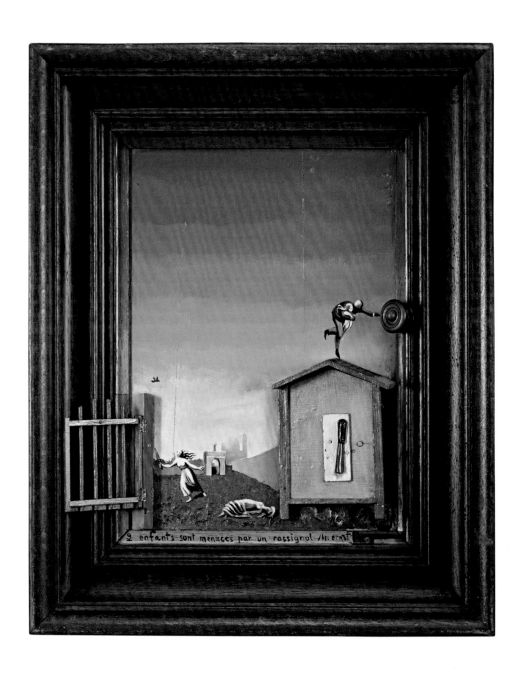

Max Ernst (French, born Germany. 1891–1976). *Two Children Are Threatened by a Nightingale*. 1924. Oil on wood with painted wood elements and frame, 27½ x 22½ x 4½" (69.8 x 57.1 x 11.4 cm). Purchase, 1937

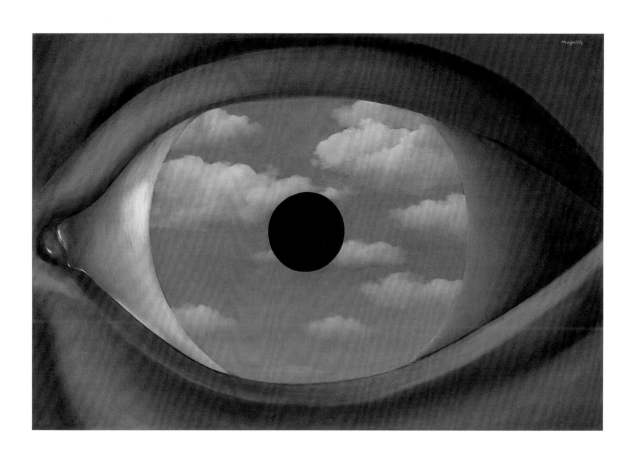

René Magritte (Belgian, 1898–1967). *The False Mirror*. 1929.
Oil on canvas, 21¼ x 31⅞" (54 x 80.9 cm). Purchase, 1936

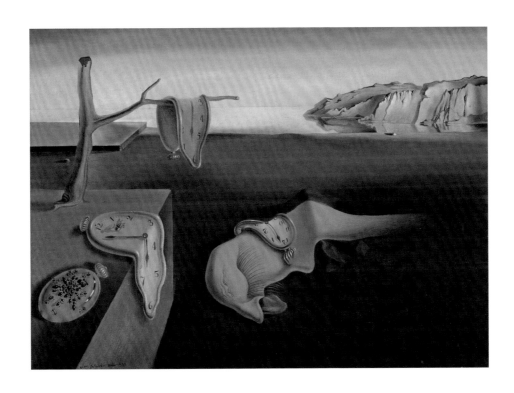

Salvador Dalí (Spanish, 1904–1989). *The Persistence of Memory*. 1931.
Oil on canvas, 9½ x 13" (24.1 x 33 cm). Given anonymously, 1934

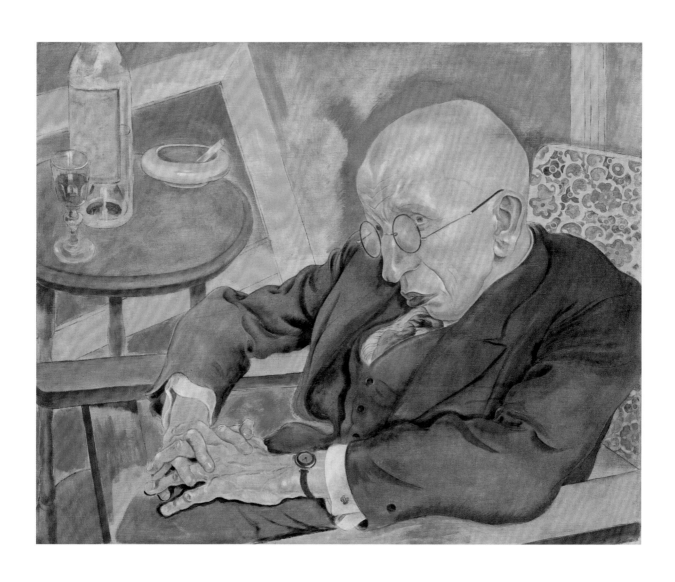

George Grosz (American, born Germany. 1893–1959). *The Poet Max Herrmann-Neisse*. 1927.
Oil on canvas, 23⅜ x 29⅛" (59.4 x 74 cm). Purchase, 1952

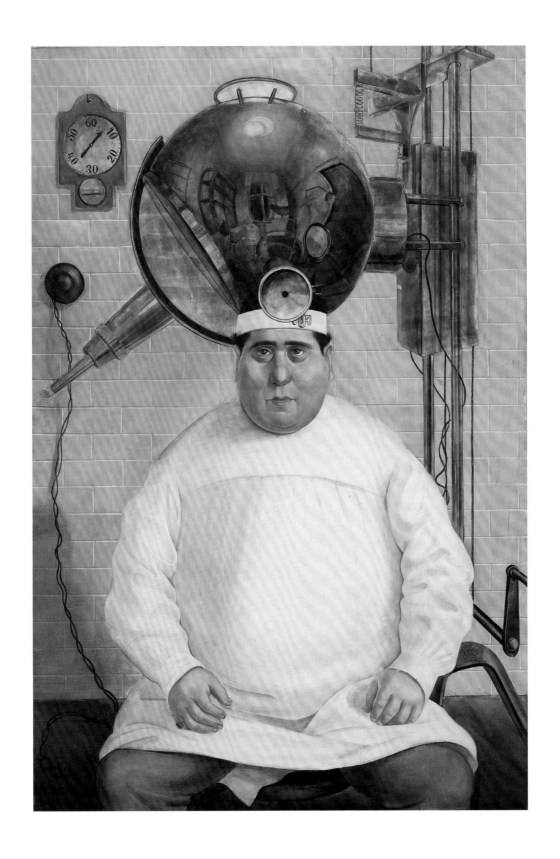

Otto Dix (German, 1891–1969). *Dr. Mayer-Hermann*. 1926. Oil and tempera on wood,
58¾ x 39" (149.2 x 99.1 cm). Gift of Philip Johnson, 1932

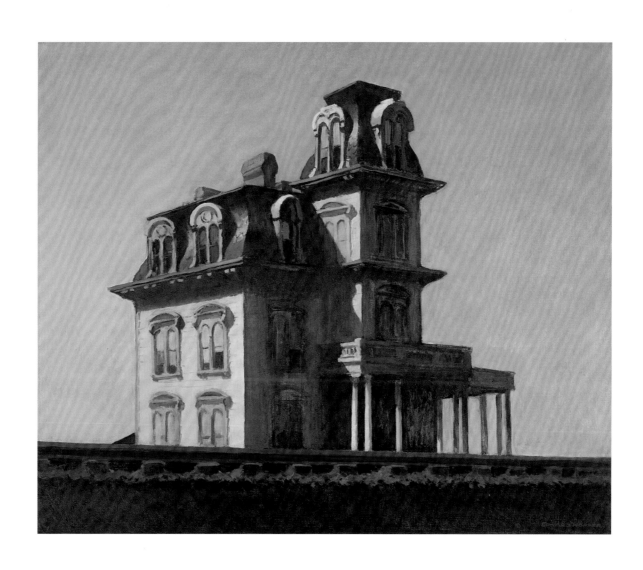

Edward Hopper (American, 1882–1967). *House by the Railroad*. 1925.
Oil on canvas, 24 x 29" (61 x 73.7 cm). Given anonymously, 1930

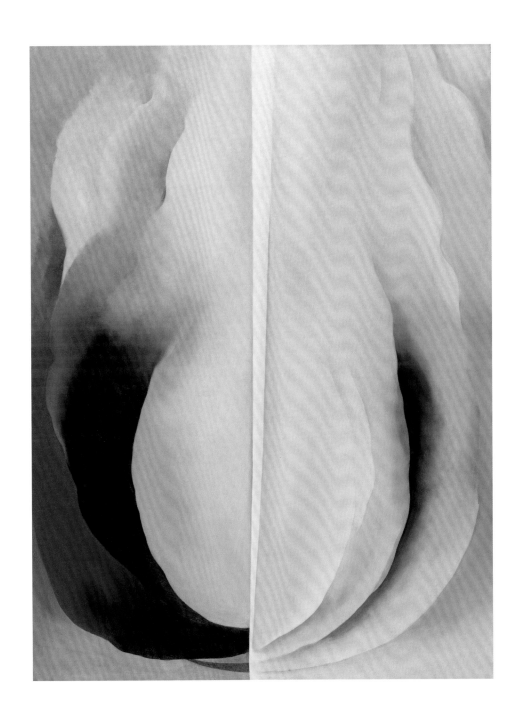

Georgia O'Keeffe (American, 1887–1986). *Abstraction Blue*. 1927. Oil on canvas,
40¼ x 30" (102.1 x 76 cm). Acquired through the Helen Acheson Bequest, 1979

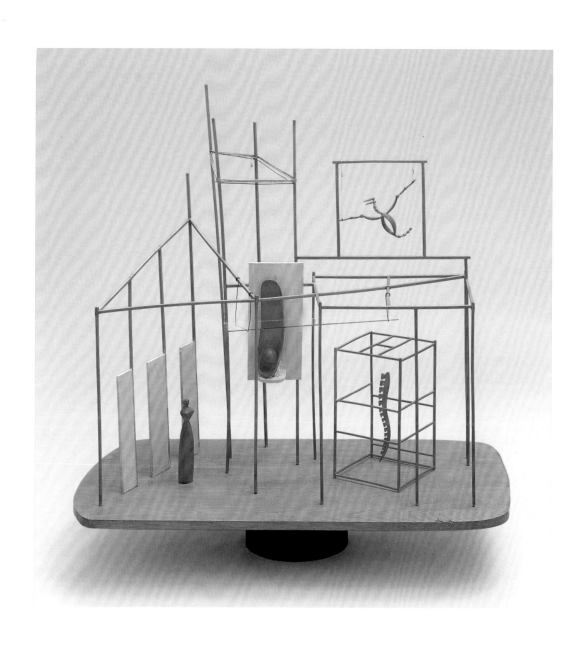

Alberto Giacometti (Swiss, 1901–1966). *The Palace at 4 a.m.* 1932.
Wood, glass, wire, and string, 25 x 28¼ x 15¾" (63.5 x 71.8 x 40 cm). Purchase, 1936

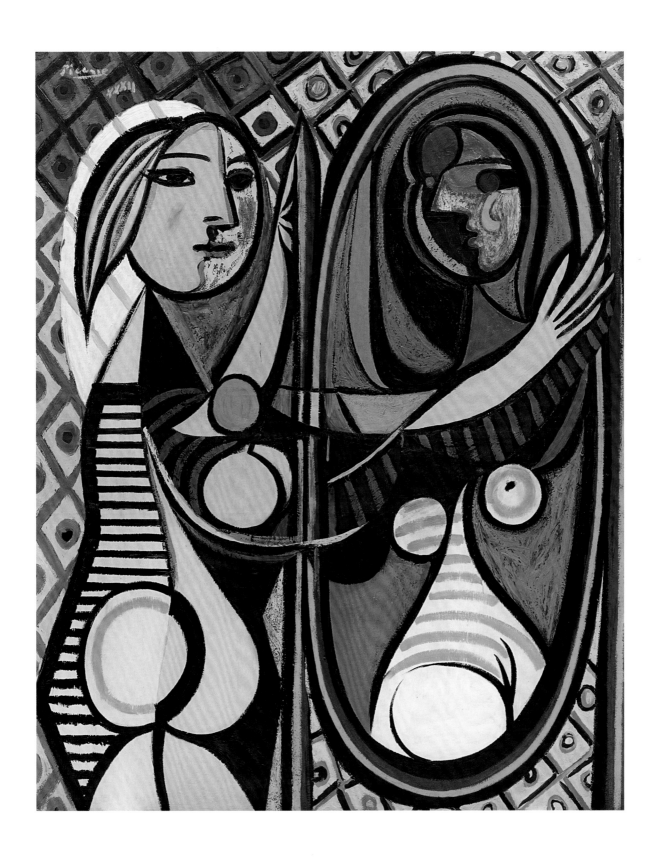

Pablo Picasso (Spanish, 1881–1973). *Girl before a Mirror*. 1932. Oil on canvas,
64 x 51¼" (162.3 x 130.2 cm). Gift of Mrs. Simon Guggenheim, 1938

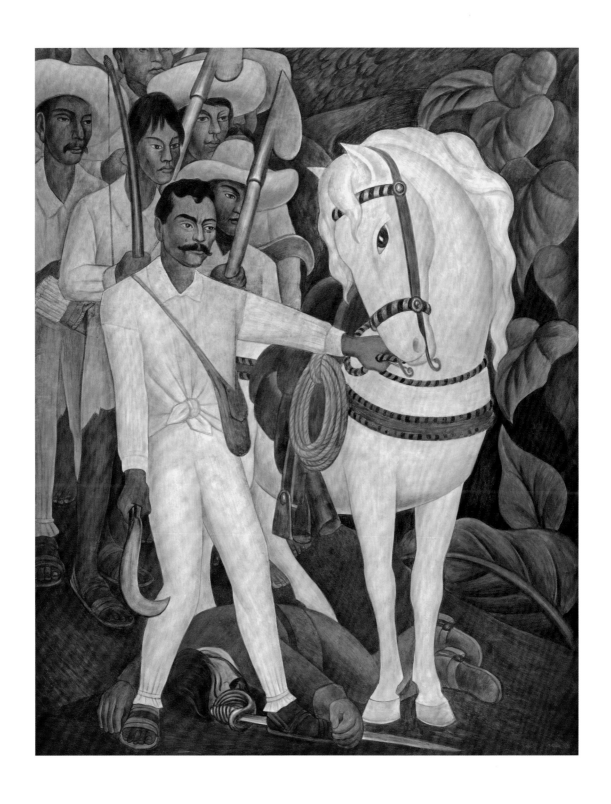

Diego Rivera (Mexican, 1886–1957). *Agrarian Leader Zapata*. 1931. Fresco on reinforced cement in galvanized-steel framework, 7' 9¾" x 6' 2" (238.1 x 188 cm). Abby Aldrich Rockefeller Fund, 1940

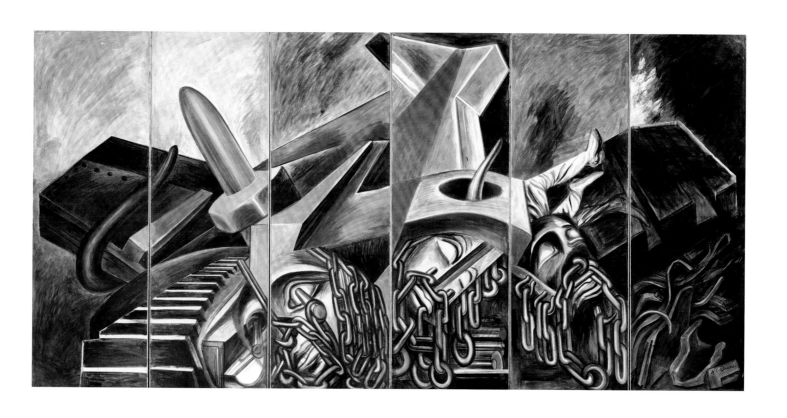

José Clemente Orozco (Mexican, 1883–1949). *Dive Bomber and Tank*. 1940.
Fresco, six panels, each 9' x 36" (275 x 91.4 cm); overall 9 x 18' (275 x 550 cm). Commissioned
through the Abby Aldrich Rockefeller Fund, 1940

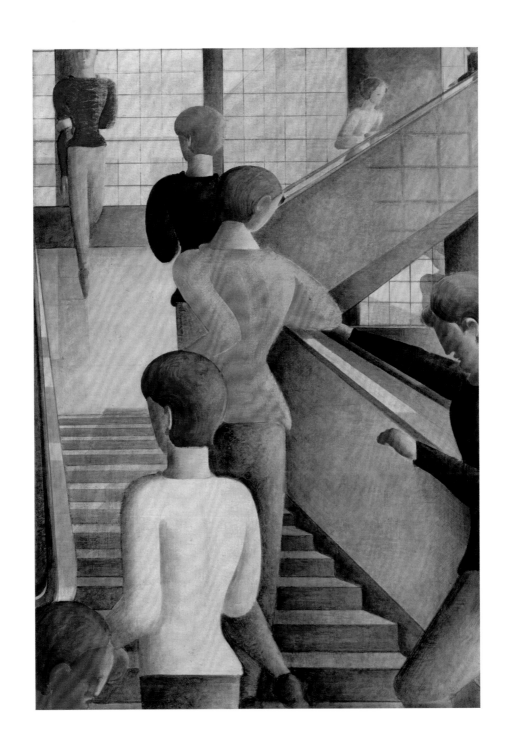

Oskar Schlemmer (German, 1888–1943). *Bauhaus Stairway*. 1932.
Oil on canvas, 63⅞ x 45" (162.3 x 114.3 cm). Gift of Philip Johnson, 1942

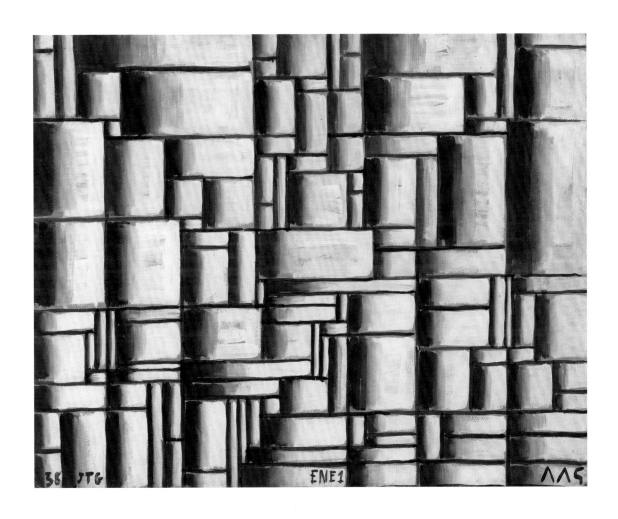

Joaquín Torres-García (Uruguayan, 1874–1949). *Construction in White and Black*. 1938. Oil on paper mounted on wood, 31¾ x 40⅛" (80.7 x 102 cm). Gift of Patricia Phelps de Cisneros in honor of David Rockefeller, 2004

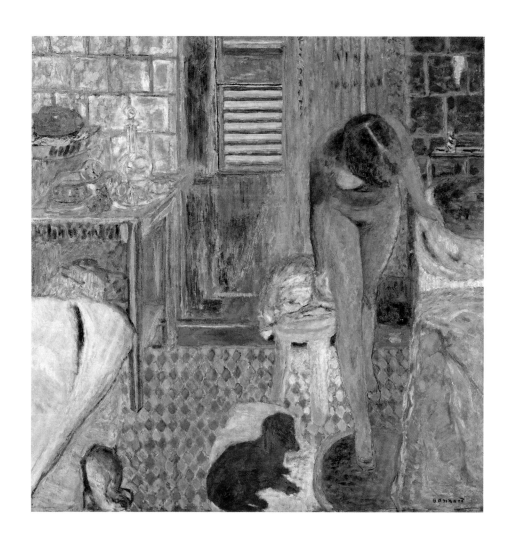

Pierre Bonnard (French, 1867–1947). *The Bathroom*. 1932. Oil on canvas,
47⅝ x 46½" (121 x 118.2 cm). Florene May Schoenborn Bequest, 1996

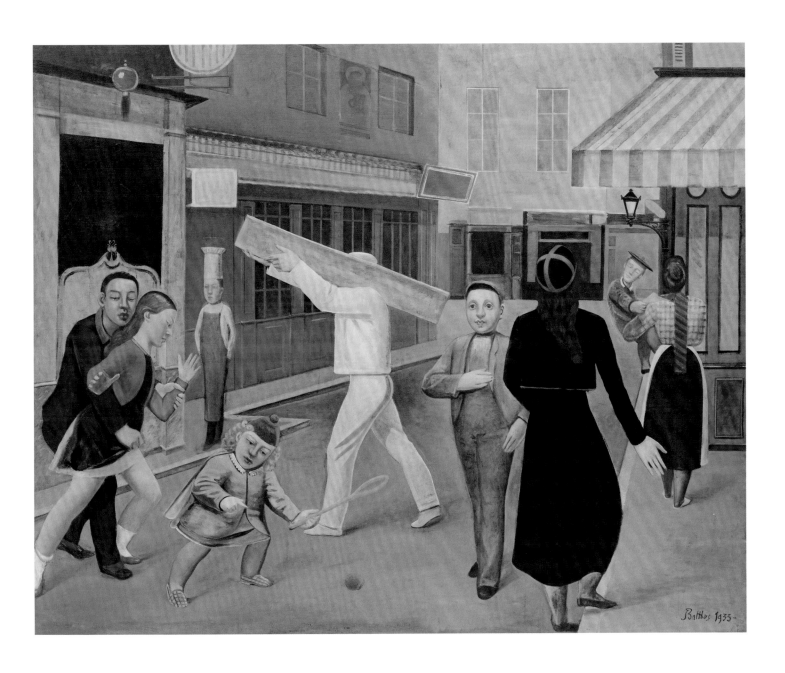

Balthus (Baltusz Klossowski de Rola) (French, 1908–2001). *The Street*. 1933.
Oil on canvas, 6' 4¾" x 7' 10½" (195 x 240 cm). James Thrall Soby Bequest, 1979

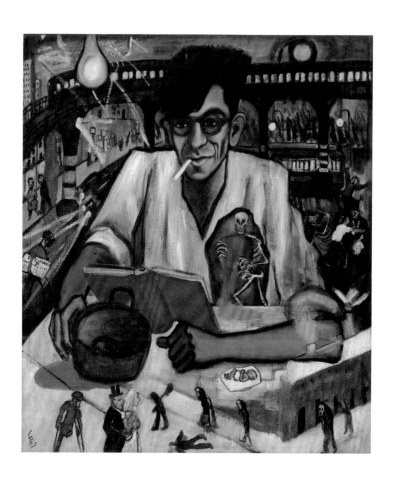

Alice Neel (American, 1900–1984). *Kenneth Fearing*. 1935. Oil on canvas, 30⅛ x 26" (76.5 x 66 cm). Gift of Hartley S. Neel and Richard Neel, 1988

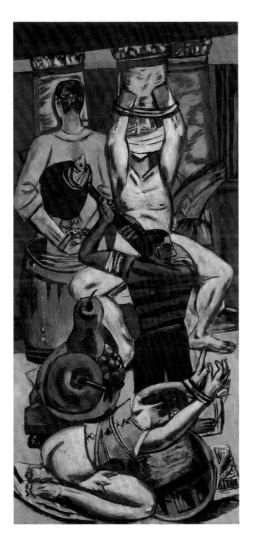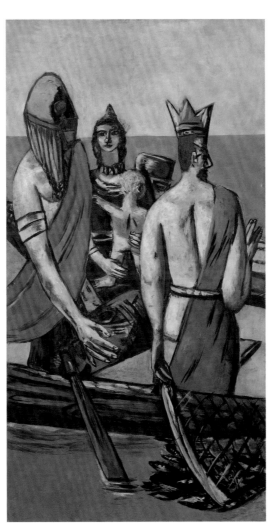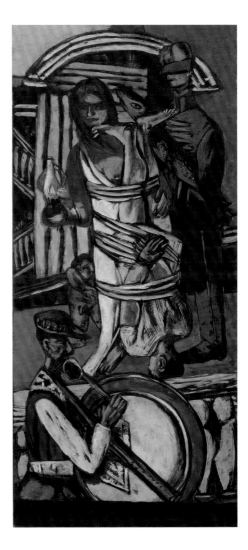

Max Beckmann (German, 1884–1950). *Departure*. 1932–35. Oil on canvas, triptych, center panel,
7' ¾" x 45⅜" (215.3 x 115.2 cm); side panels, each 7' ¾" x 39¼" (215.3 x 99.7 cm). Given anonymously (by exchange), 1942

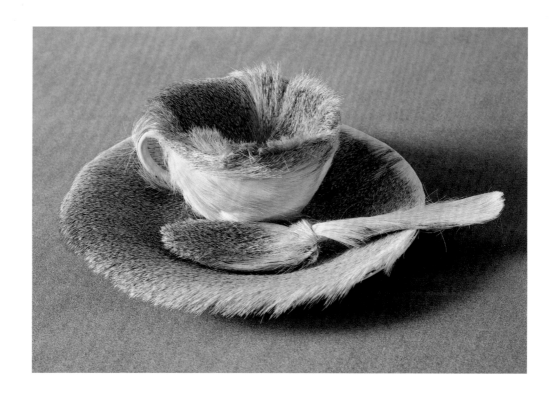

Meret Oppenheim (Swiss, 1913–1985). *Object*. 1936. Fur-covered cup, 4⅜" (10.9 cm) diam.; saucer, 9⅜" (23.7 cm) diam.; and spoon, 8" (20.2 cm) long; overall 2⅞" (7.3 cm) high. Purchase, 1946

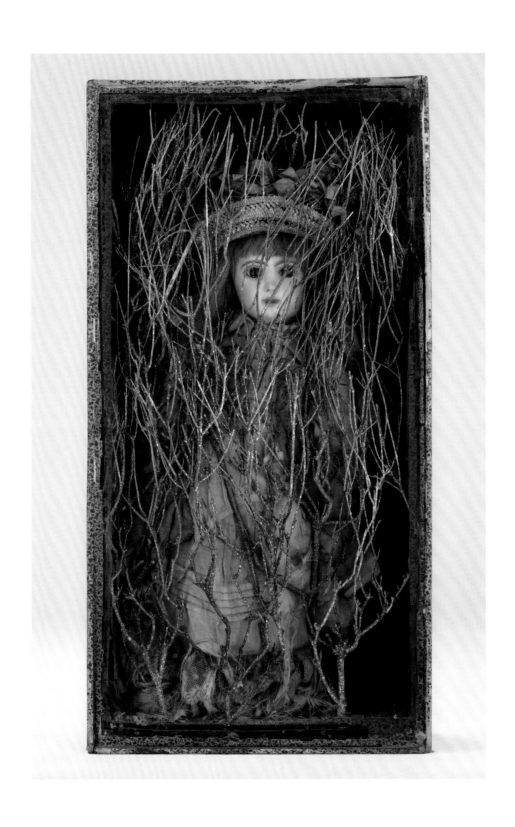

Joseph Cornell (American, 1903–1972). *Untitled (Bébé Marie)*. Early 1940s.
Papered and painted wood box with painted corrugated-cardboard bottom, containing doll in cloth
dress and straw hat with cloth flowers, dried flowers, and twigs flecked with paint, 23½ x 12⅜ x 5¼"
(59.7 x 31.5 x 13.3 cm). Acquired through the Lillie P. Bliss Bequest, 1980

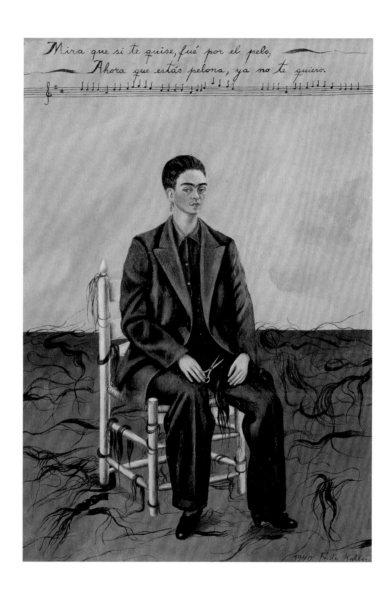

Frida Kahlo (Mexican, 1907–1954). *Self-Portrait with Cropped Hair*. 1940.
Oil on canvas, 15¾ x 11" (40 x 27.9 cm). Gift of Edgar Kaufmann, Jr., 1943

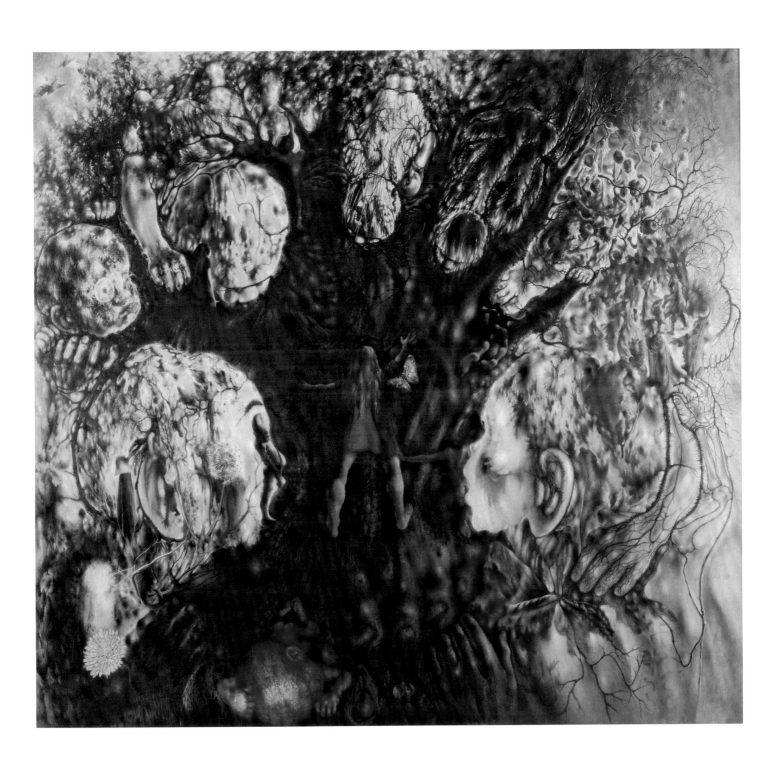

Pavel Tchelitchew (American, born Russia. 1898–1957). *Hide-and-Seek*. 1940–42.
Oil on canvas, 6' 6½" x 7' ¾" (199.3 x 215.3 cm). Mrs. Simon Guggenheim Fund, 1942

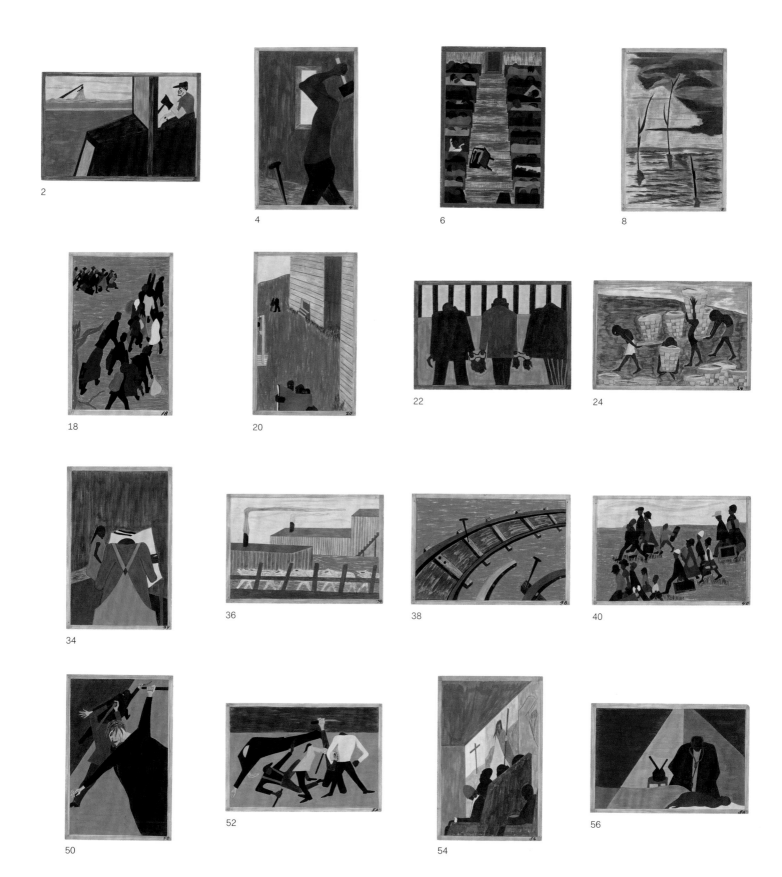

Jacob Lawrence (American, 1917–2000). *The Migration Series*. 1940–41. From a series of sixty works (thirty even-numbered panels in the Museum's collection and thirty odd-numbered panels in the collection of The Phillips Collection, Washington, D.C.), casein tempera on hardboard, 18 x 12" (45.7 x 30.5 cm) and 12 x 18" (30.5 x 45.7 cm). Gift of Mrs. David M. Levy, 1942

10

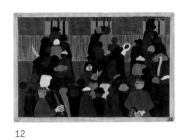

12

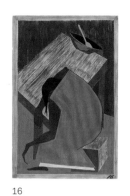

14

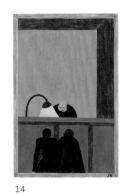

16

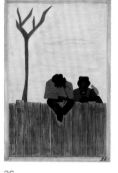

26

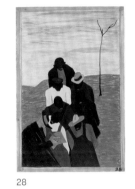

28

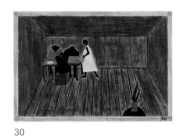

30

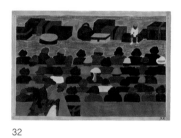

32

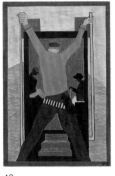

42

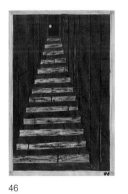

44

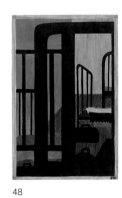

46

48

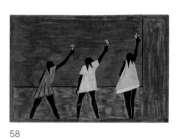

58

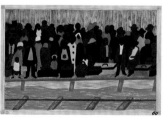

60

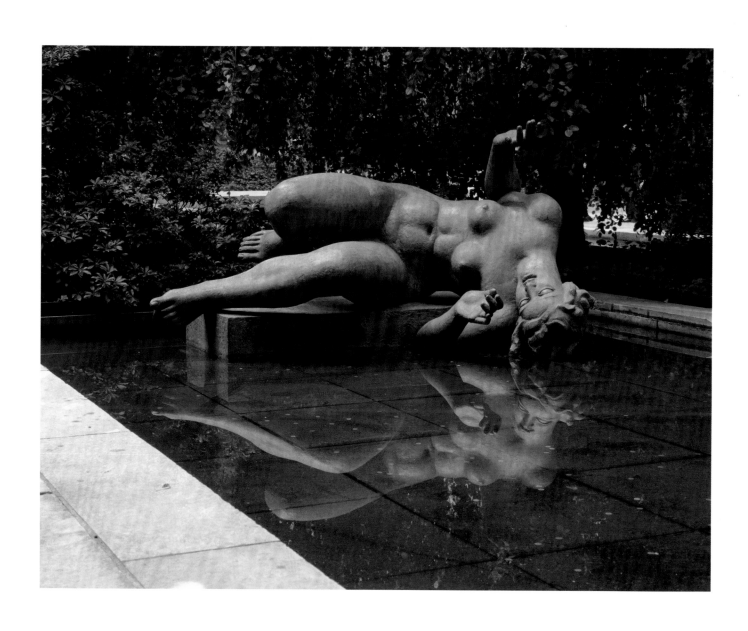

Aristide Maillol (French, 1861–1944). *The River*. Begun 1938–39; completed 1943
(cast 1948). Lead, 53¾" x 7' 6" x 66" (136.5 x 228.6 x 167.7 cm), and lead base designed by the artist,
9¾ x 67 x 27¾" (24.8 x 170.1 x 70.4 cm). Mrs. Simon Guggenheim Fund, 1949

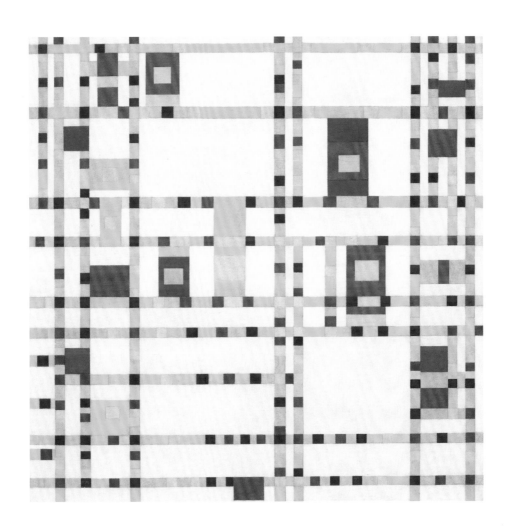

Piet Mondrian (Dutch, 1872–1944). *Broadway Boogie Woogie*. 1942–43.
Oil on canvas, 50 x 50" (127 x 127 cm). Given anonymously, 1943

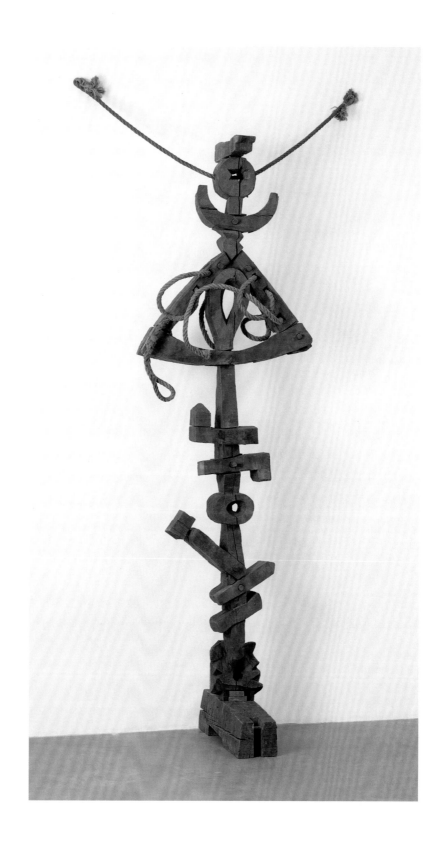

Frederick Kiesler (American, born Romania. 1890–1965). *Totem for All Religions*. 1947. Wood and rope, 9' 4¼" x 34⅛" x 30⅞" (285.1 x 86.6 x 78.4 cm). Gift of Mr. and Mrs. Armand P. Bartos, 1971

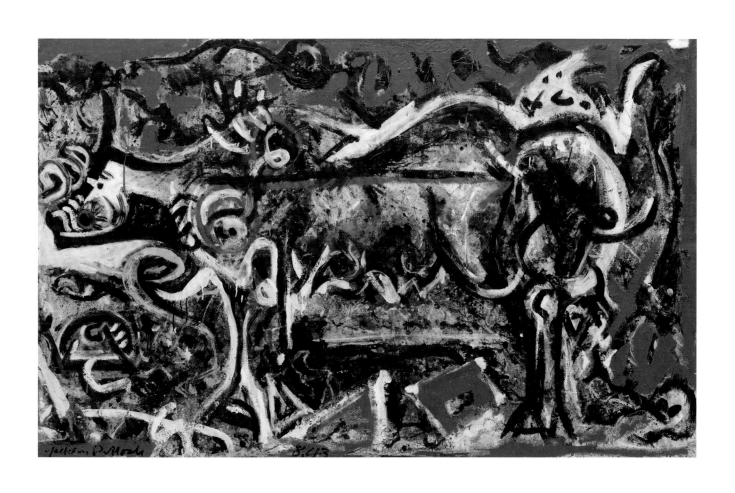

Jackson Pollock (American, 1912–1956). *The She-Wolf*. 1943.

Oil, gouache, and plaster on canvas, 41⅞ x 67" (106.4 x 170.2 cm). Purchase, 1944

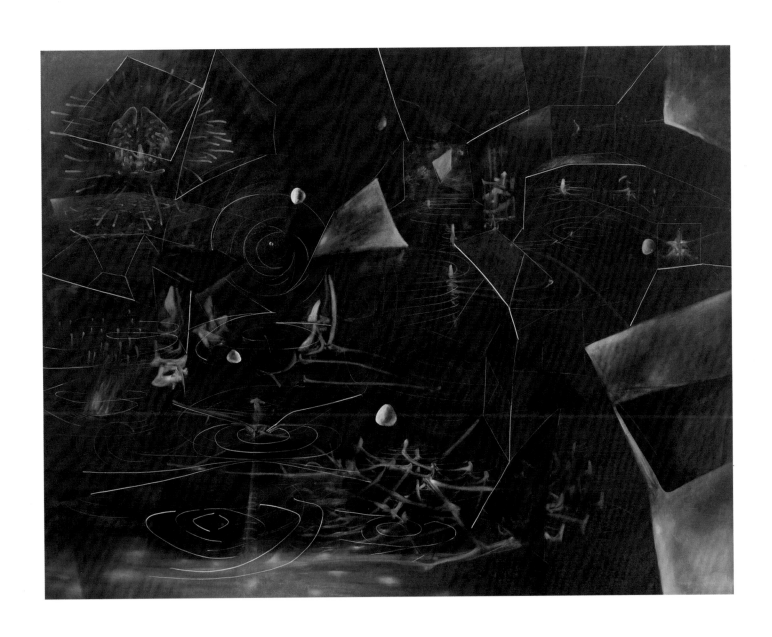

Roberto Matta (Chilean, 1911–2002). *The Vertigo of Eros*. 1944.
Oil on canvas, 6' 5" x 8' 3" (195.6 x 251.5 cm). Given anonymously, 1944

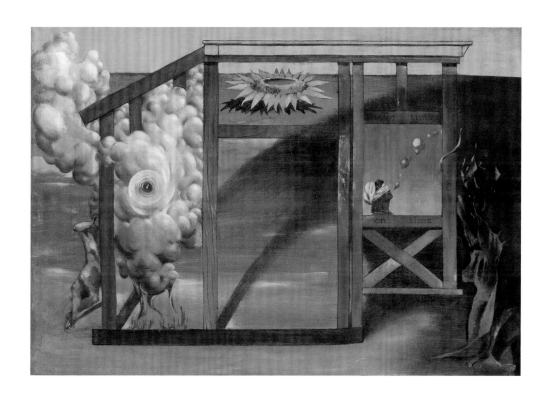

Dorothea Tanning (American, 1910–2012). *On Time Off Time*. 1948.
Oil on canvas, 14⅛ x 20½" (35.9 x 52.1 cm). Committee on Painting and Sculpture
Funds and The Modern Women's Fund, 2010

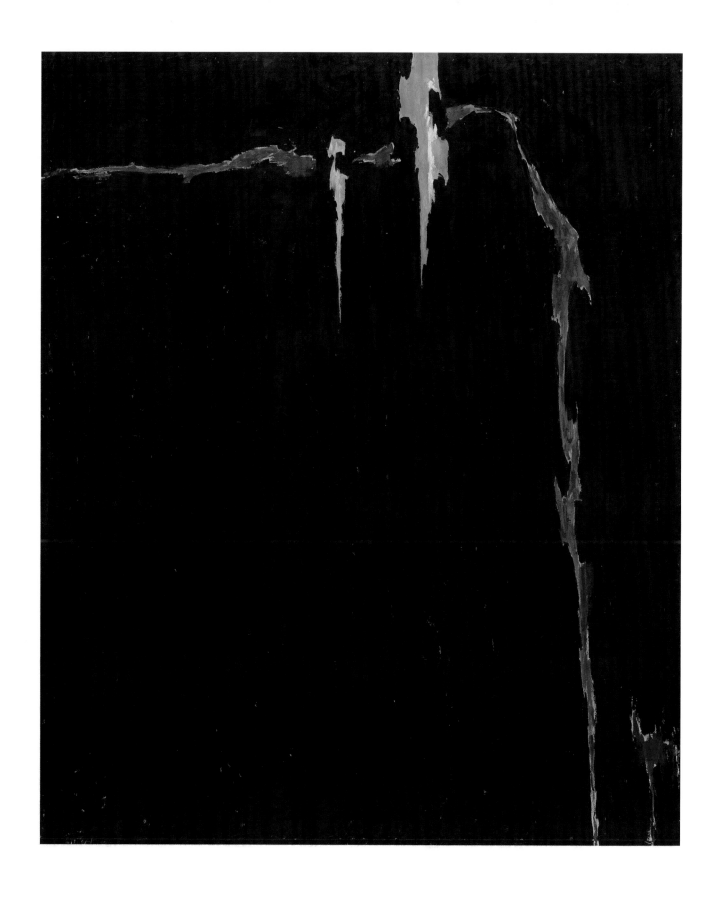

Clyfford Still (American, 1904–1980). *1944-N No. 2*. 1944. Oil on canvas,
8' 8¼" x 7' 3¼" (264.5 x 221.4 cm). The Sidney and Harriet Janis Collection, 1967

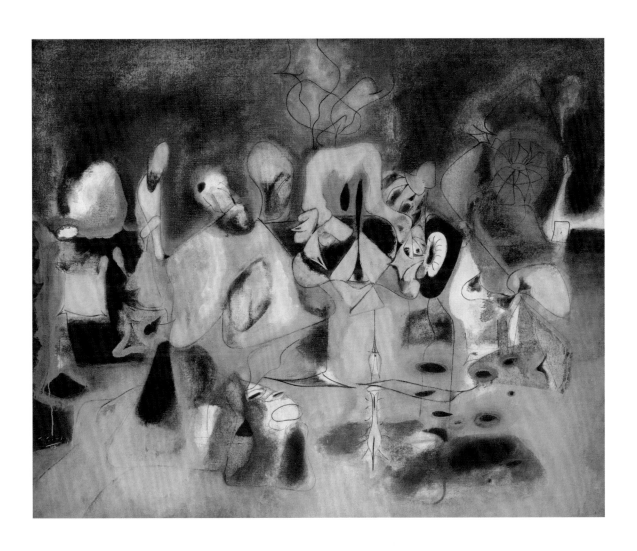

Arshile Gorky (American, born Armenia. 1904–1948). *Diary of a Seducer*. 1945.

Oil on canvas, 50 x 62" (126.7 x 157.5 cm). Gift of Mr. and Mrs. William A. M. Burden, 1985

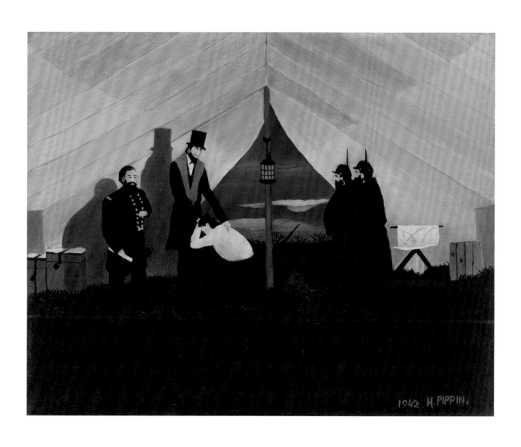

Horace Pippin (American, 1888–1946). *Abe Lincoln, The Great Emancipator*. 1942.
Oil on canvas, 24 x 30" (60.9 x 76.2 cm). Gift of Helen Hooker Roelof, 1977

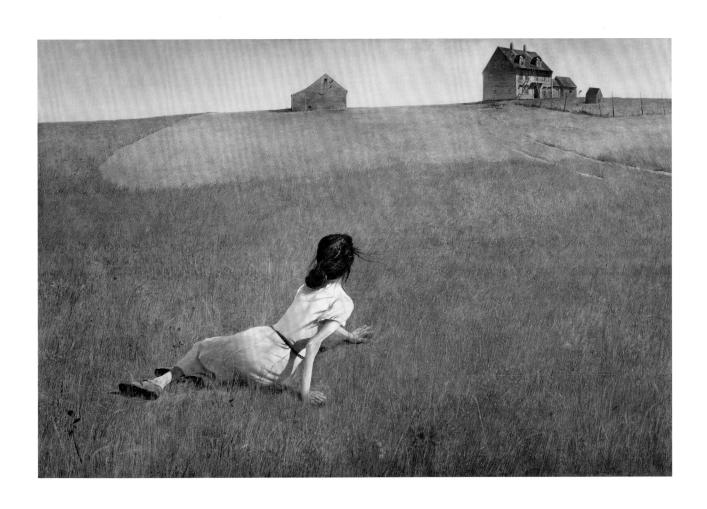

Andrew Wyeth (American, 1917–2009). *Christina's World*. 1948.
Tempera on panel, 32¼ x 47¾" (81.9 x 121.3 cm). Purchase, 1949

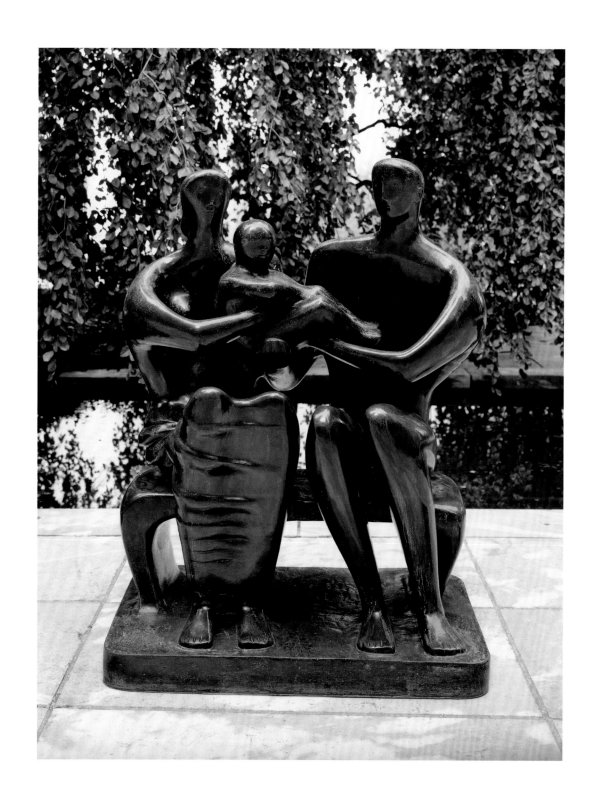

Henry Moore (British, 1898–1986). *Family Group*. 1948–49 (cast 1950).
Bronze, 59¼ x 46½ x 29⅞" (150.5 x 118 x 75.9 cm). A. Conger Goodyear Fund, 1951

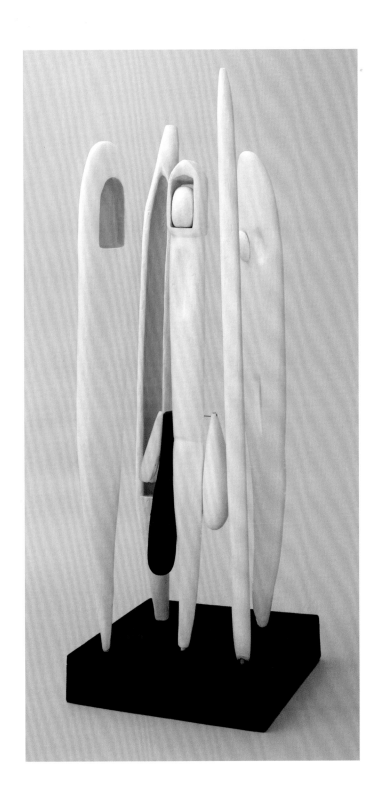

Louise Bourgeois (American, born France. 1911–2010). *Quarantania, I*. 1947–53;
reassembled by the artist 1981. Painted wood on wood base, 6' 9¼" (206.4 cm) high, and base,
6 x 27¼ x 27" (15.2 x 69.1 x 68.6 cm). Gift of Ruth Stephan Franklin, 1969

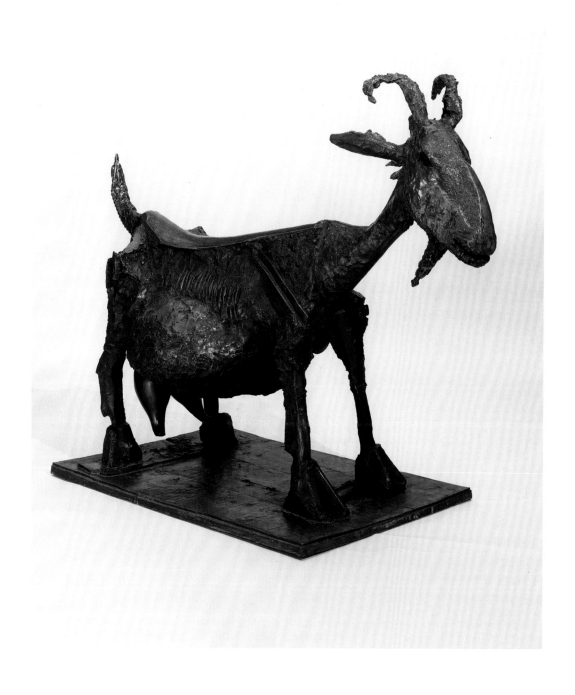

Pablo Picasso (Spanish, 1881–1973). *She-Goat*. 1950 (cast 1952). Bronze, 46⅜ x 56⅜ x 28⅛" (117.7 x 143.1 x 71.4 cm). Mrs. Simon Guggenheim Fund, 1959

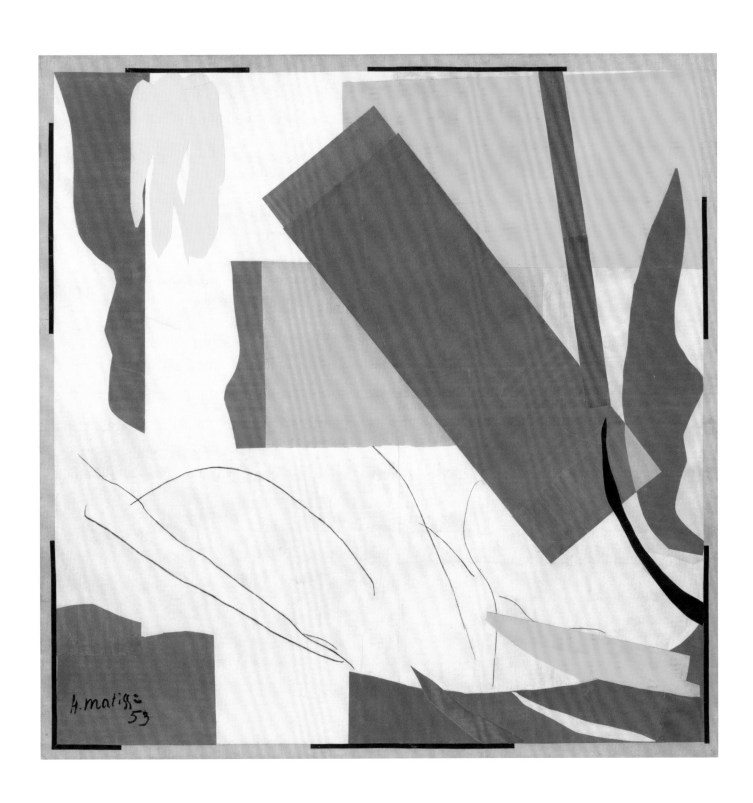

Henri Matisse (French, 1869–1954). *Memory of Oceania*. 1952–53.
Gouache on paper, cut and pasted, and charcoal on paper mounted on canvas,
9' 4" x 9' 4⅞" (284.4 x 286.4 cm). Mrs. Simon Guggenheim Fund, 1968

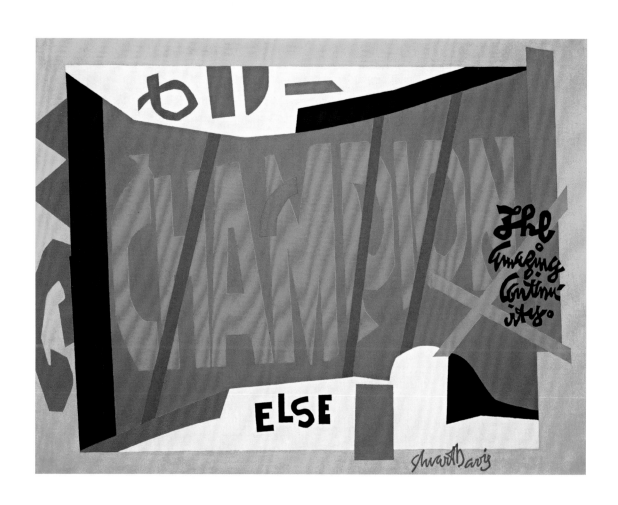

Stuart Davis (American, 1892–1964). *Visa*. 1951. Oil on canvas,
40 x 52" (101.6 x 132.1 cm). Gift of Mrs. Gertrud A. Mellon, 1953

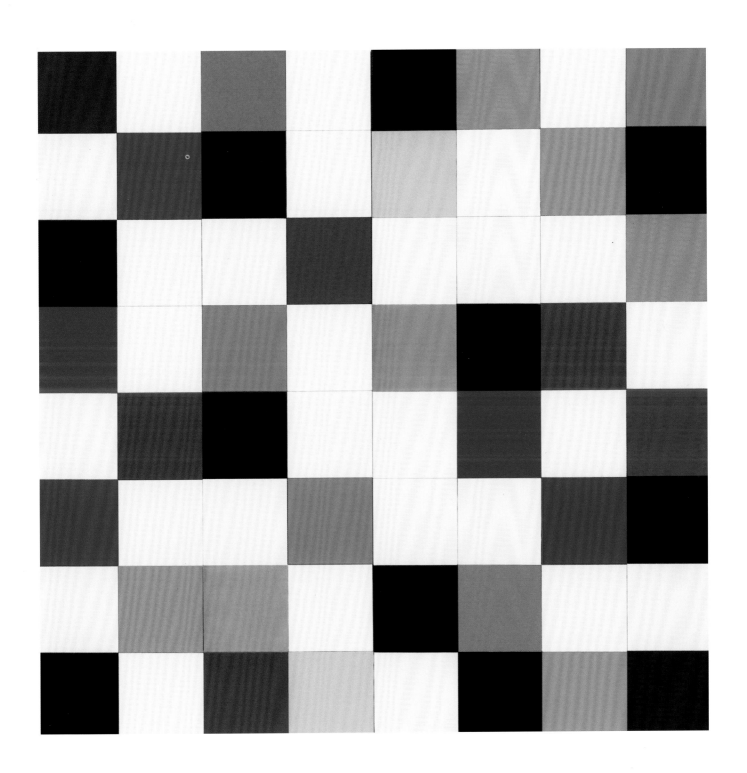

Ellsworth Kelly (American, born 1923). *Colors for a Large Wall*. 1951. Oil on canvas, sixty-four panels, overall 7' 10½" x 7' 10½" (240 x 240 cm). Gift of the artist, 1969

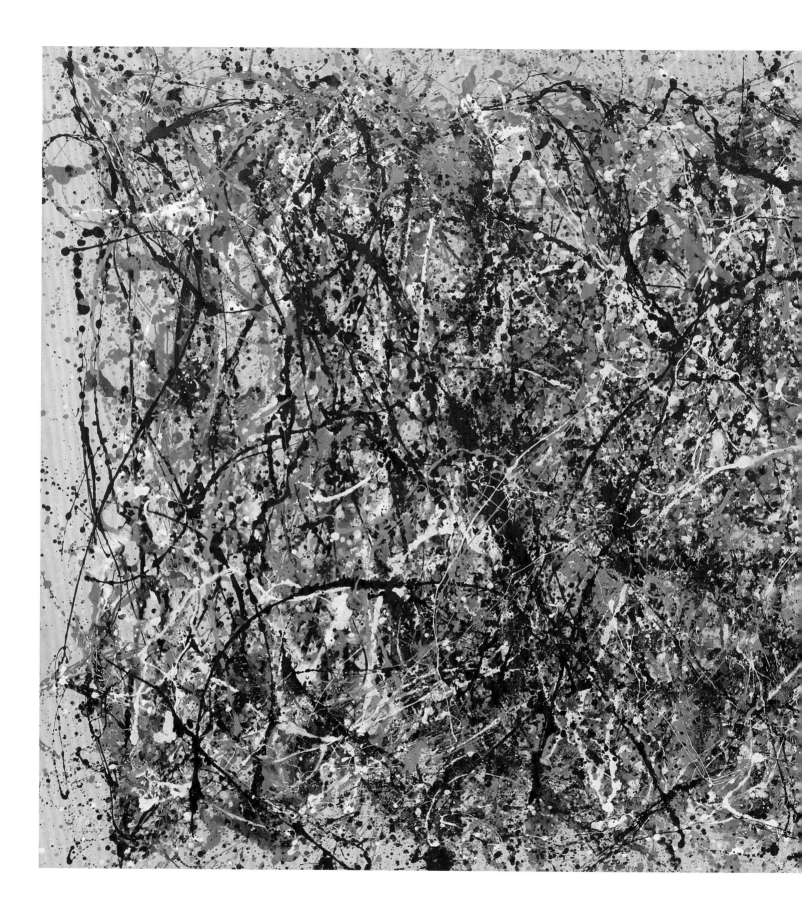

Jackson Pollock (American, 1912–1956). *One: Number 31, 1950*. 1950. Oil and enamel paint on canvas, 8' 10" x 17' 5⅝" (269.5 x 530.8 cm). Sidney and Harriet Janis Collection Fund (by exchange), 1968

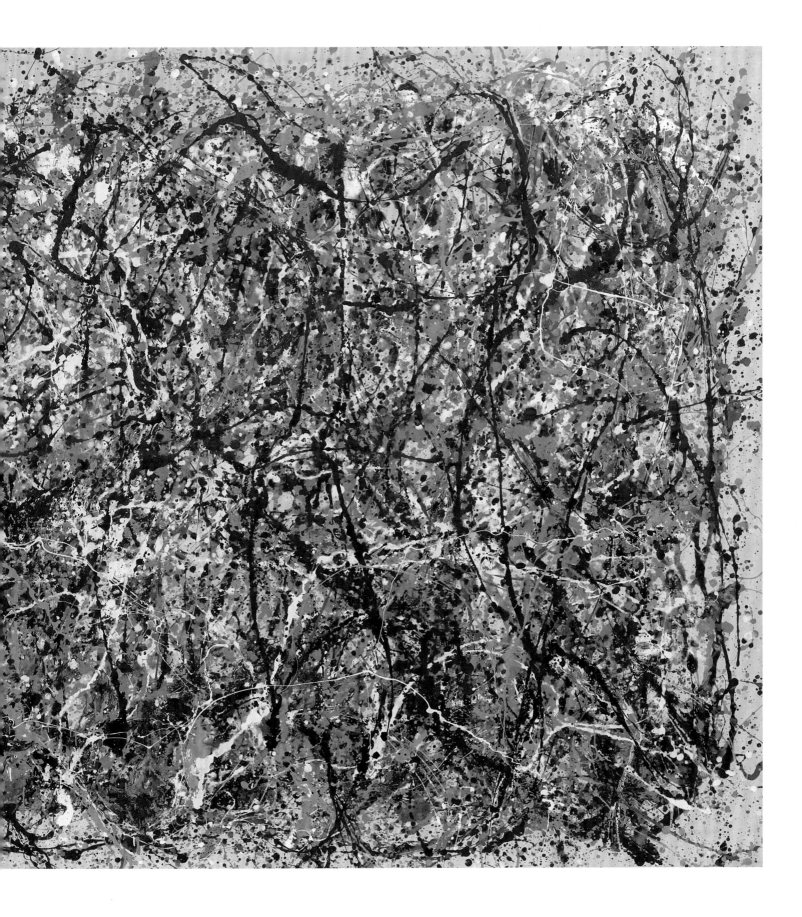

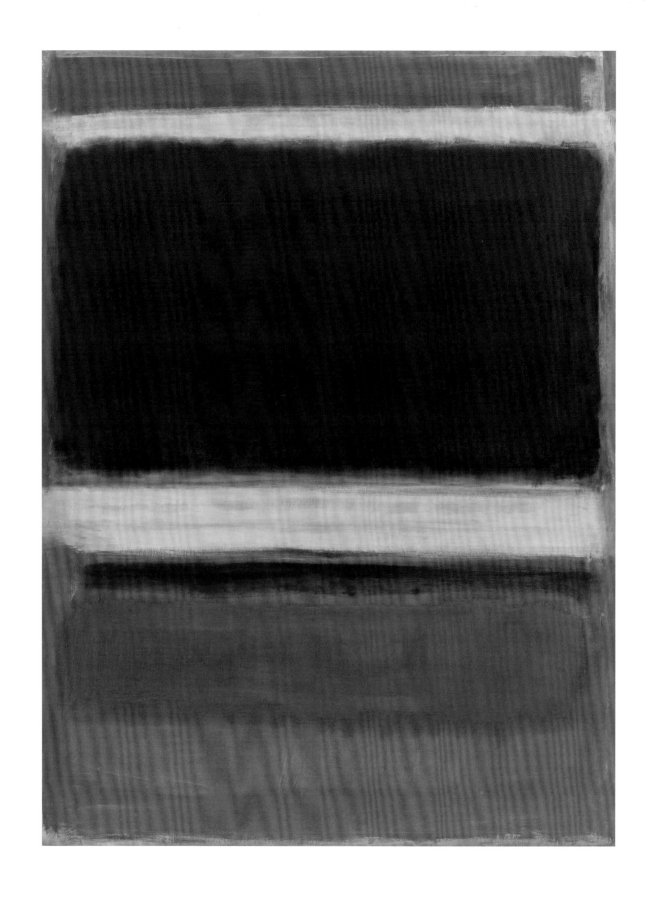

Mark Rothko (American, born Russia [now Latvia]. 1903–1970). *No. 3/No. 13*. 1949. Oil on canvas,
7' 1⅜" x 65" (216.5 x 164.8 cm). Bequest of Mrs. Mark Rothko through The Mark Rothko Foundation, Inc., 1981

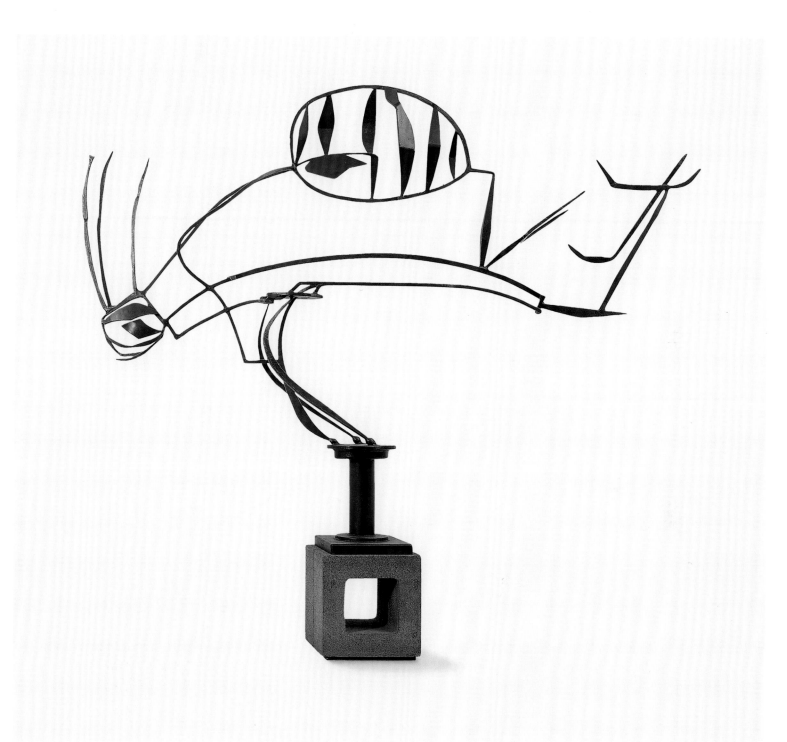

David Smith (American, 1906–1965). *Australia*. 1951. Painted steel, 6' 7½" x 8' 11⅞" x 16⅛" (202 x 274 x 41 cm); and cinder-block base, 17½ x 16¾ x 15¼" (44.5 x 42.5 x 38.7 cm). Gift of William Rubin, 1968

Barnett Newman (American, 1905–1970). *Vir Heroicus Sublimis*. 1950–51.
Oil on canvas, 7' 11⅜" x 17' 9¼" (242.2 x 541.7 cm). Gift of Mr. and Mrs. Ben Heller, 1969

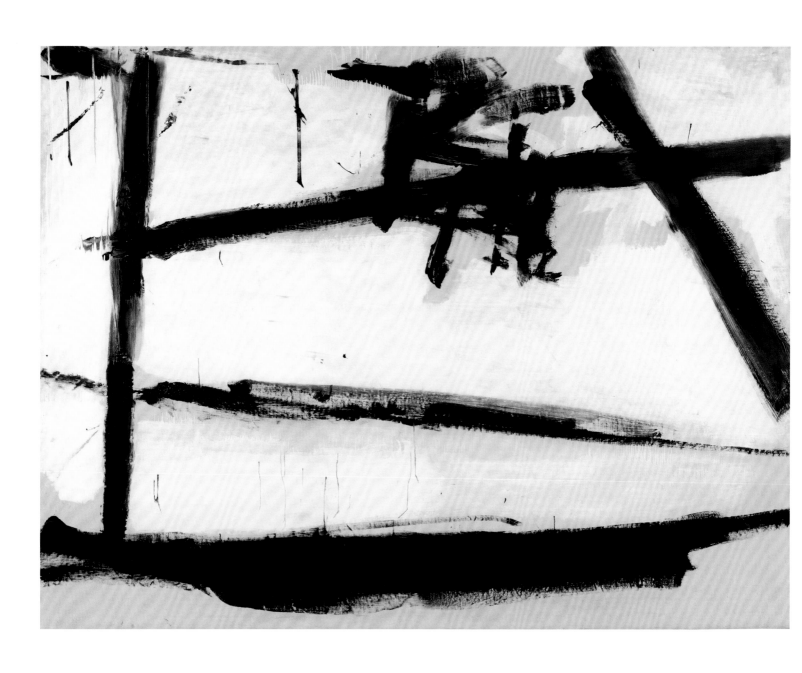

Franz Kline (American, 1910–1962). *Painting Number 2*. 1954. Oil on canvas, 6' 8½" x 8' 11"
(204.3 x 271.8 cm). Mr. and Mrs. Joseph H. Hazen and Mr. and Mrs. Francis F. Rosenbaum Funds, 1969

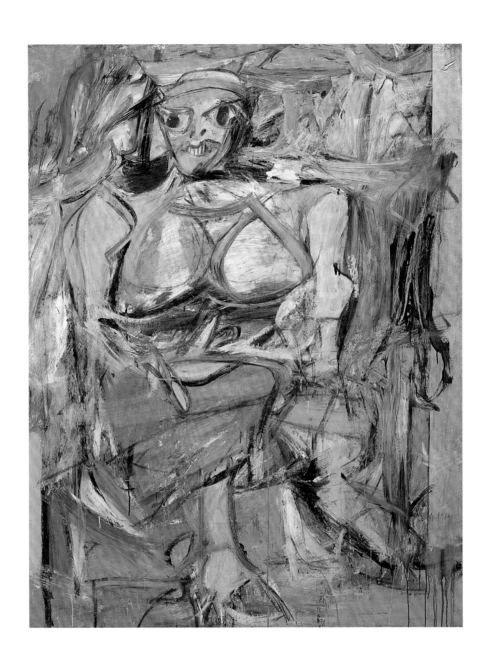

Willem de Kooning (American, born the Netherlands. 1904–1997). *Woman, I.*
1950–52. Oil on canvas, 6' 3⅞" x 58" (192.7 x 147.3 cm). Purchase, 1953

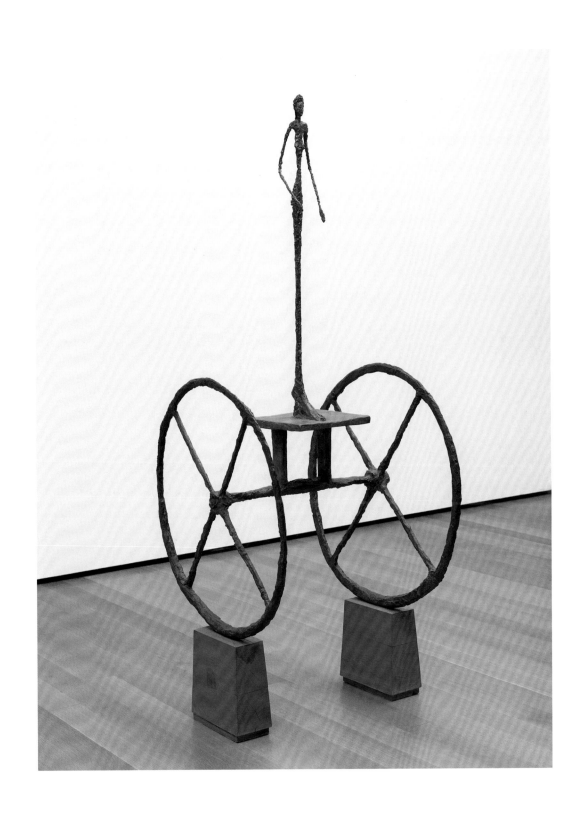

Alberto Giacometti (Swiss, 1901–1966). *The Chariot*. 1950. Painted bronze, 57 x 26 x 26⅛"
(144.8 x 65.8 x 66.2 cm), and wood base, 9¾ x 4½ x 9¼" (24.8 x 11.5 x 23.5 cm). Purchase, 1951

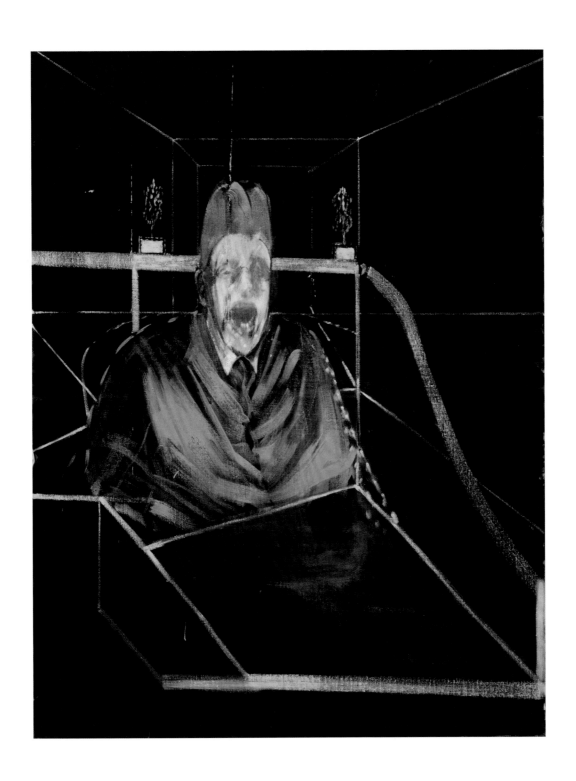

Francis Bacon (British, born Ireland. 1909–1992). *Study for Portrait VII*. 1953.
Oil on canvas, 60 x 46⅛" (152.5 x 117 cm). Gift of Mr. and Mrs. William A. M. Burden, 1956

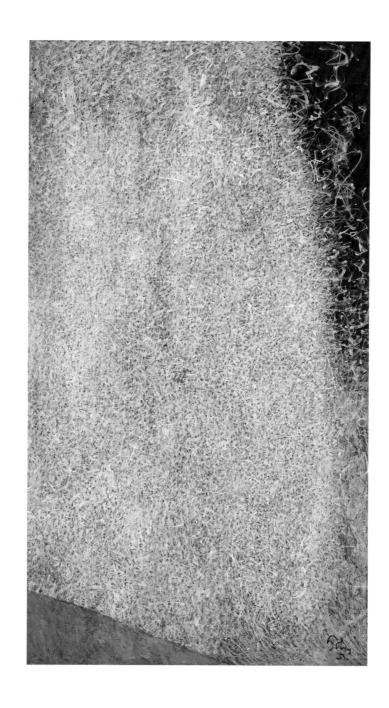

Mark Tobey (American, 1890–1976). *Edge of August*. 1953.
Casein on composition board, 48 x 28" (121.9 x 71.1 cm). Purchase, 1954

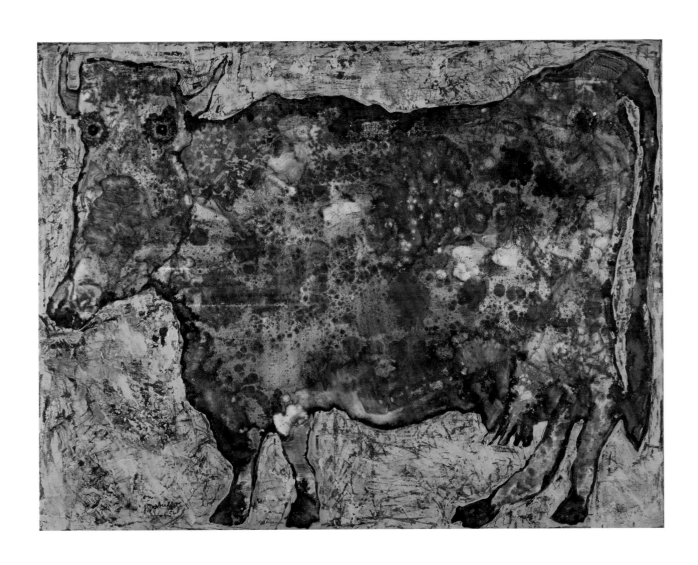

Jean Dubuffet (French, 1901–1985). *The Cow with the Subtile Nose*. 1954. Oil and enamel on canvas, 35 x 45¾" (88.9 x 116.1 cm). Benjamin Scharps and David Scharps Fund, 1956

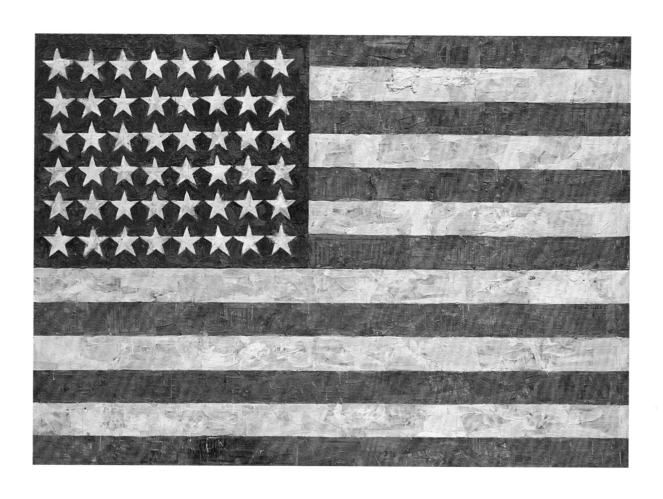

Jasper Johns (American, born 1930). *Flag*. 1954–55 (dated 1954 on reverse). Encaustic, oil, and collage on fabric mounted on plywood, 42¼ x 60⅝" (107.3 x 153.8 cm). Gift of Philip Johnson in honor of Alfred H. Barr, Jr., 1973

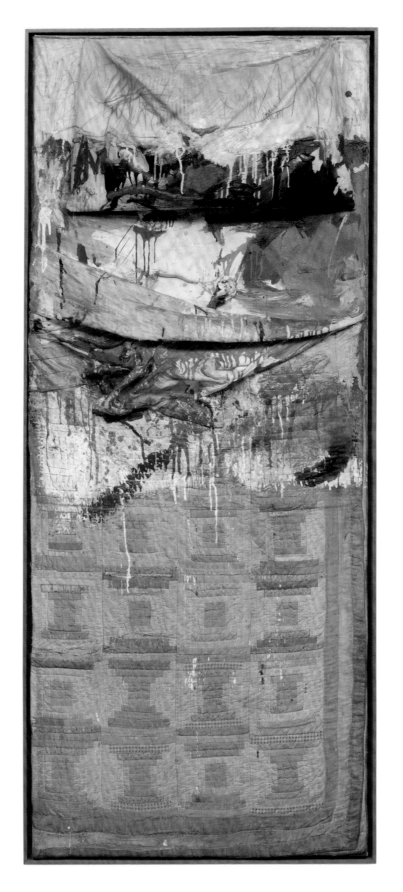

Robert Rauschenberg (American, 1925–2008). *Bed*. 1955.
Oil and pencil on pillow, quilt, and sheet on wood supports, 6' 3¼" x 31½" x 8"
(191.1 x 80 x 20.3 cm). Gift of Leo Castelli in honor of Alfred H. Barr, Jr., 1989

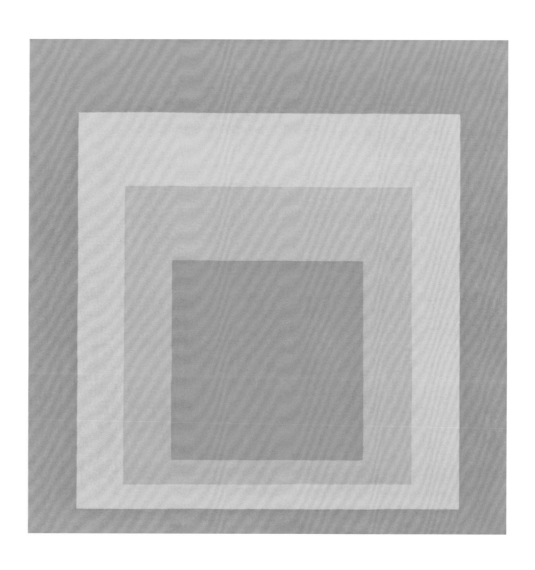

Josef Albers (American, born Germany. 1888–1976). *Homage to the Square:*
Two Whites between Two Yellows. 1958. Oil on composition board, 40 x 40" (101.5 x 101.5 cm).
Mary Sisler Bequest, 1990

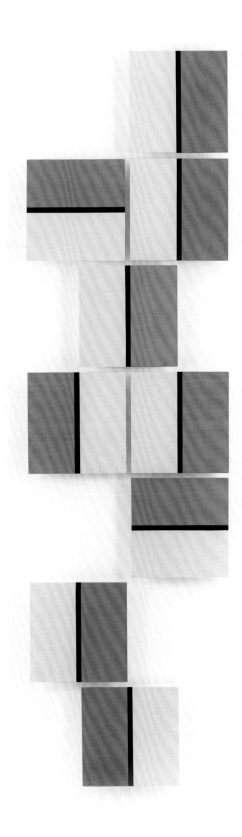

Lygia Pape (Brazilian, 1927–2004). *Orange*. 1955. Oil and tempera
on board, nine panels, each 15⅝ x 15⅝ x 1½" (39.7 x 39.7 x 3.8 cm). Promised gift
of Marie-Josée and Henry R. Kravis, 2008

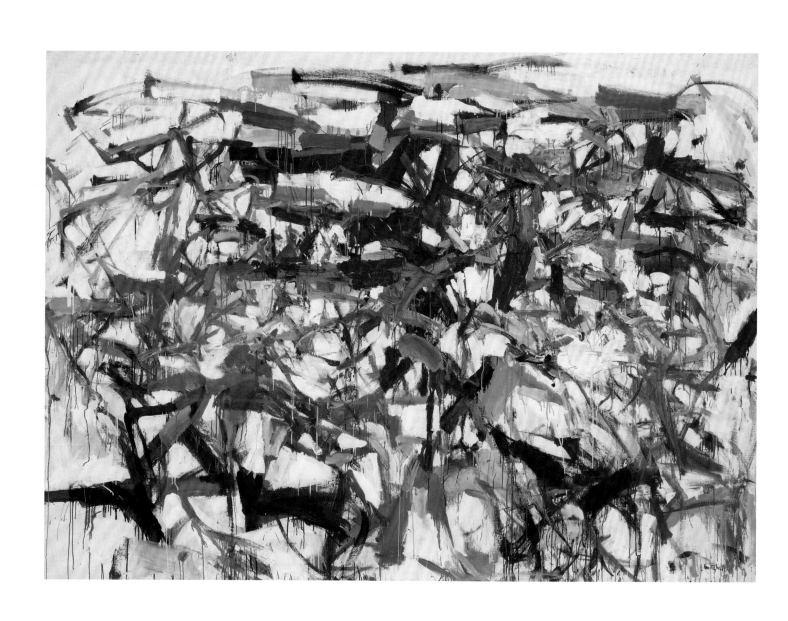

Joan Mitchell (American, 1925–1992). *Ladybug*. 1957.
Oil on canvas, 6' 5⅞" x 9' (197.9 x 274 cm). Purchase, 1961

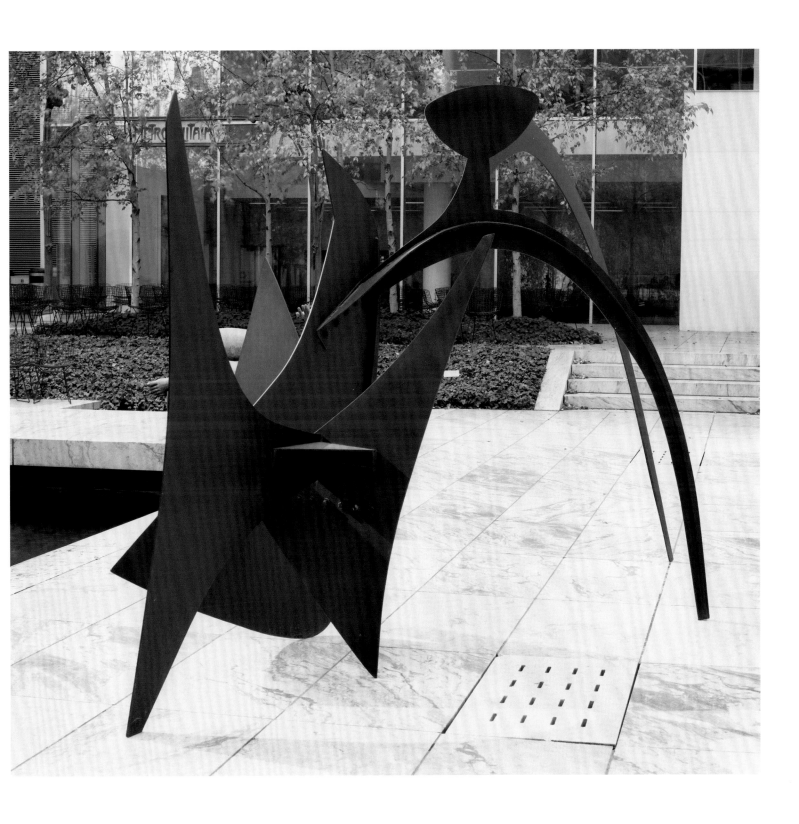

Alexander Calder (American, 1898–1976). *Black Widow*. 1959. Painted sheet steel,
7' 8" x 14' 3" x 7' 5" (233.3 x 434.1 x 226.2 cm). Mrs. Simon Guggenheim Fund, 1963

Helen Frankenthaler (American, 1928–2011). *Jacob's Ladder*. 1957.
Oil on canvas, 9' 5⅜" x 69⅞" (287.9 x 177.5 cm). Gift of Hyman N. Glickstein, 1960

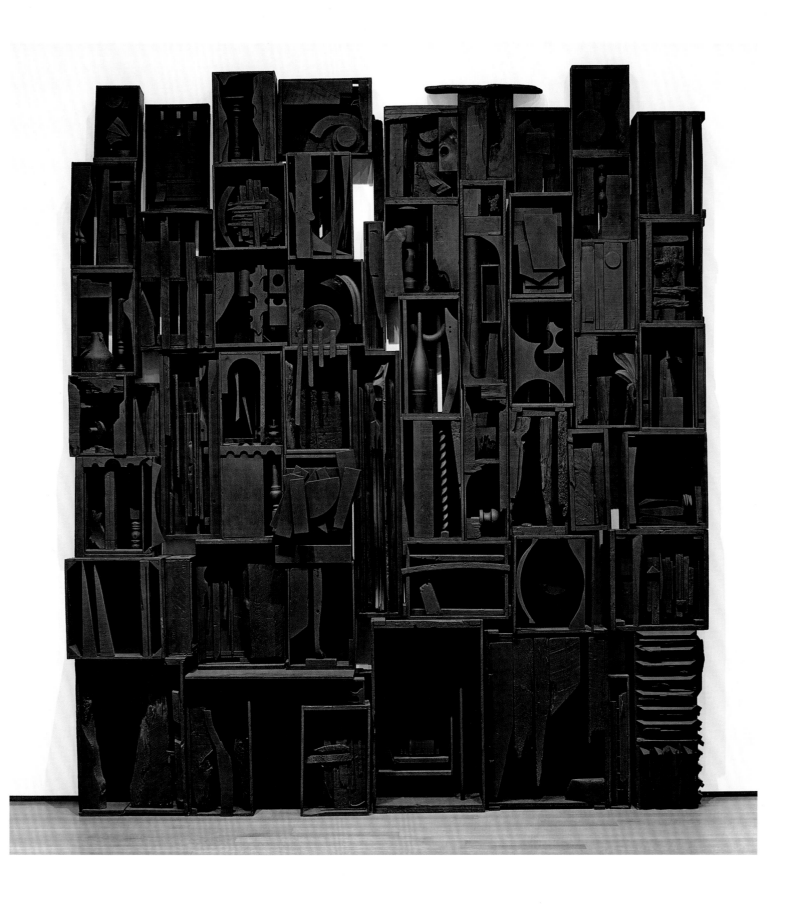

Louise Nevelson (American, born Ukraine. 1899–1988). *Sky Cathedral*. 1958. Painted
wood, 11' 3½" x 10' ¼" x 18" (343.9 x 305.4 x 45.7 cm). Gift of Mr. and Mrs. Ben Mildwoff, 1958

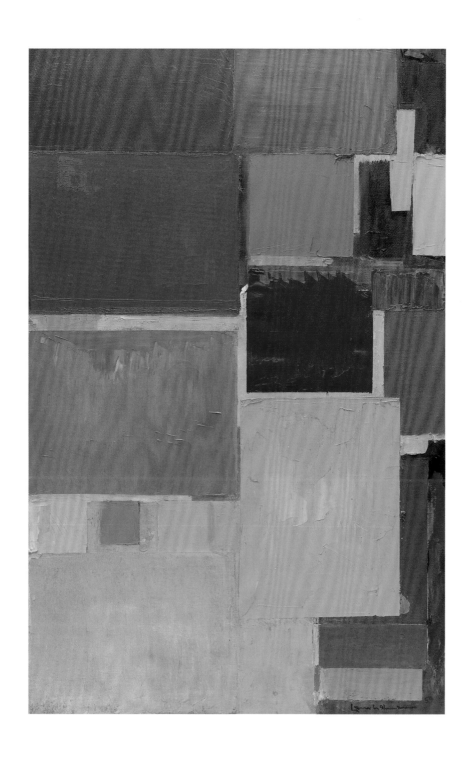

Hans Hofmann (American, born Germany. 1880–1966). *Cathedral*. 1959. Oil on canvas, 6' 2" x 48" (188 x 122 cm). Fractional and promised gift of Agnes Gund in honor of William Rubin, 1991

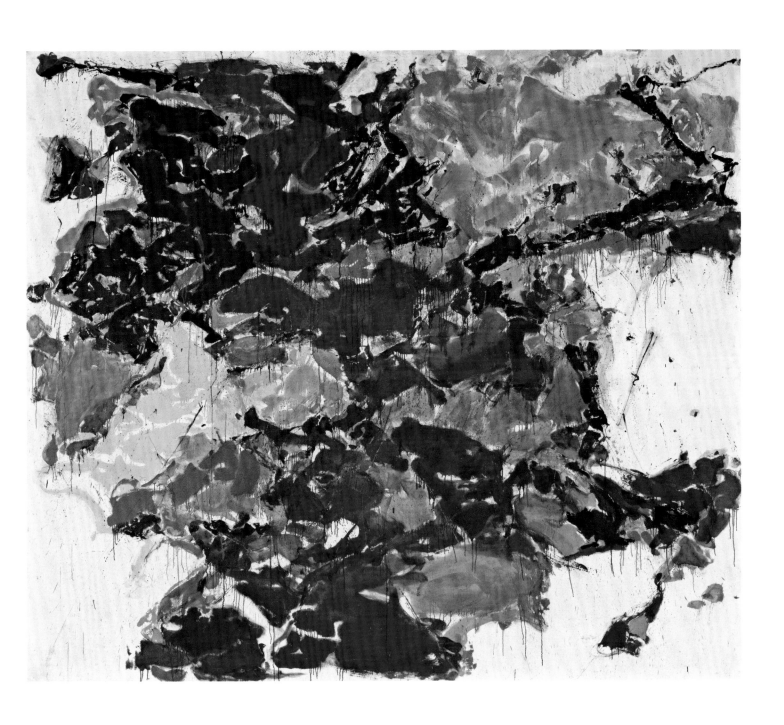

Sam Francis (American, 1923–1994). *Towards Disappearance, II*. 1957–58.
Oil on canvas, 9' ½" x 10' 5⅞" (275.6 x 319.7 cm). Blanchette Hooker Rockefeller Fund, 1976

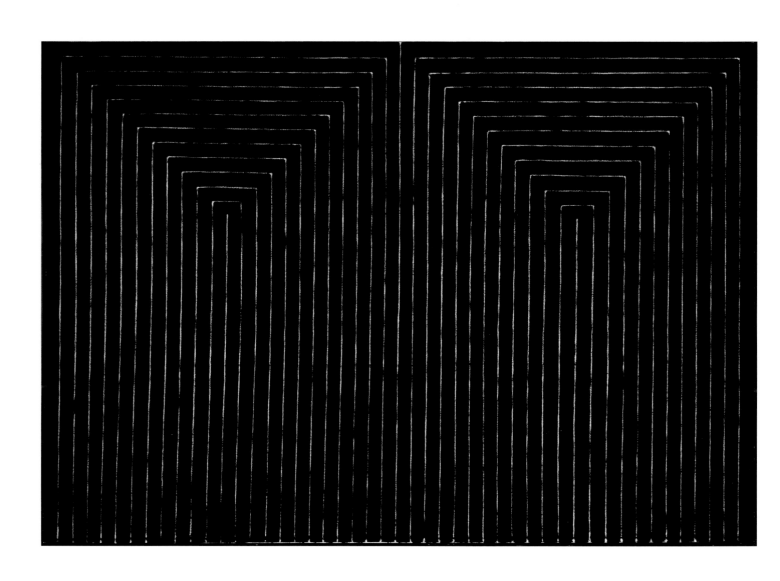

Frank Stella (American, born 1936). *The Marriage of Reason and Squalor, II*. 1959.
Enamel on canvas, 7' 6¾" x 11' ¾" (230.5 x 337.2 cm). Larry Aldrich Foundation Fund, 1959

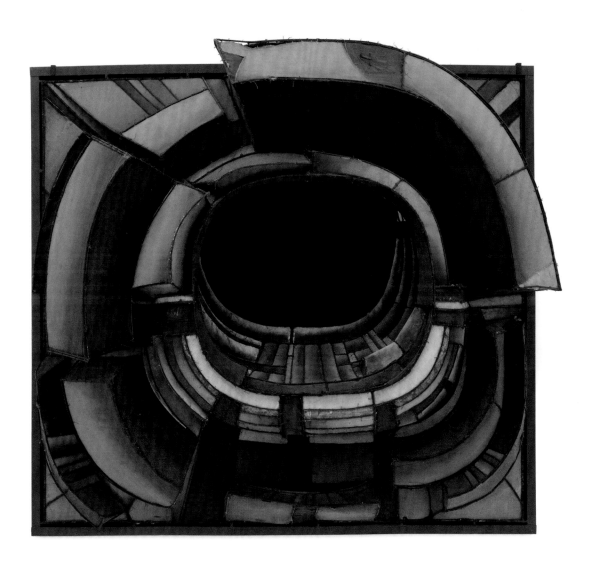

Lee Bontecou (American, born 1931). *Untitled*. 1961. Welded steel, canvas, black fabric, rawhide, copper wire, and soot, 6' 8¼" x 7' 5" x 34¾" (203.6 x 226 x 88 cm). Kay Sage Tanguy Fund, 1963

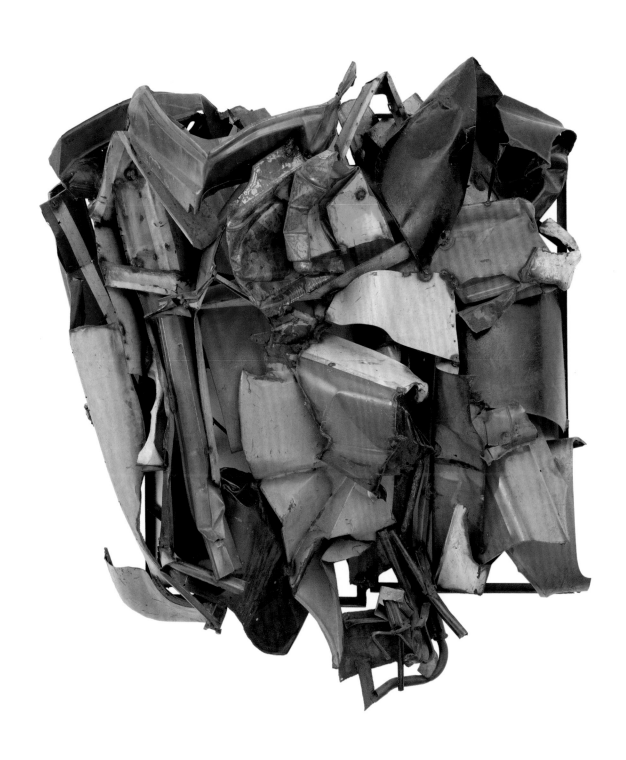

John Chamberlain (American, 1927–2011). *Essex*. 1960. Automobile parts and other metal,
9' x 6' 8" x 43" (274.3 x 203.2 x 109.2 cm). Gift of Mr. and Mrs. Robert C. Scull and purchase, 1961

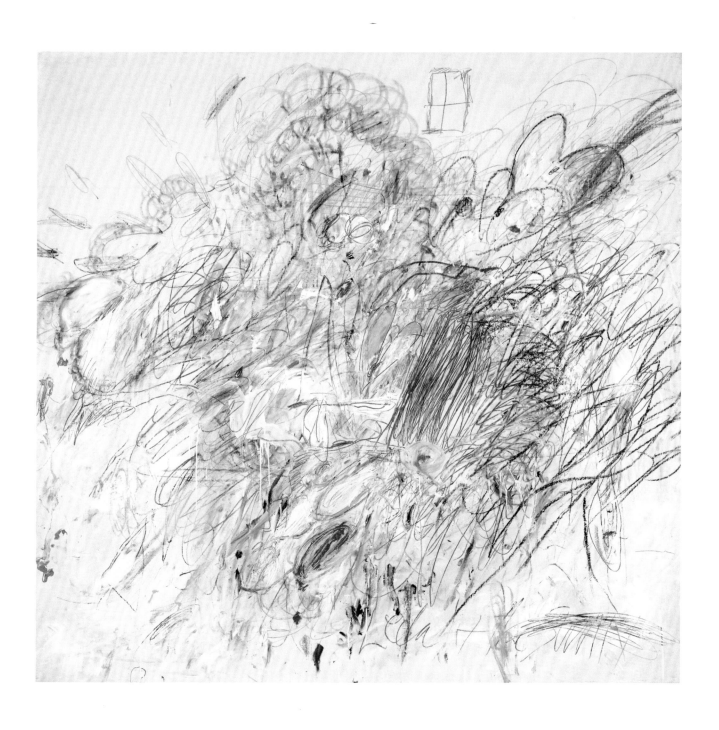

Cy Twombly (American, 1928–2011). *Leda and the Swan*. 1962. Oil, pencil, and crayon on canvas, 6' 3" x 6' 6¾"
(190.5 x 200 cm). Acquired through the Lillie P. Bliss Bequest and The Sidney and Harriet Janis Collection (both by exchange), 1994

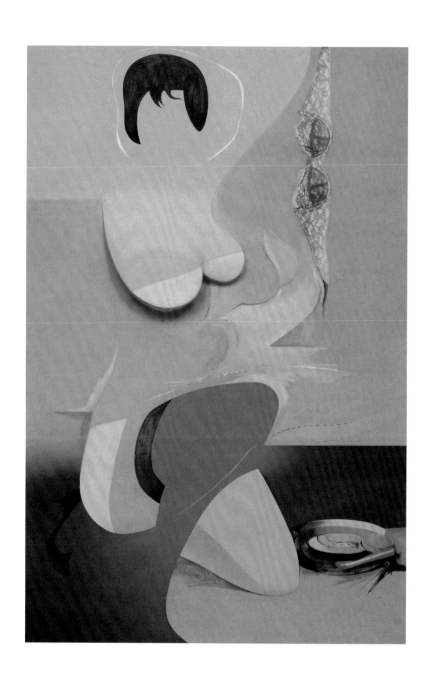

Richard Hamilton (British, 1922–2011). *Pin-up*. 1961.
Oil, cellulose, and collage on panel, 53¾ x 37¾ x 3" (136.5 x 95.8 x 7.6 cm)
including frame. Enid A. Haupt Fund and an anonymous fund, 1996

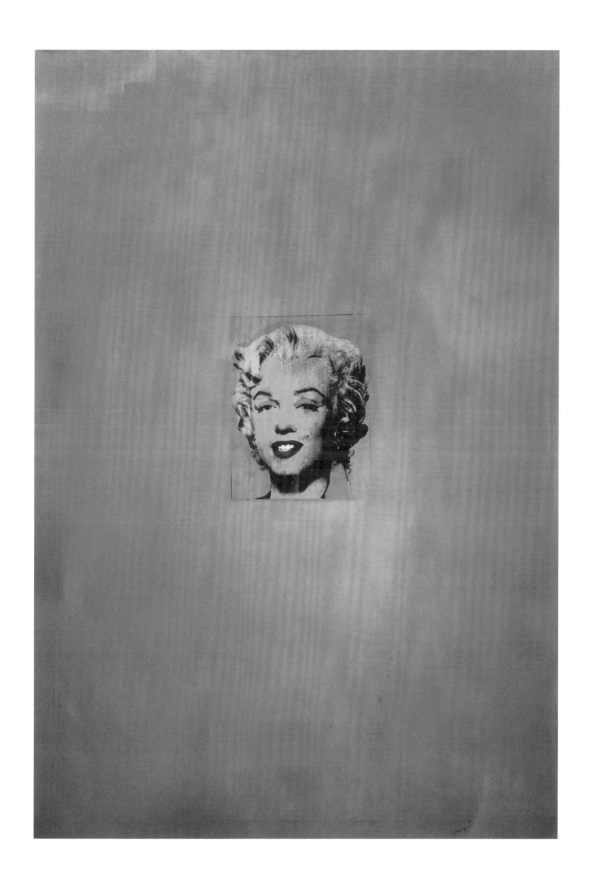

Andy Warhol (American, 1928–1987). *Gold Marilyn Monroe*. 1962. Silkscreen ink on synthetic polymer paint on canvas, 6' 11¼" x 57" (211.4 x 144.7 cm). Gift of Philip Johnson, 1962

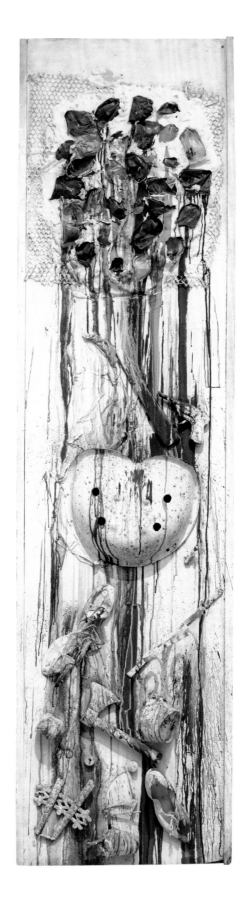

Niki de Saint Phalle (French, 1930–2002). *Shooting Painting American Embassy.* 1961.
Paint, plaster, wood, plastic bags, shoe, twine, metal seat, axe, metal can, toy gun, wire mesh, shot pellets, and other objects on wood, 8' ³⁄₈" x 25⁷⁄₈" x 8⁵⁄₈" (244.8 x 65.7 x 21.9 cm). Gift of the Niki Charitable Art Foundation, 2011

Agnes Martin (American, born Canada. 1912–2004). *The Tree*. 1964.
Oil and pencil on canvas, 6 x 6' (182.8 x 182.8 cm). Larry Aldrich Foundation Fund, 1965

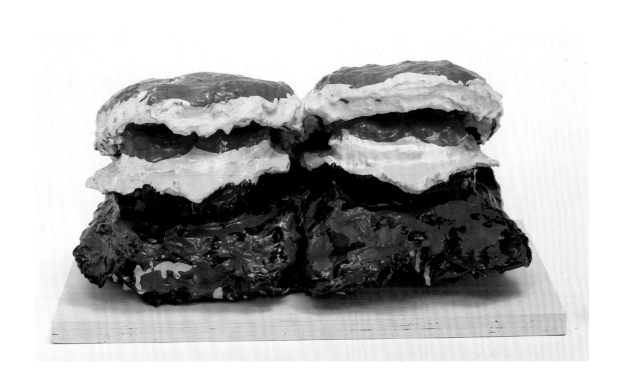

Claes Oldenburg (American, born Sweden, 1929). *Two Cheeseburgers, with Everything (Dual Hamburgers)*. 1962. Burlap soaked in plaster, painted with enamel, 7 x 14¾ x 8⅝" (17.8 x 37.5 x 21.8 cm).
Philip Johnson Fund, 1962

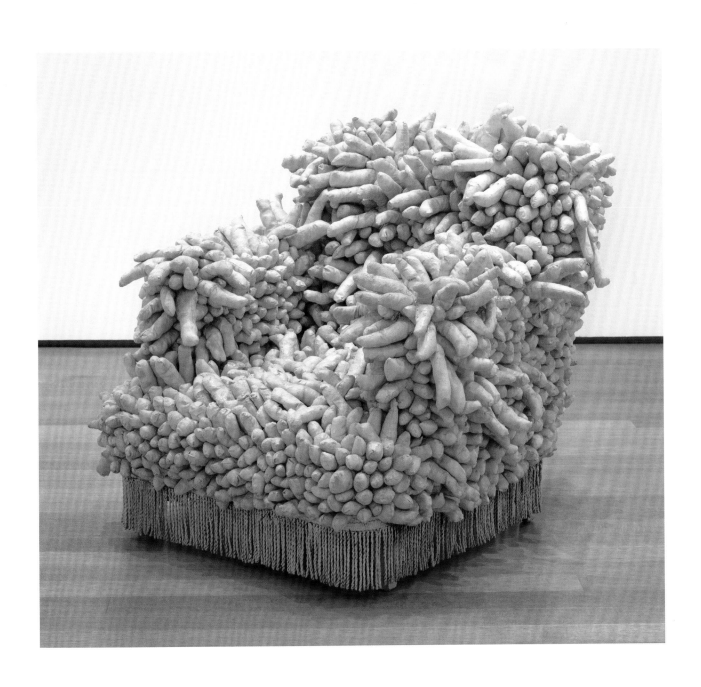

Yayoi Kusama (Japanese, born 1929). *Accumulation No. 1*. 1962. Sewn stuffed
fabric, paint, and chair fringe, 37 x 39 x 43" (94 x 99.1 x 109.2 cm). Purchase, 2012

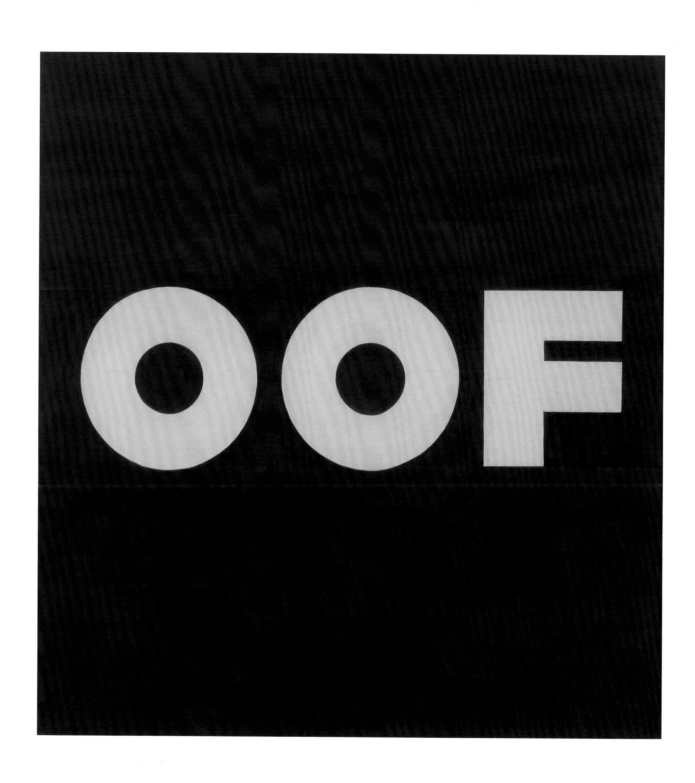

Edward Ruscha (American, born 1937). *OOF*. 1962 (reworked 1963). Oil on canvas, 71½ x 67"
(181.5 x 170.2 cm). Gift of Agnes Gund, the Louis and Bessie Adler Foundation, Inc., Robert and Meryl Meltzer,
Jerry I. Speyer, Anna Marie and Robert F. Shapiro, Emily and Jerry Spiegel, an anonymous donor, and purchase, 1988

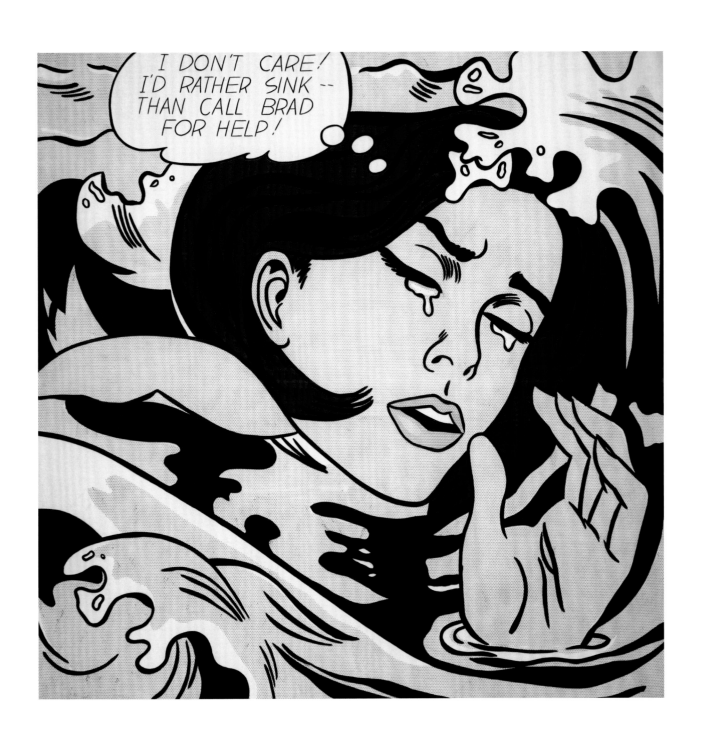

Roy Lichtenstein (American, 1923–1997). *Drowning Girl*. 1963.
Oil and synthetic polymer paint on canvas, 67⅝ x 66¾" (171.6 x 169.5 cm).
Philip Johnson Fund (by exchange) and gift of Mr. and Mrs. Bagley Wright, 1971

James Rosenquist (American, born 1933). *F-111*. 1964–65. Oil on canvas with aluminum, twenty-three parts, overall 10 x 86' (304.8 x 2,621.3 cm). Gift of Mr. and Mrs. Alex L. Hillman and Lillie P. Bliss Bequest (both by exchange), 1996

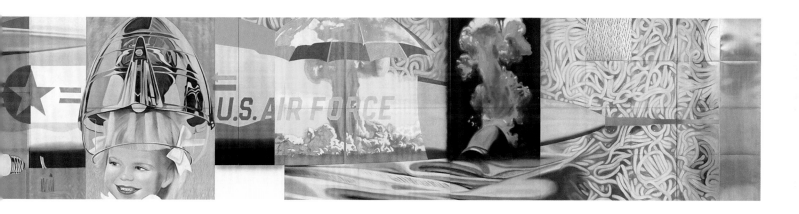

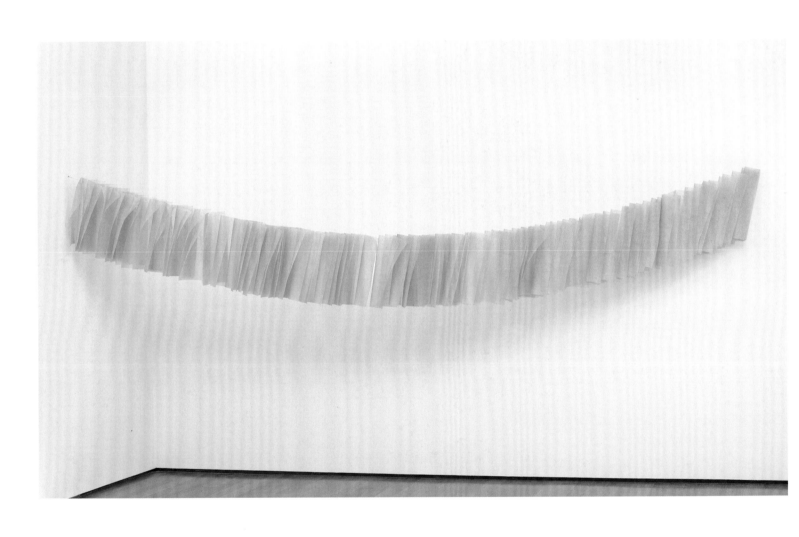

Mira Schendel (Brazilian, born Switzerland. 1919–1988). *Little Train*. 1965. Japanese paper and nylon, dimensions variable. Richard Zeisler Bequest, gift of John Hay Whitney, and Marguerite K. Stone Bequest (all by exchange); and gift of Patricia Phelps de Cisneros and Mimi Haas through the Latin American and Caribbean Fund, 2008

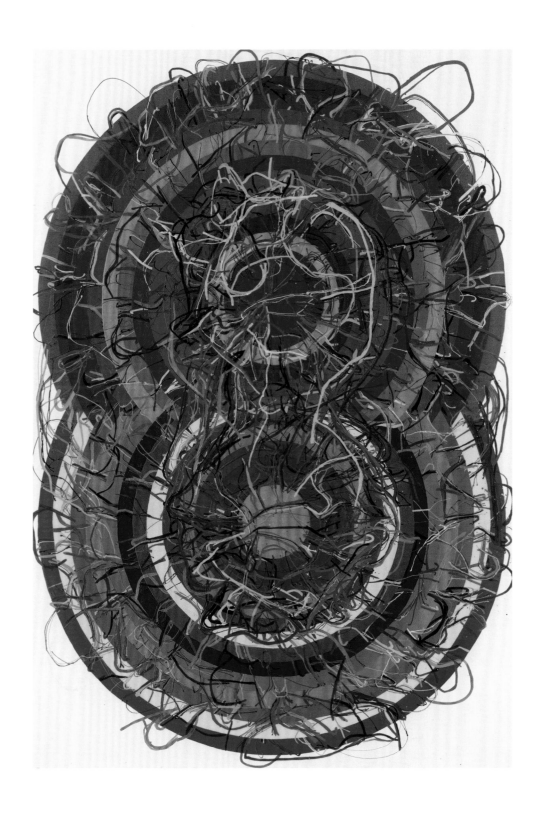

Atsuko Tanaka (Japanese, 1932–2005). *Untitled*. 1964. Synthetic polymer paint on canvas, 10' 11¼" x 7' 4¾" (333.4 x 225.4 cm). John G. Powers Fund, 1965

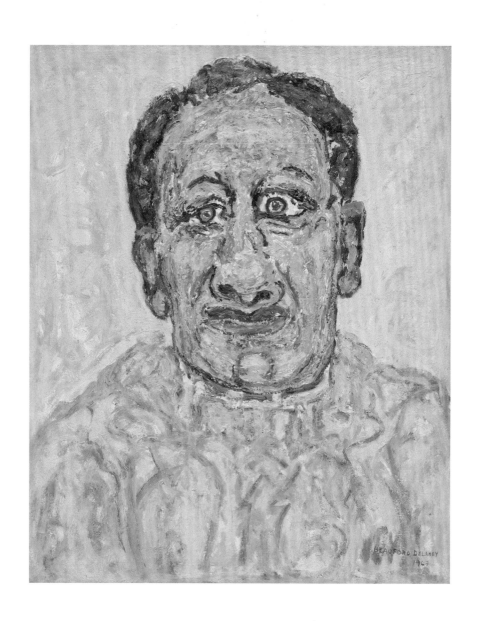

Beauford Delaney (American, 1901–1979). *Portrait of Howard Swanson*. 1967.
Oil on canvas, 39 x 31¾" (99.1 x 80.6 cm). Committee on Painting and Sculpture Funds, 2013

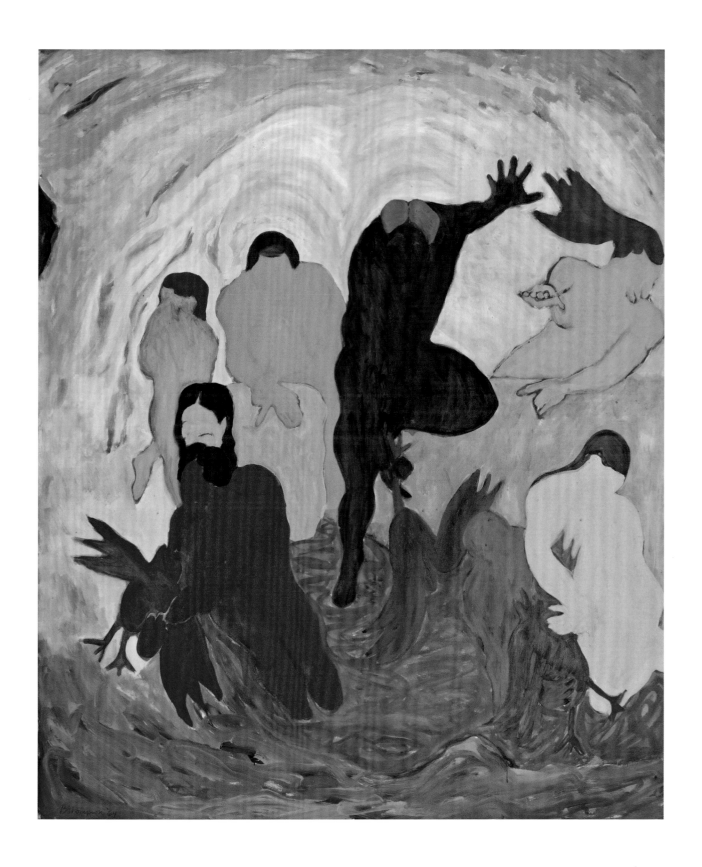

Bob Thompson (American, 1937–1965). *St. Matthew's Description of the End of the World*. 1964.
Oil on canvas, 6' x 60⅛" (182.8 x 152.8 cm). Blanchette Hooker Rockefeller Fund, 1971

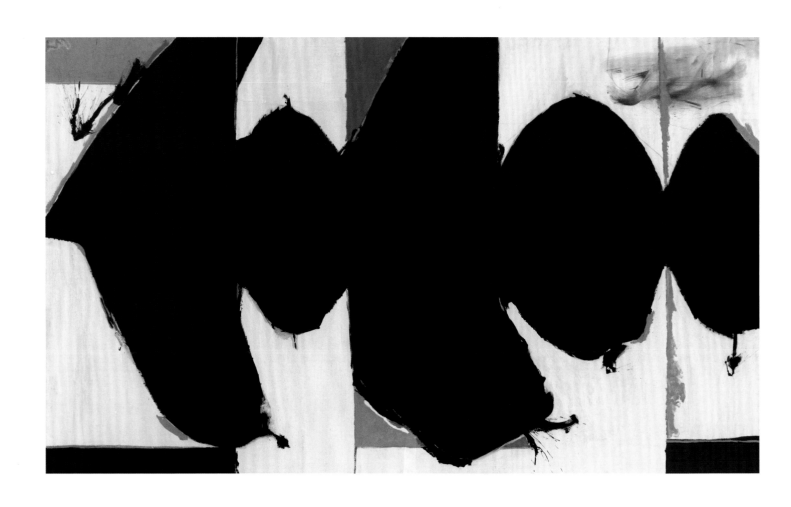

Robert Motherwell (American, 1915–1991). *Elegy to the Spanish Republic, 108*. 1965–67.
Oil on canvas, 6' 10" x 11' 6¼" (208.2 x 351.1 cm). Charles Mergentime Fund, 1970

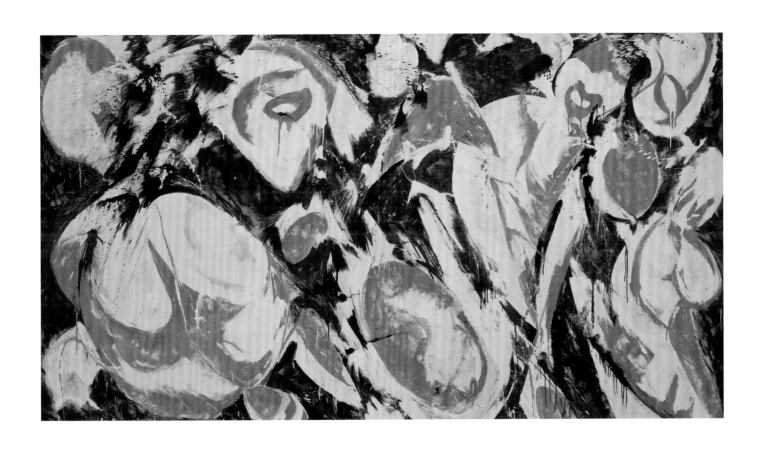

Lee Krasner (American, 1908–1984). *Gaea*. 1966. Oil on canvas,
69" x 10' 5½" (175.3 x 318.8 cm). Kay Sage Tanguy Fund, 1977

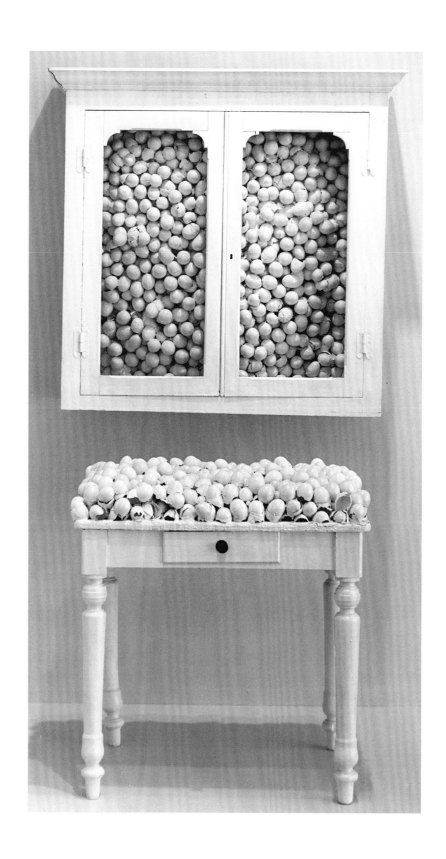

Marcel Broodthaers (Belgian, 1924–1976). *White Cabinet and White Table*. 1965.
Painted cabinet, 33⅞ x 32¼ x 24½" (86 x 82 x 62 cm), table, 41 x 39⅜ x 15¾" (104 x 100 x 40 cm), and eggshells. Fractional and promised gift of Jo Carole and Ronald S. Lauder, 1992

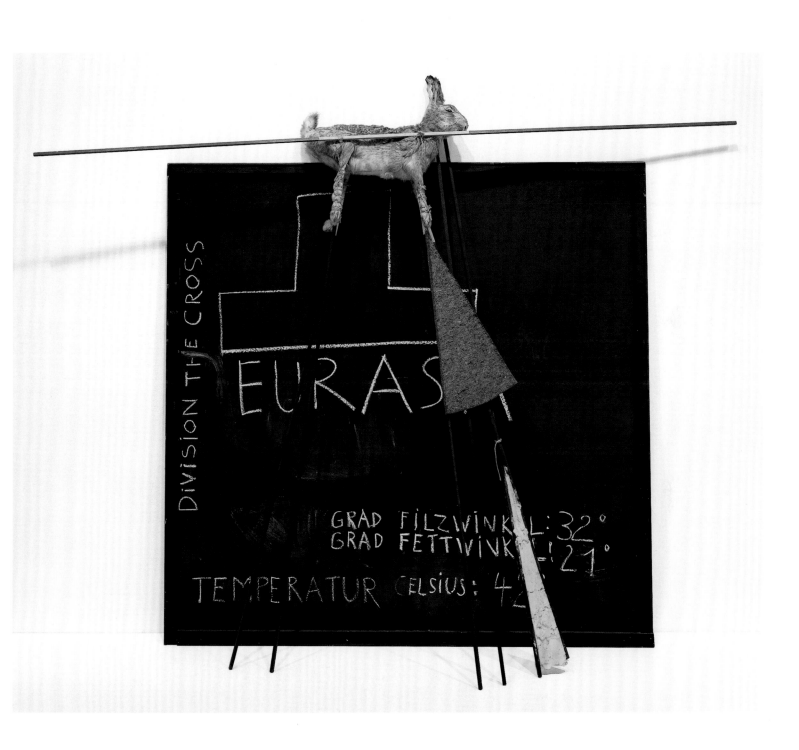

Joseph Beuys (German, 1921–1986). *Eurasia Siberian Symphony 1963*. 1966. Panel with chalk drawing, felt, fat, taxidermied hare, and painted poles, 6' x 7' 6¾" x 20" (183 x 230 x 50 cm). Gift of Frederic Clay Bartlett (by exchange), 2000

Robert Ryman (American, born 1930). *Twin*. 1966. Oil on cotton, 6' 3¾" x 6' 3⅞" x 3"
(192.4 x 192.6 cm x 7.6 cm). Charles and Anita Blatt Fund and purchase, 1971

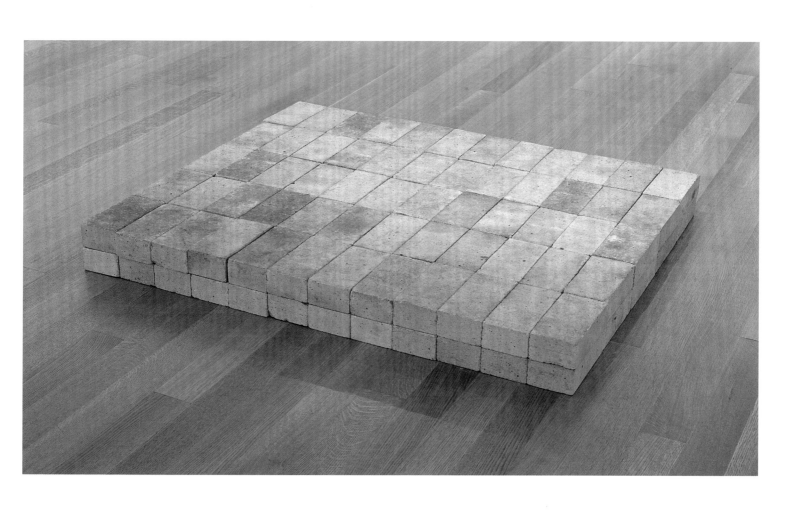

Carl Andre (American, born 1935). *Equivalent V.* 1966–69. Firebricks, 120 units, overall 5 x 45 x 54" (12.8 x 114.3 x 137.2 cm). Bequest of Richard S. Zeisler (by exchange), 2008

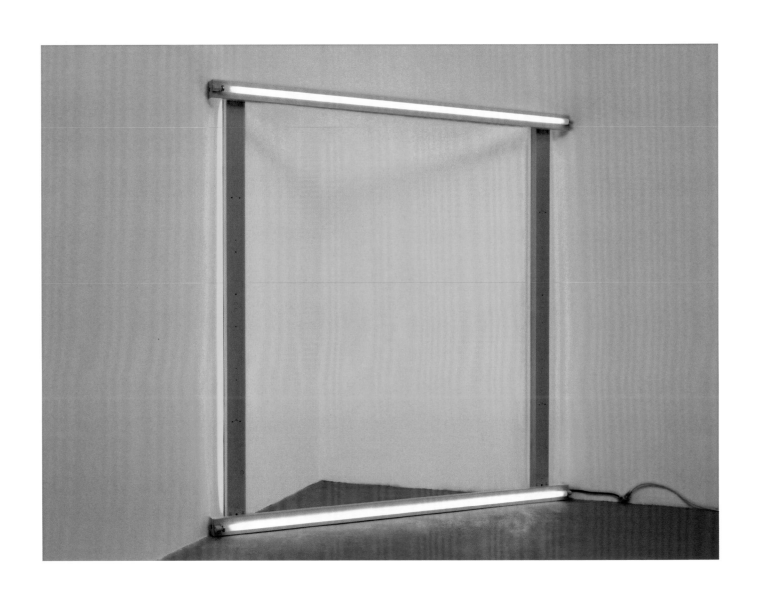

Dan Flavin (American, 1933–1996). *untitled (to the "innovator" of Wheeling Peachblow)*. 1968.
Fluorescent lights and metal fixtures, 8' ½" x 8' ¼" x 5¾" (245 x 244.3 x 14.5 cm). Edition 2/3. Helena Rubinstein Fund, 1969

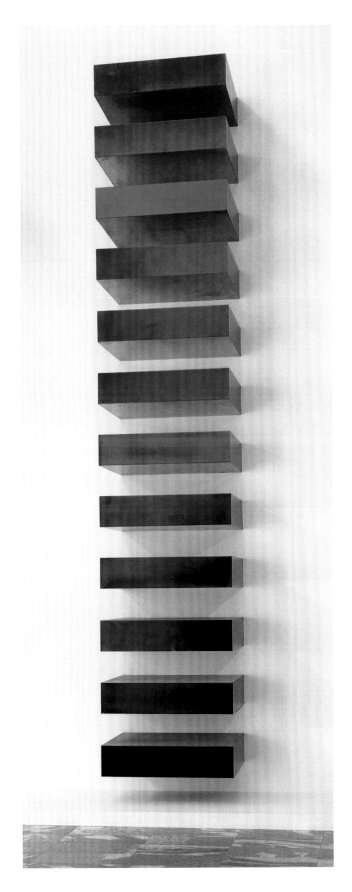

Donald Judd (American, 1928–1994). *Untitled (Stack)*. 1967. Lacquer on galvanized iron, twelve units, each 9 x 40 x 31" (22.8 x 101.6 x 78.7 cm), installed vertically with 9" (22.8 cm) intervals. Helen Acheson Bequest (by exchange) and gift of Joseph Helman, 1997

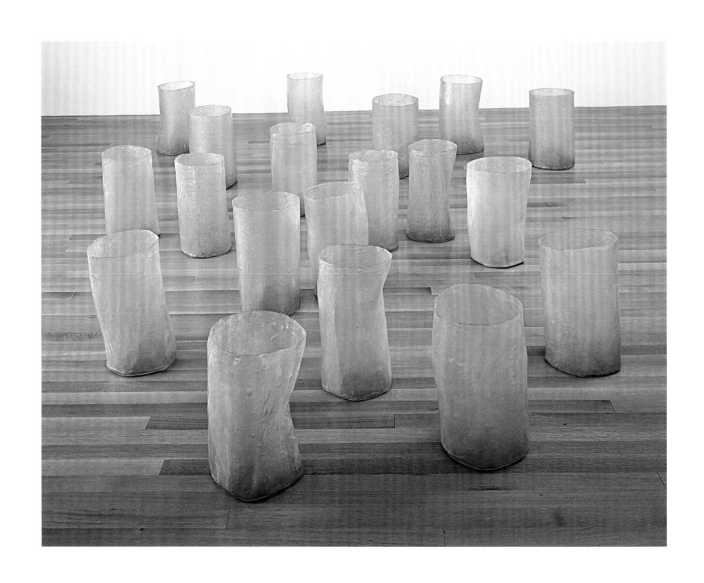

Eva Hesse (American, born Germany. 1936–1970). *Repetition Nineteen III*. 1968. Fiberglass and polyester resin, nineteen units, each 19 to 20¼" (48 to 51 cm) x 11 to 12¾" (27.8 to 32.2 cm) diam. Gift of Charles and Anita Blatt, 1969

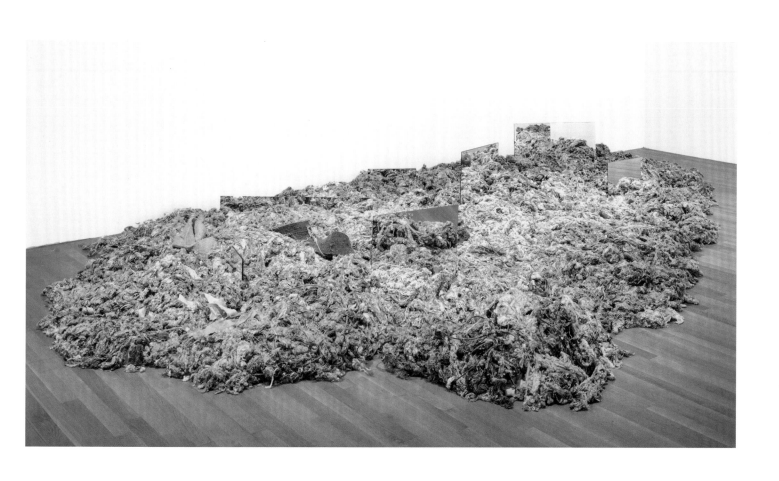

Robert Morris (American, born 1931). *Untitled*. 1968. Felt, asphalt, mirrors, wood, copper tubing, steel cable, and lead, dimensions variable. Gift of Philip Johnson, 1984

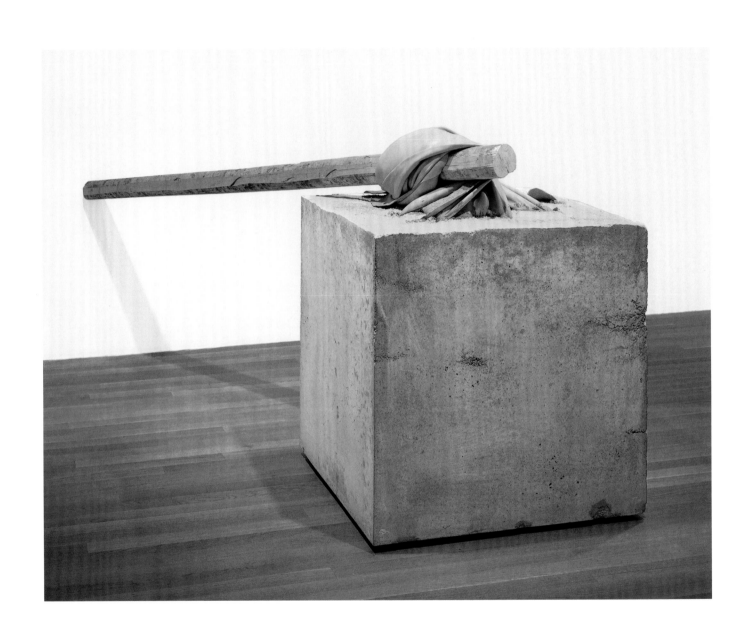

Giovanni Anselmo (Italian, born 1934). *Torsion*. 1968. Cement, leather, and wood,
52" x 9' 5" x 58" (132.1 x 287 x 147.3 cm). Gift of Jo Carole and Ronald S. Lauder, 2000

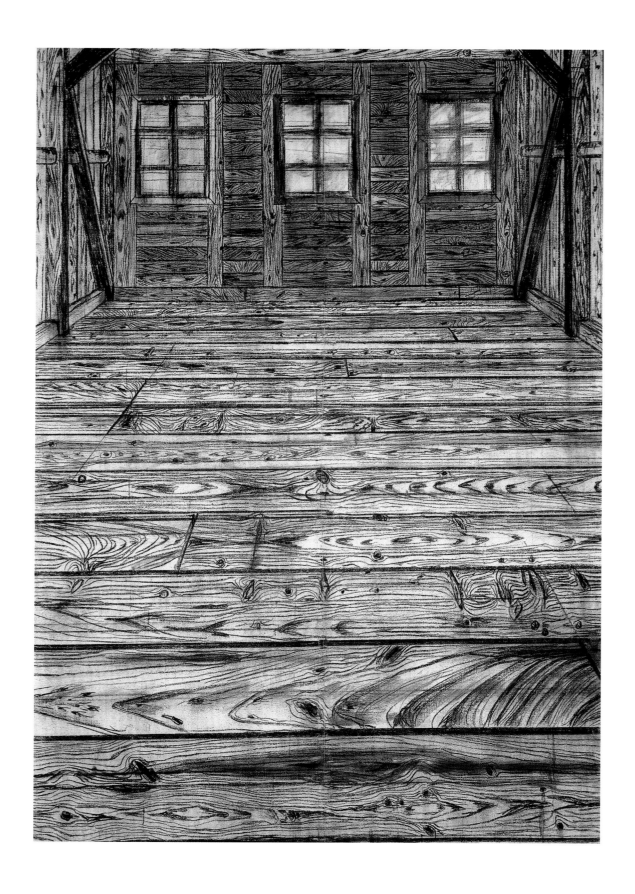

Anselm Kiefer (German, born 1945). *Wooden Room*. 1972. Charcoal and oil on burlap, 9' 10" x 7' 2½" (299.7 x 219.7 cm). Gift of The Jerry and Emily Spiegel Family Foundation, Inc., 2001

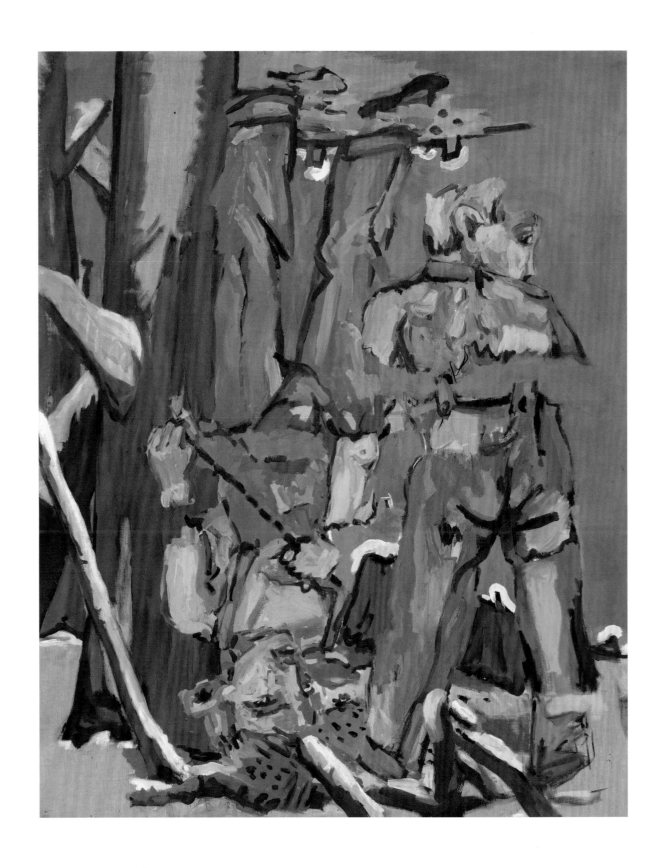

Georg Baselitz (German, born 1938). *Woodmen*. 1967–68. Charcoal and synthetic resin on canvas, 8' 2" x 6' 6¾" (248.7 x 200 cm). Gift of Jo Carole and Ronald S. Lauder, Leon Black, Donald L. Bryant, Jr., Thomas W. Weisel, Doris and Donald Fisher, Mimi and Peter Haas, Enid A. Haupt Fund, 1999

Blinky Palermo (German, 1943–1977). *Untitled*. 1970. Dyed cotton mounted on
muslin, 6' 6¾" x 6' 6¾" (200 x 200 cm). Gift of Jo Carole and Ronald S. Lauder, 1997

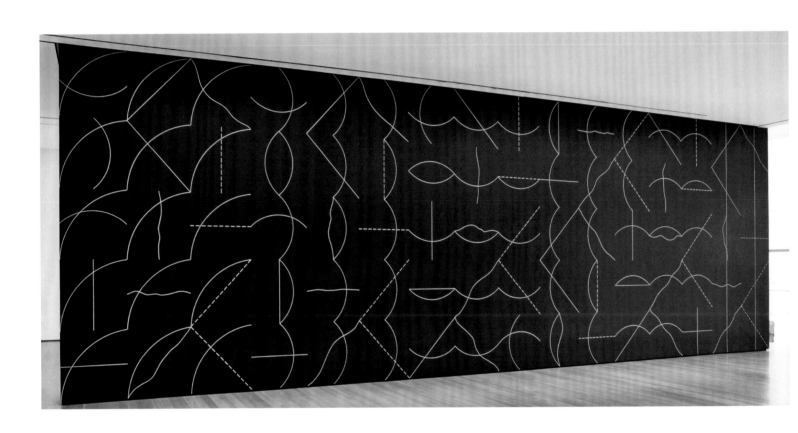

Sol LeWitt (American, 1928–2007). *Wall Drawing #260. On Black Walls, All Two-Part Combinations of White Arcs from Corners and Sides, and White Straight, Not-Straight, and Broken Lines.* 1975.

Crayon on painted wall, dimensions variable. Gift of an anonymous donor, 1978

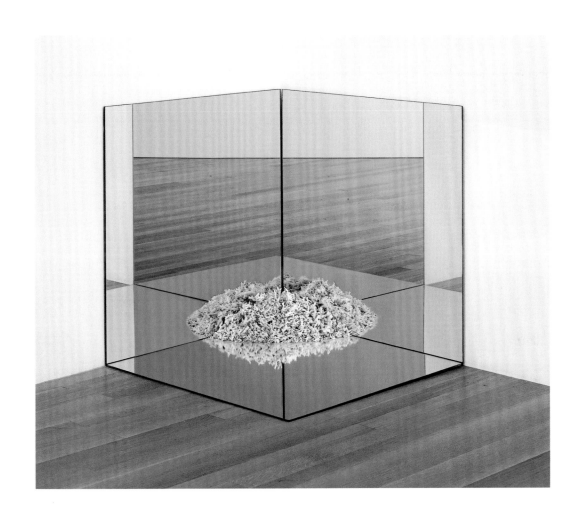

Robert Smithson (American, 1938–1973). *Corner Mirror with Coral*. 1969. Mirrors and coral, 36 x 36 x 36" (91.5 x 91.5 x 91.5 cm). Fractional and promised gift of Agnes Gund, 1991

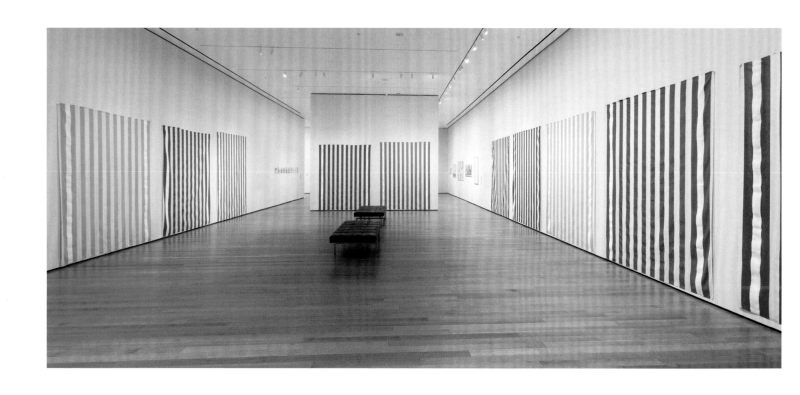

Daniel Buren (French, born 1938). *Striped cotton fabric with vertical white and colored bands of 8,7cm (+/ 0,3 cm) each. The two external white bands covered over with acrylic white paint recto-verso.* 1970.
Synthetic polymer paint on striped cotton fabric, twelve parts, overall dimensions variable. Gift of Herman J. Daled, 2011

IN RELATION TO AN INCREASE IN QUANTITY REGARDLESS OF QUALITY:

HAVING BEEN PLACED UPON A PLANE
() UPON A PLANE
HAVING BEEN PLACED ()

Lawrence Weiner (American, born 1942).
IN RELATION TO AN INCREASE IN QUANTITY REGARDLESS OF QUALITY:
HAVING BEEN PLACED UPON A PLANE
() UPON A PLANE
HAVING BEEN PLACED ()
Cat. #373 (1974). 1973–74.
Language + the materials referred to, dimensions variable. Given anonymously, 1975

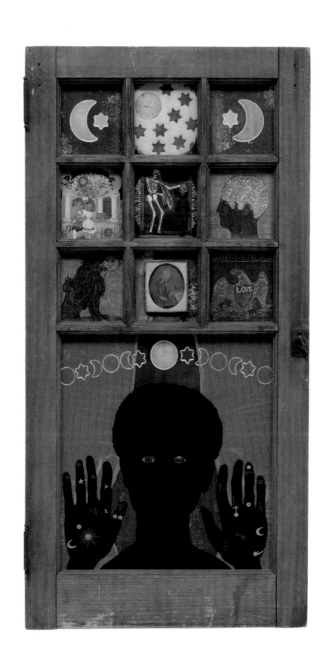

Betye Saar (American, born 1926). *Black Girl's Window*. 1969.
Mixed mediums, 35¾ x 18 x 1½" (90.8 x 45.7 x 3.8 cm). The Modern Women's
Fund and Committee on Painting and Sculpture Funds, 2013

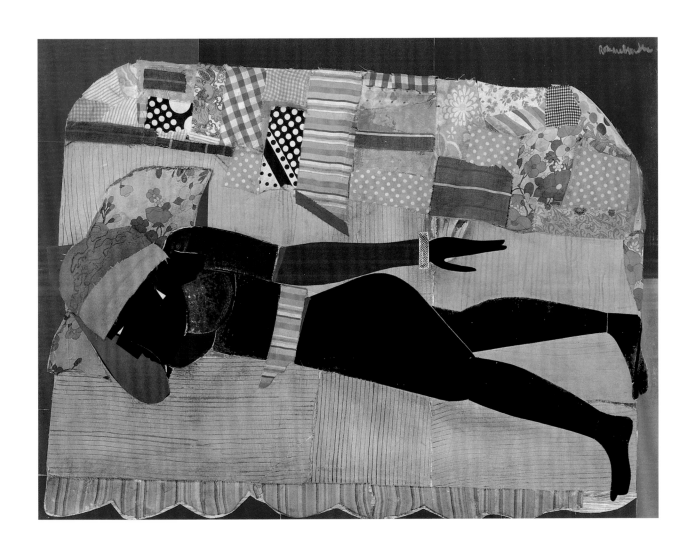

Romare Bearden (American, 1911–1988). *Patchwork Quilt*. 1970. Cut-and-pasted cloth and paper with synthetic polymer paint on composition board, 35¾ x 47⅞" (90.9 x 121.6 cm). Blanchette Hooker Rockefeller Fund, 1970

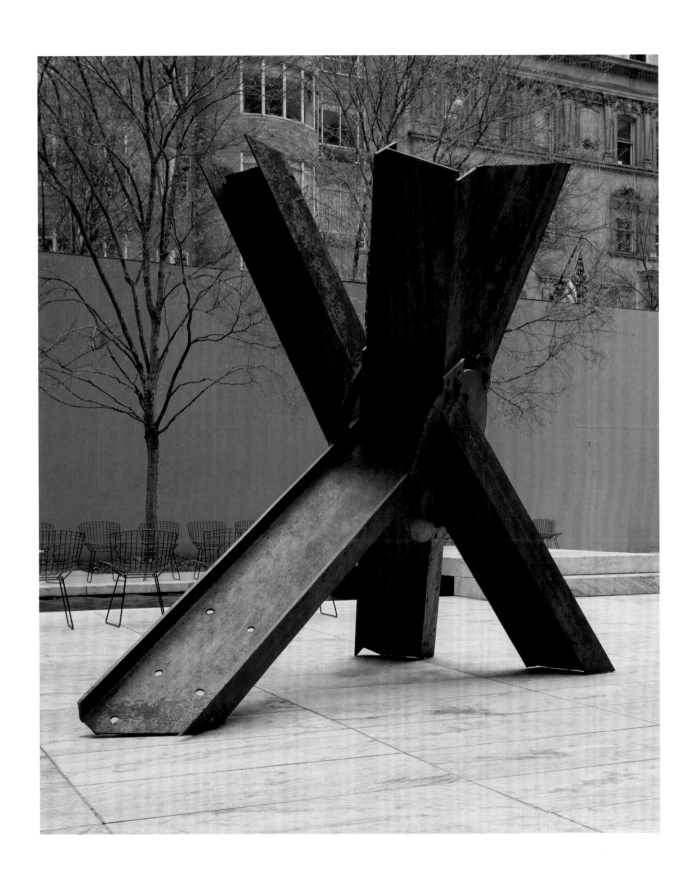

Mark di Suvero (American, born 1933). *For Roebling*. 1971. Steel, 9' 1" x 8' 6" x 9' 11½"
(276.9 x 259.1 x 303.5 cm). Gift of Mr. and Mrs. S. I. Newhouse, Jr., 1991

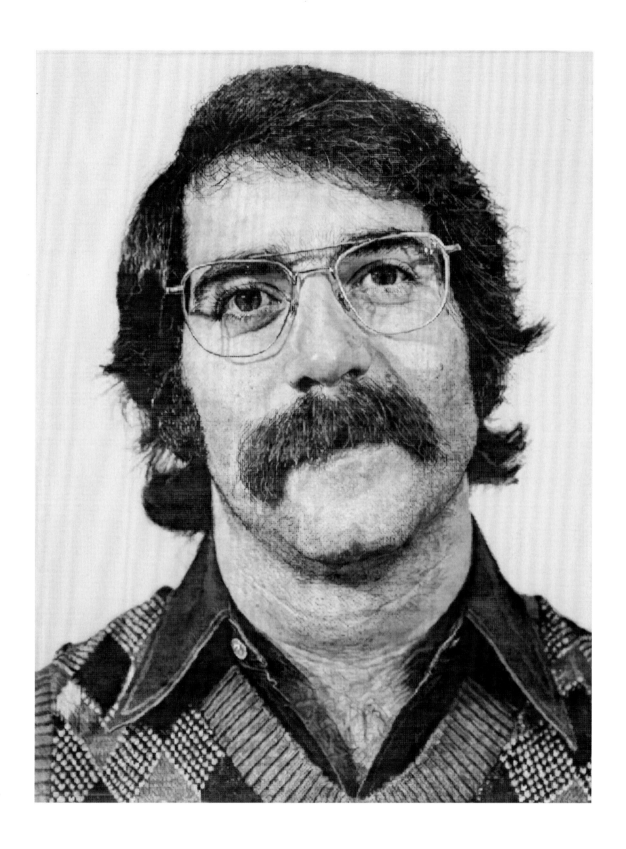

Chuck Close (American, born 1940). *Robert/104,072*. 1973–74. Synthetic polymer paint and ink with graphite on gessoed canvas, 9' x 7' (274.4 x 213.4 cm). Gift of J. Frederic Byers III and promised gift of an anonymous donor, 1976

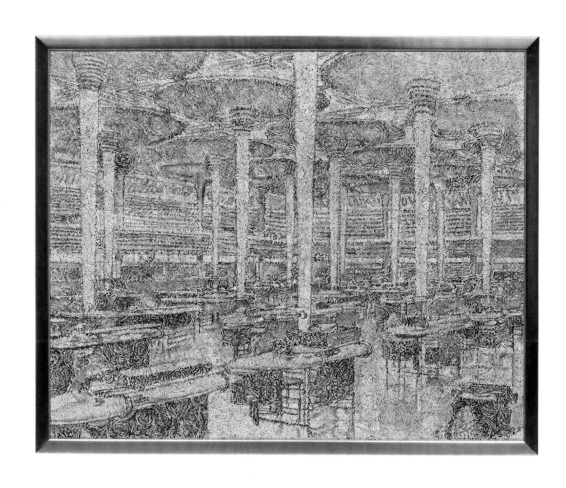

Richard Artschwager (American, 1923–2013). *Johnson Wax Building*. 1974. Synthetic polymer paint on board with metal frame, 47½ x 59½" (120.7 x 151.1 cm). Gift of Edward R. Broida, 2005

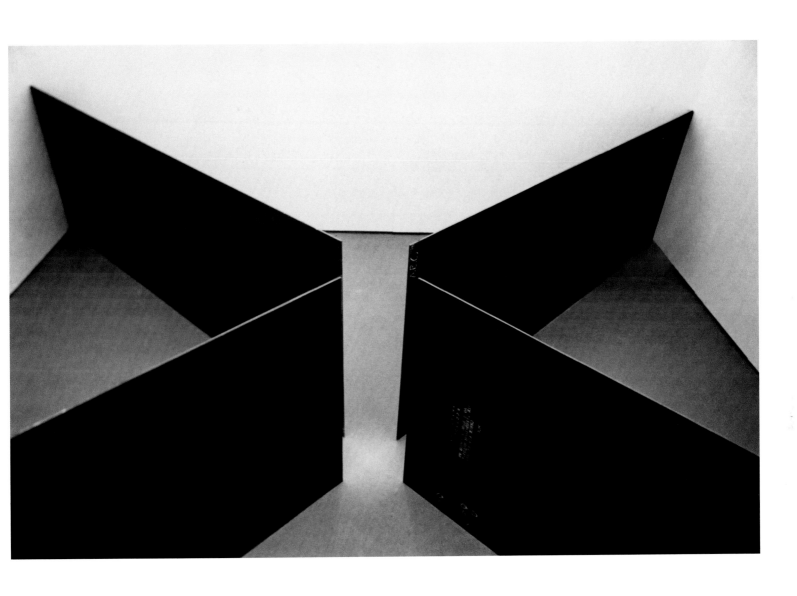

Richard Serra (American, born 1939). *Circuit*. 1972. Hot-rolled steel, four plates, each 8' x 24' x 1" (240 x 730 x 2.5 cm). Gift of the artist in honor of Harald Szeemann and gift of Enid A. Haupt and S. I. Newhouse, Jr. (both by exchange), 2014

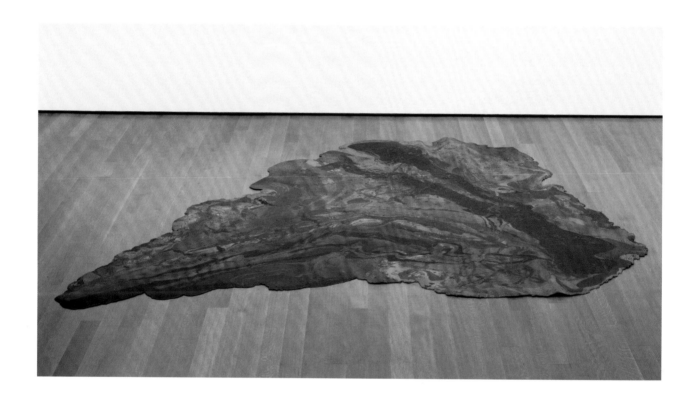

Lynda Benglis (American, born 1941). *Blatt*. 1969. Dayglo pigment and poured latex. 128 x 103"
(325.1 x 261.6 cm). Gift of the Fuhrman Family Foundation through The Modern Women's Fund, 2012

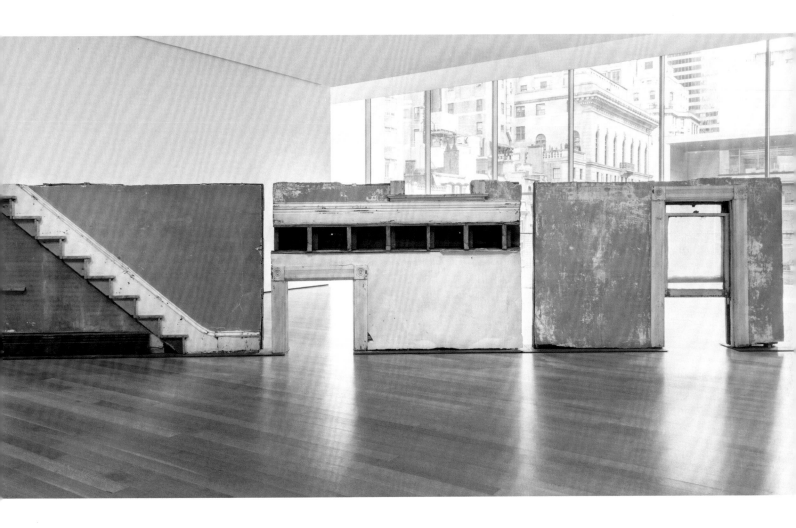

Gordon Matta-Clark (American, 1943–1978). *Bingo*. 1974. Building fragments: painted wood, metal, plaster, and glass in three sections, overall, 69" x 25' 7" x 10" (175.3 x 779.8 x 25.4 cm). Nina and Gordon Bunshaft Bequest Fund, Nelson A. Rockefeller Bequest Fund, and the Enid A. Haupt Fund, 2004

Jack Whitten (American, born 1939). *Siberian Salt Grinder*. 1974. Synthetic polymer paint on canvas, 6' 8" x 50" (203.2 x 127 cm). Nina and Gordon Bunshaft Fund and The Friends of Education of The Museum of Modern Art, 2010

Susan Rothenberg (American, born 1945). *Axes*. 1976. Synthetic polymer paint, gesso, charcoal, and pencil on canvas, 64⅝" x 8' 8⅞" (164.2 x 266.4 cm). Purchased with the aid of funds from the National Endowment for the Arts, 1977

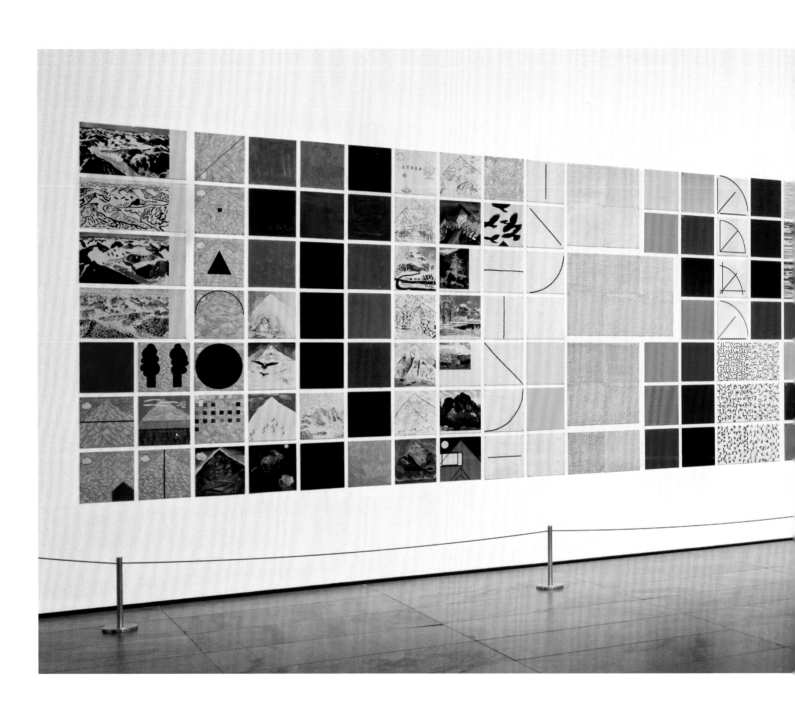

Jennifer Bartlett (American, born 1941). *Rhapsody* (detail). 1975–76. Enamel on steel, 987 plates, each plate 12 x 12" (30.4 x 30.4 cm); overall approx. 7' 6" x 153' (228.6 x 4663.4 cm). Gift of Edward R. Broida, 2005

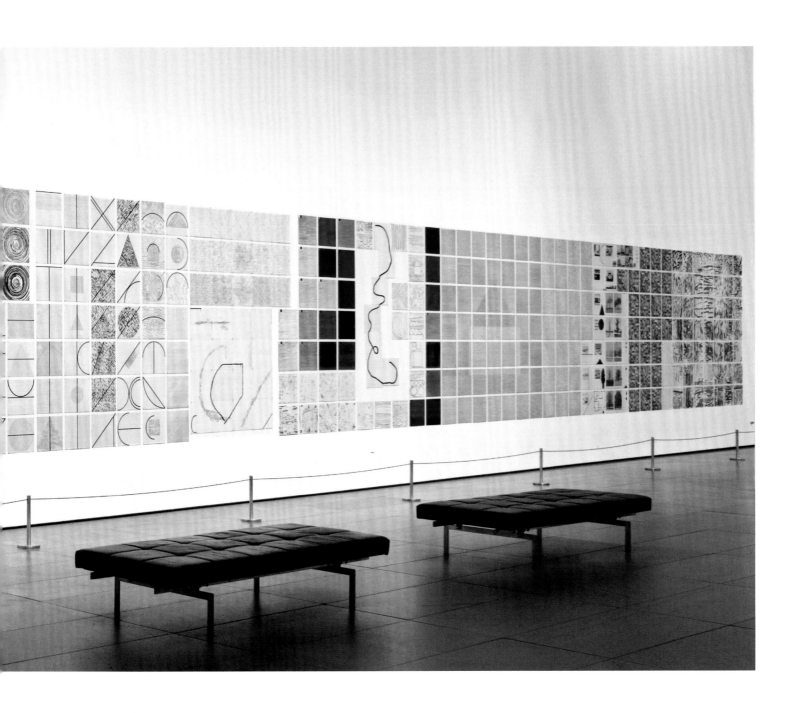

Lee Ufan (Korean, born 1936). *From Line*. 1974. Oil on canvas, 71½ x 89⅜"
(181.6 x 227 cm). Committee on Painting and Sculpture Funds, 2010

Jackie Winsor (American, born Canada, 1941). *Burnt Piece*. 1977–78. Cement, burnt wood, and wire mesh, 33⅞ x 34 x 34" (86.1 x 86.4 x 86.4 cm). Gift of Agnes Gund, 1991

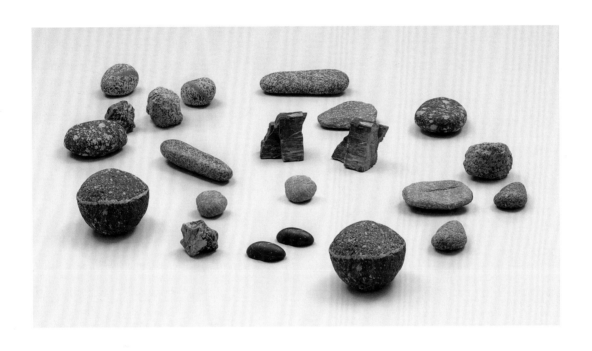

Vija Celmins (American, born Latvia, 1938). *To Fix the Image in Memory*. 1977–82.
Stones and painted bronze, eleven pairs, overall dimensions variable. Gift of Edward R. Broida in honor of
David and Renee McKee, 2005

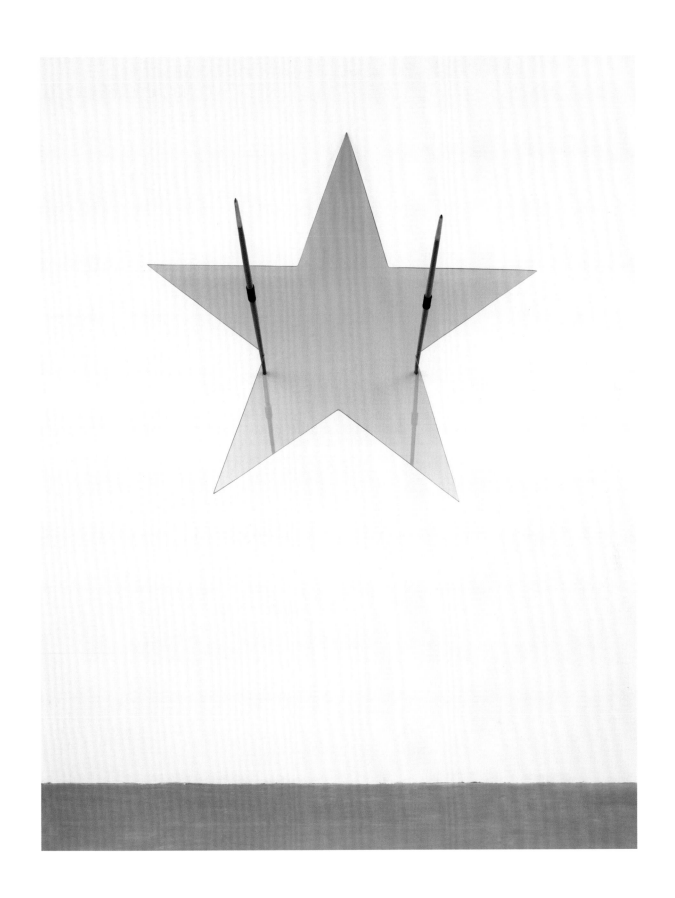

Gilberto Zorio (Italian, born 1944). *Crystal Star with Javelins*. 1977. Glass and steel, 6' 2½" x 6' 2½" x 8' 6½" (189.2 x 189.2 x 260.4 cm). Anne and Sid Bass Fund, 1986

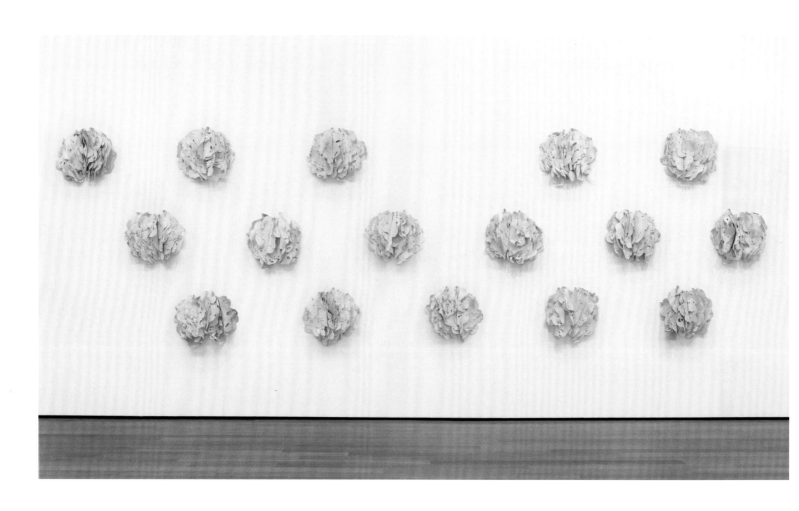

Hannah Wilke (American, 1940–1993). *Ponder-r-rosa 4, White Plains, Yellow Rocks*. 1975.
Latex, metal snaps, and push pins, sixteen sculptures, each 17 x 26 x 5¾" (43.2 x 66 x 14.6 cm); overall 68" x 20' 10" x 5¾"
(172.7 x 635 x 14.6 cm). Committee on Painting and Sculpture Funds and gift of Marsie, Emanuelle, Damon, and
Andrew Scharlatt, Hannah Wilke Collection & Archive, Los Angeles, 2008

Richard Diebenkorn (American, 1922–1993). *Ocean Park 115*. 1979.
Oil on canvas, 8' 4" x 6' 9" (254 x 205.6 cm). Mrs. Charles G. Stachelberg Fund, 1979

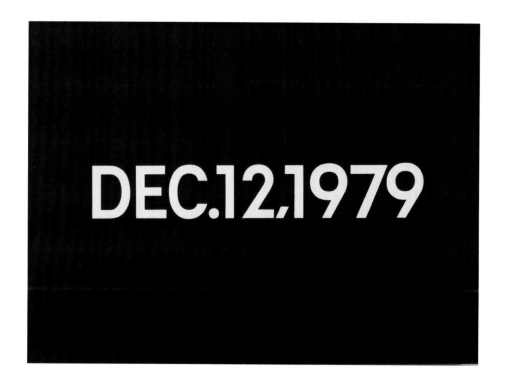

On Kawara (Japanese, 1933–2014). *Wednesday, Dec. 12, 1979*. 1979. Synthetic polymer paint on canvas, 18¼ x 24⅜" (46.4 x 62.5 cm). Blanchette Hooker Rockefeller Fund, 1981

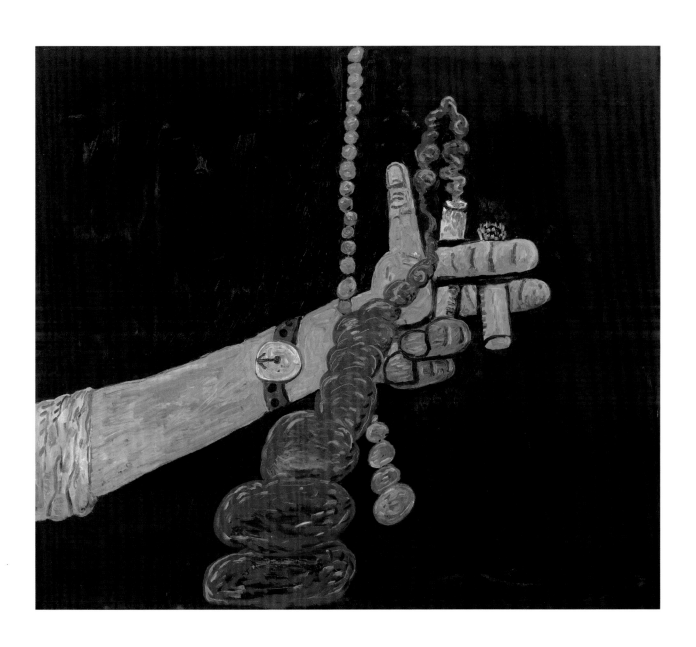

Philip Guston (American, born Canada. 1913–1980). *Talking*. 1979.
Oil on canvas, 68⅛" x 6' 6¼" (173 x 198.8 cm). Gift of Edward R. Broida, 2005

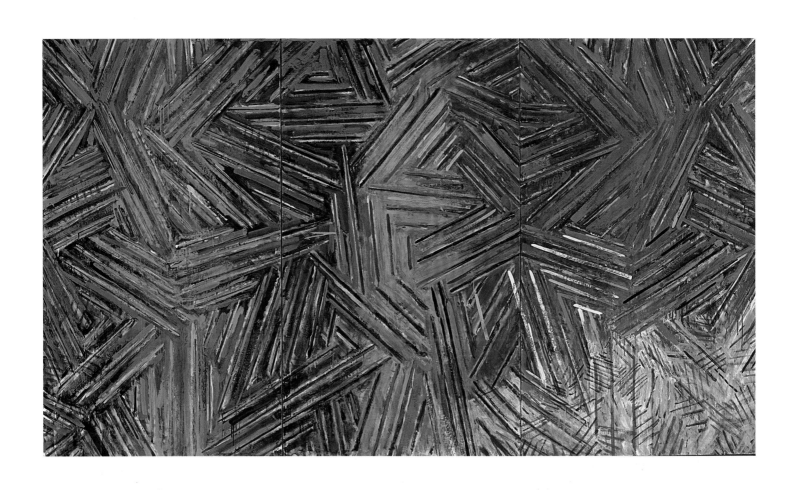

Jasper Johns (American, born 1930). *Between the Clock and the Bed*. 1981.
Encaustic on canvas, three panels, overall 6' ⅛" x 10' 6⅜" (183.2 x 321 cm). Gift of Agnes Gund, 1982

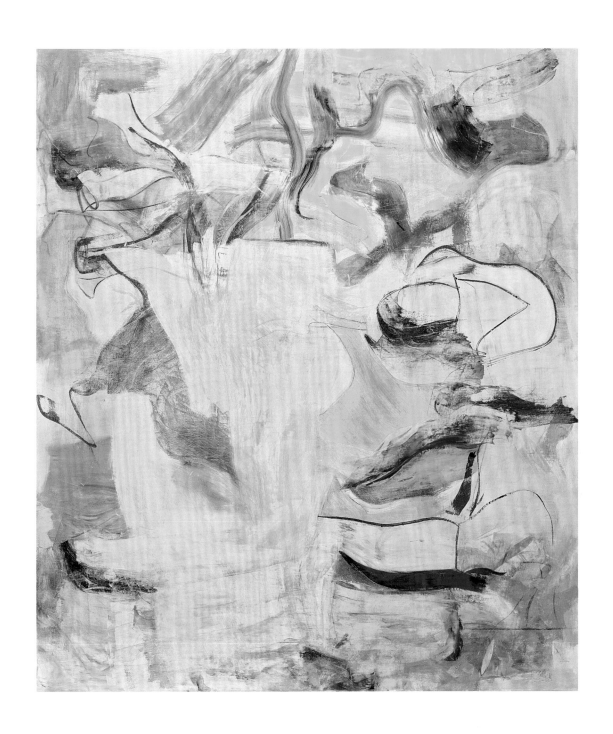

Willem de Kooning (American, born the Netherlands. 1904–1997). *Pirate (Untitled II)*. 1981.
Oil on canvas, 7' 4" x 6' 4¾" (223.4 x 194.4 cm). Sidney and Harriet Janis Collection Fund, 1982

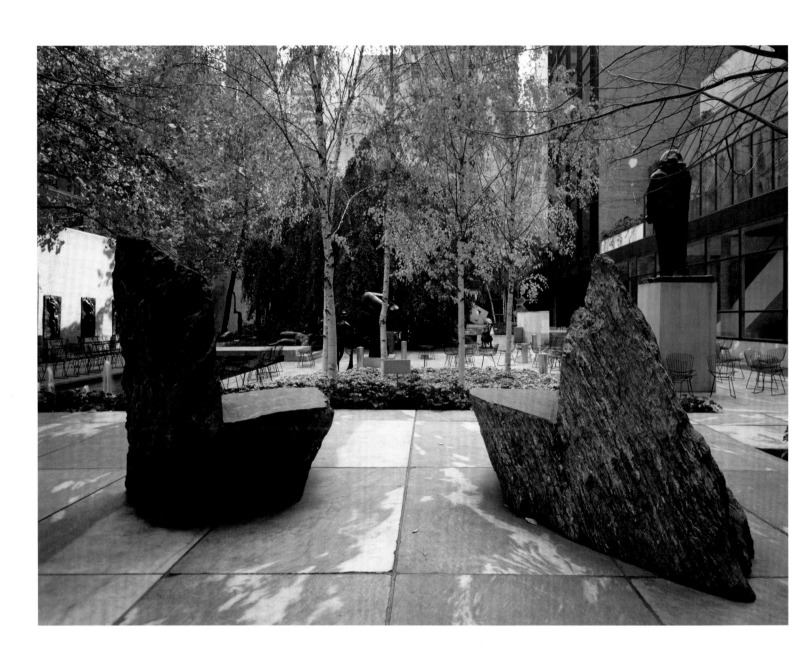

Scott Burton (American, 1939–1989). *Pair of Rock Chairs*. 1980–81. Stone (gneiss),
two parts, 49¼ x 43½ x 40" (125.1 x 110.5 x 101.6 cm) and 44 x 66 x 42½" (111.6 x 167.7 x 108 cm).
Acquired through the Philip Johnson, Mr. and Mrs. Joseph Pulitzer, Jr., and Robert Rosenblum Funds, 1981

Jenny Holzer (American, born 1950). *Living: Some days you wake and immediately* 1980–82. Bronze, 8 x 10" (20.3 x 25.4 cm). Committee on Painting and Sculpture Funds, 2007

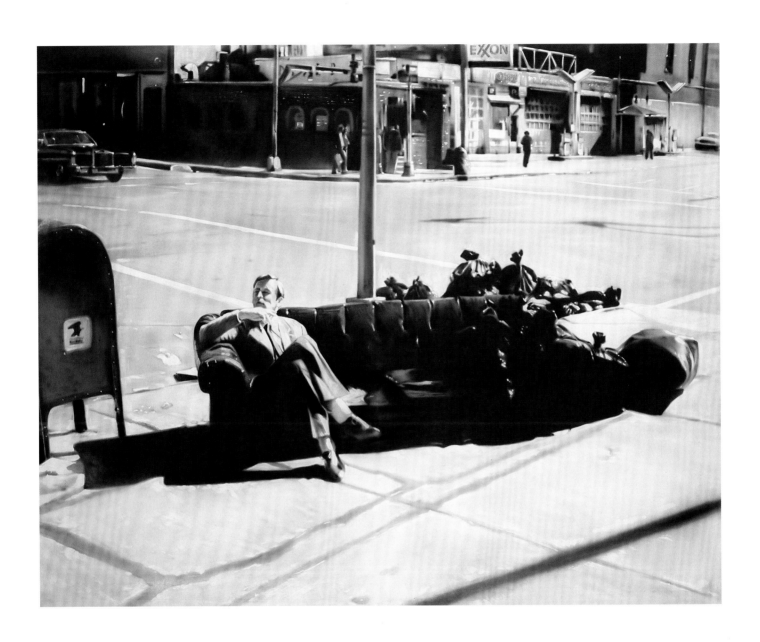

Martin Kippenberger (German, 1953–1997). *Untitled* from the series *Dear Painter, Paint for Me.* 1981.
Synthetic polymer paint on canvas, 7' 10½" x 9' 9¾" (240 x 299.1 cm). Gift of Steven and Alexandra Cohen, 2007

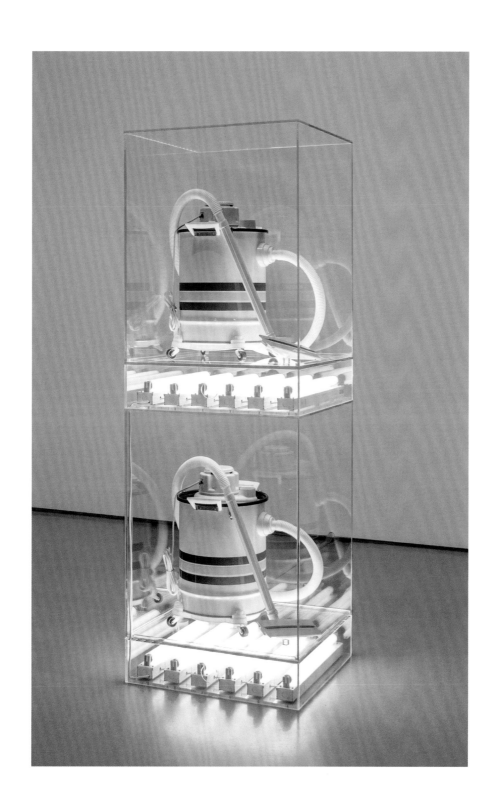

Jeff Koons (American, born 1955). *New Shelton Wet/Dry Doubledecker*. 1981.
Vacuum cleaners, plexiglass, and fluorescent lights, 8' ⅝" x 28" x 28" (245.4 x 71.1 x 71.1 cm). Gift of
Werner and Elaine Dannheisser, 1996

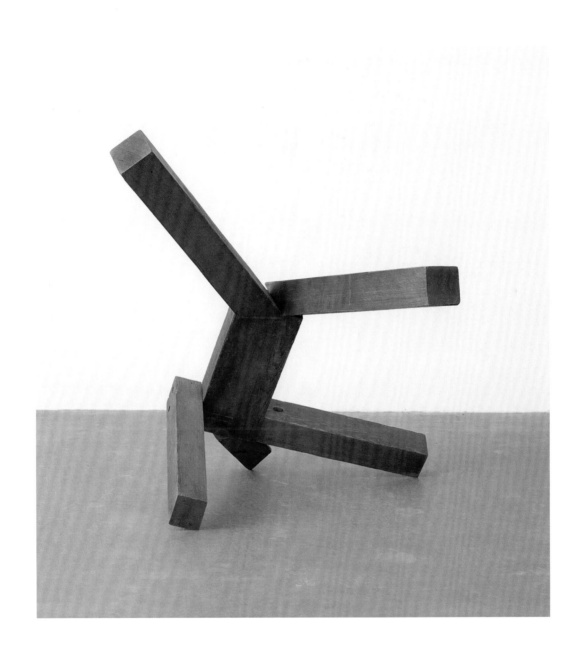

Joel Shapiro (American, born 1941). *Untitled*. 1982. Cedar, 46¼ x 48 x 48¼"
(117.4 x 122 x 122.5 cm). Fractional and promised gift of an anonymous donor, 1992

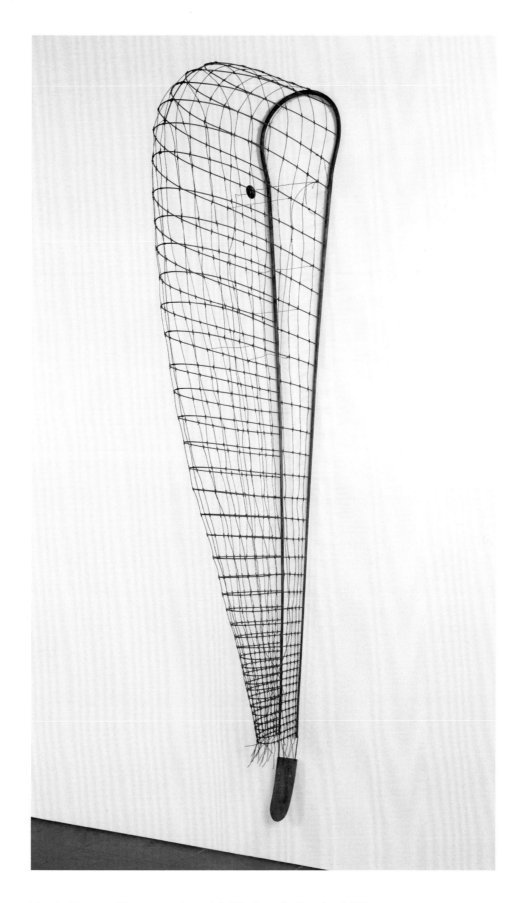

Martin Puryear (American, born 1941). *Greed's Trophy*. 1984. Steel rod and wire, wood, rattan, and leather, 12' 9" x 20" x 55" (388.6 x 50.8 x 139.7 cm). David Rockefeller Fund, 1984

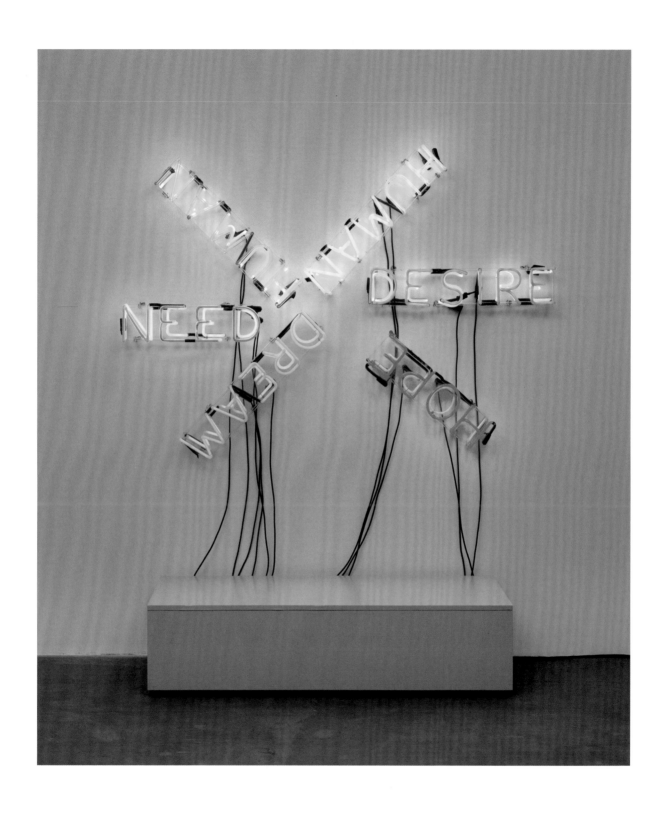

Bruce Nauman (American, born 1941). *Human/Need/Desire*. 1983. Neon tubing and wire with glass tubing suspension frames, 7' 10⅜" x 70½" x 25¾" (239.8 x 179 x 65.4 cm). Gift of Emily and Jerry Spiegel, 1991

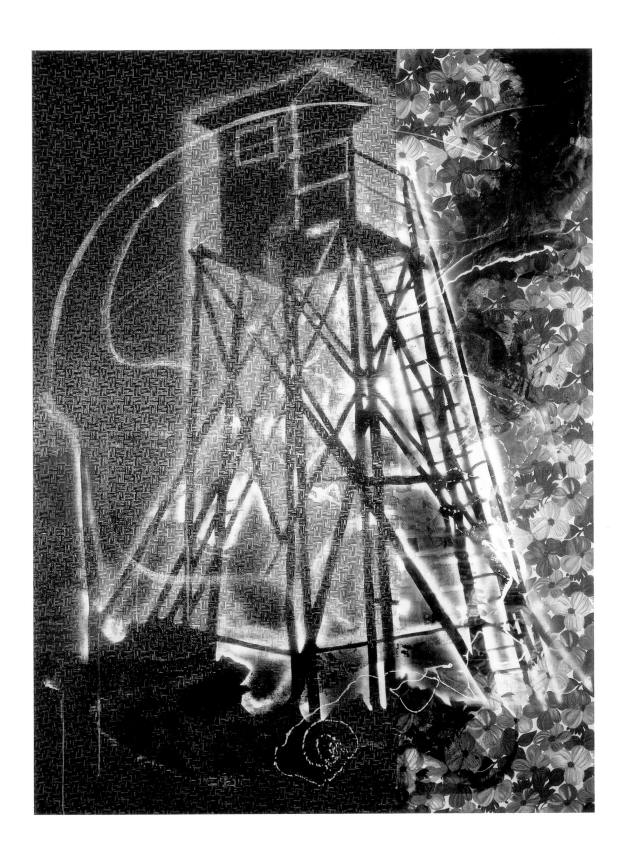

Sigmar Polke (German, 1941–2010). *Watchtower*. 1984. Synthetic polymer paints and dry pigment on patterned fabric, 9' 10" x 7' 4½" (300 x 224.8 cm). Fractional and promised gift of Jo Carole and Ronald S. Lauder, 1991

Gerhard Richter (German, born 1932). *October 18, 1977*. 1988. Fifteen paintings, oil on canvas, installation dimensions variable. The Sidney and Harriet Janis Collection, gift of Philip Johnson, and acquired through the Lillie P. Bliss Bequest (all by exchange); Enid A. Haupt Fund; Nina and Gordon Bunshaft Bequest Fund; and gift of Emily Rauh Pulitzer, 1995

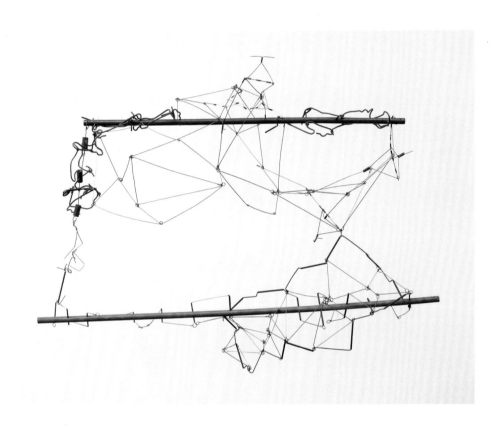

Gego (Gertrud Goldschmidt) (Venezuelan, born Germany. 1912–1994). *Drawing without Paper 84/25 and 84/26*. 1984 and 1987. Enamel on wood and stainless-steel wire, 23⅝ x 34⅝ x 16¾" (60 x 88 x 40 cm). Gift of Patricia Phelps de Cisneros in honor of Susan and Glenn Lowry, 2004

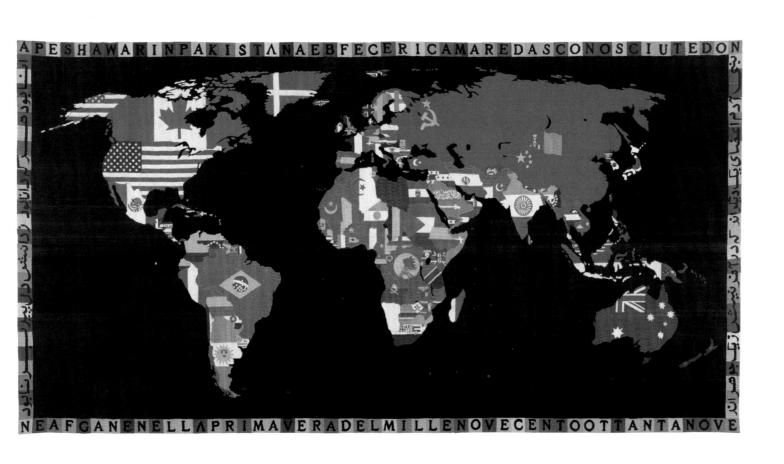

Alighiero Boetti (Italian, 1940–1994). *Map of the World*. 1989. Embroidery
on fabric, 46¼" x 7' 3¾" x 2" (117.5 x 227.7 x 5.1 cm). Scott Burton Fund, 1999

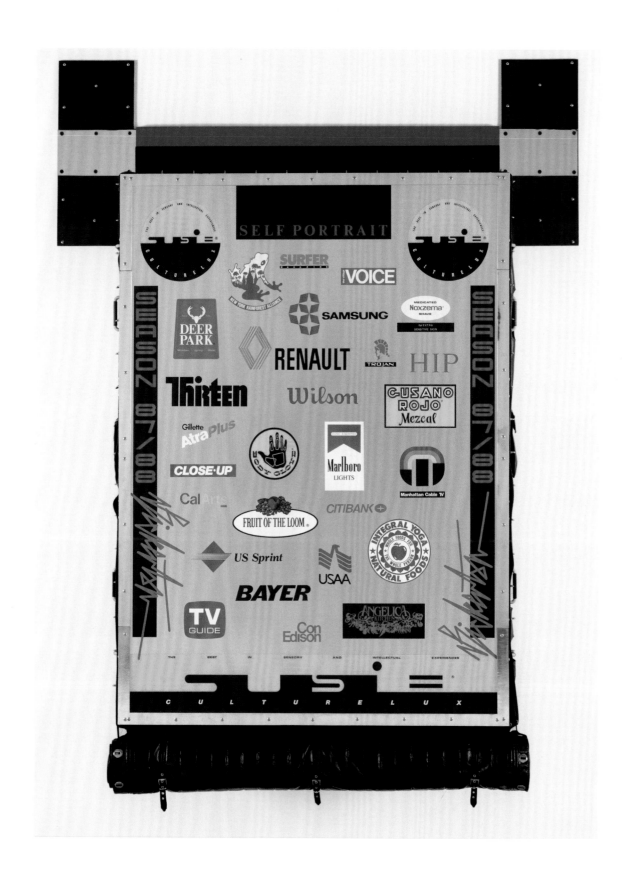

Ashley Bickerton (British, born 1959). *Tormented Self-Portrait (Susie at Arles)*. 1987–88.
Synthetic polymer paint, bronze powder, and lacquer on wood, anodized aluminum, rubber, plastic, formica,
leather, chrome-plated steel, and canvas, 7' 5⅜" x 68¾" x 15¾" (227.1 x 174.5 x 40 cm). Purchase, 1988

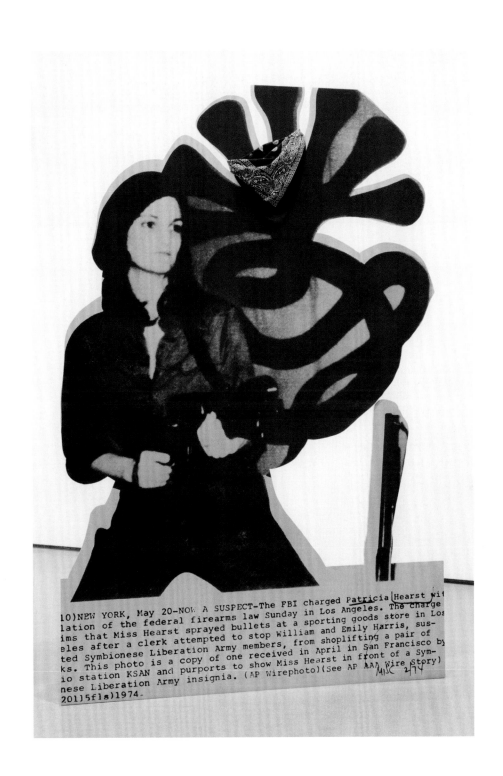

Cady Noland (American, born 1956). *Tanya as Bandit*. 1989.

Silkscreen ink on aluminum and bandana, 6' x 48" x ⅜" (182.9 x 121.9 x 1 cm).

Gift of Kathy and Richard S. Fuld, Jr., 2007

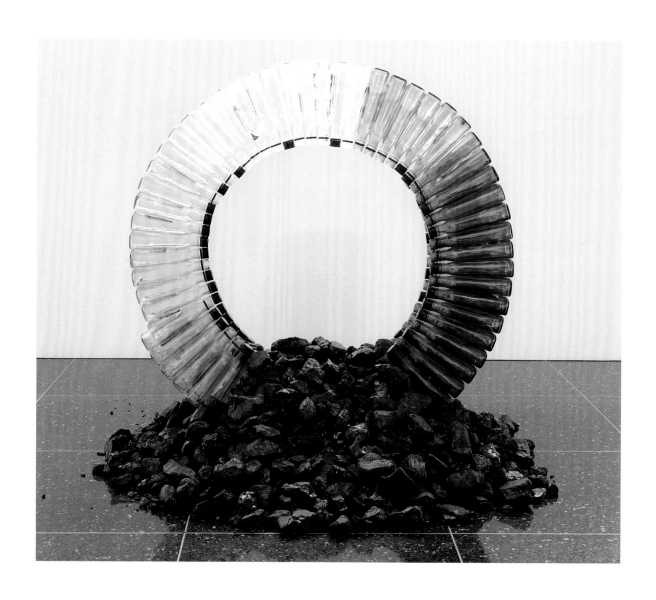

David Hammons (American, born 1943). *Untitled (Night Train)*. 1989. Glass, silicone glue, and coal, 42 x 42 x 30" (106.7 x 106.7 x 76.2 cm), depth and width variable. Gift of the Hudgins Family in memory of Lawrence D. "Butch" Morris, 2013

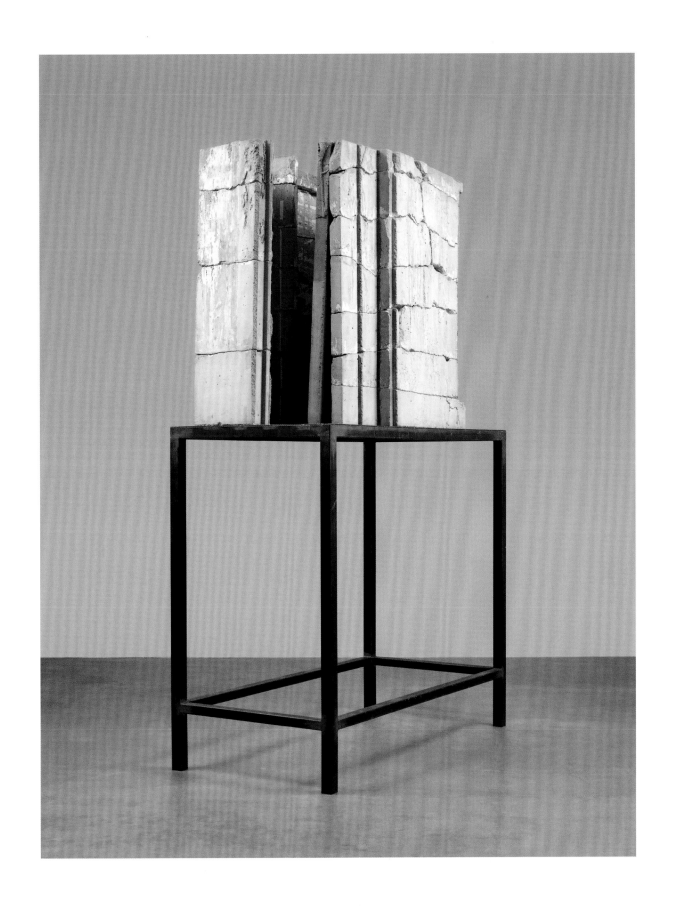

Isa Genzken (German, born 1948). *Painting*. 1989. Concrete and steel, 8' 7⁹⁄₁₆" x 63" x 30⁵⁄₁₆"
(263 x 160 x 77 cm). Gift of Susan and Leonard Feinstein and an anonymous donor, 2011

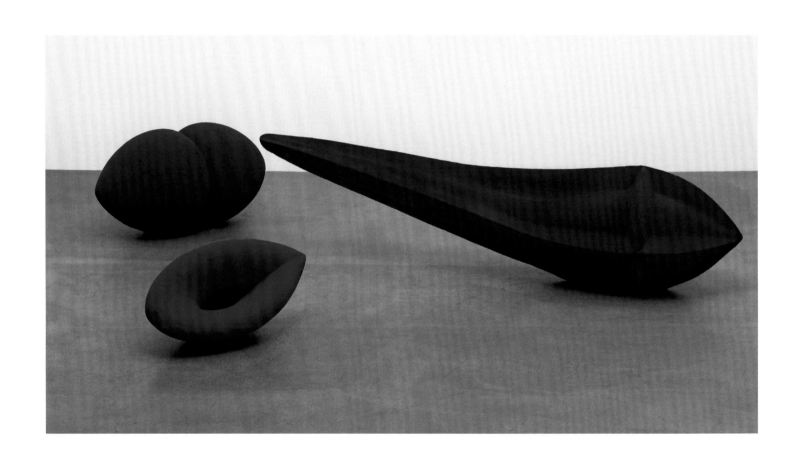

Anish Kapoor (British, born India, 1954). *A Flower, A Drama Like Death*. 1986. Polystyrene, plaster, cloth, gesso, and raw pigment in three parts, overall approx. 22" x 11' 8" x 60" (55.8 x 355.6 x 152.4 cm). Sid R. Bass Fund, 1987

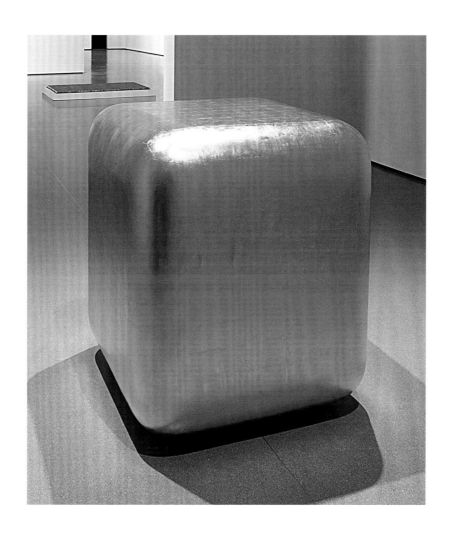

James Lee Byars (American, 1932–1997). *The Table of Perfect*. 1989.
Gold leaf on white marble, 39¼ x 39¼ x 39¼" (99.7 x 99.7 x 99.7 cm). Committee on
Painting and Sculpture Funds, 1998

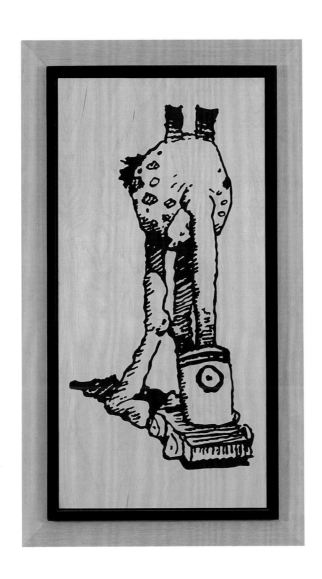

Sherrie Levine (American, born 1947). *Untitled (Mr. Austridge: 2)*. 1989.
Casein on wood in artist's frame, 47⅛" x 27⅛" (119.7 x 68.9 cm). Committee on Painting
and Sculpture Funds, 2009

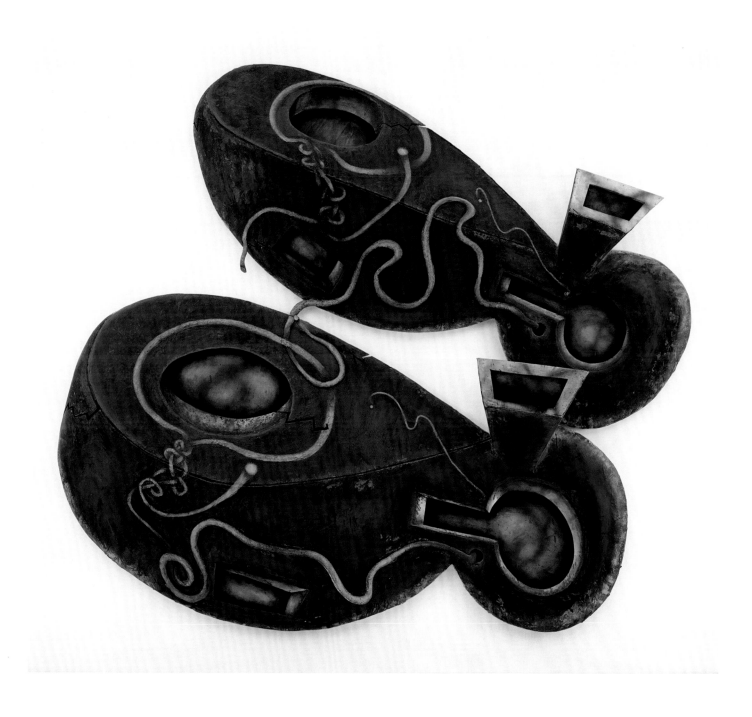

Elizabeth Murray (American, 1940–2007). *Dis Pair*. 1989–90. Oil and plastic cap on canvas and wood, two panels, overall 10' 2½" x 10' 9¼" x 13" (331.3 x 328.3 x 33 cm). Gift of Marcia Riklis, Arthur Fleischer, Jr., and Anna Marie and Robert F. Shapiro; Blanchette Hooker Rockefeller Fund; and purchase, 1990

Christopher Wool (American, born 1955). *Untitled*. 1990. Enamel on aluminum, 9' x 6' (274.3.x 182.9 cm). Gift of the Louis and Bessie Adler Foundation, Inc., 1991

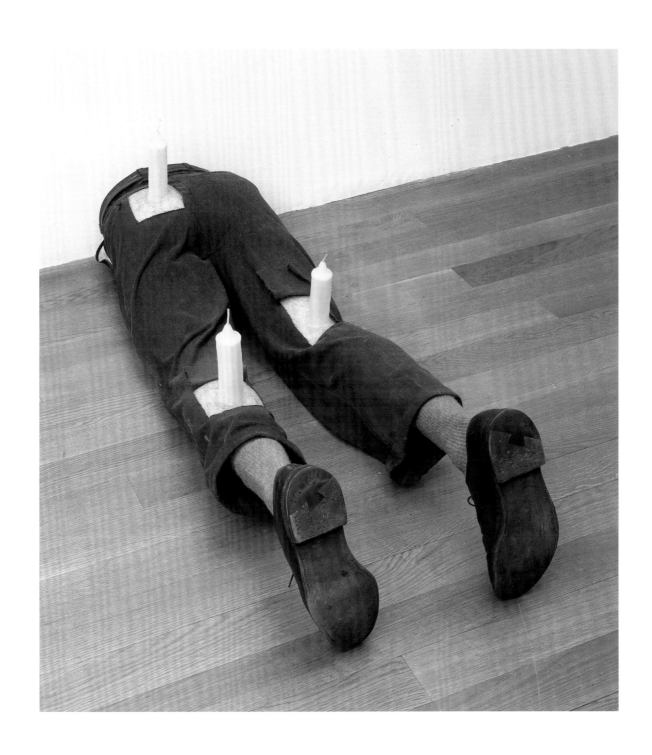

Robert Gober (American, born 1954). *Untitled*. 1991. Wood, beeswax, leather, fabric, and human hair, 13¼ x 16½ x 46⅛" (33.6 x 41.9 x 117.2 cm). Gift of Werner and Elaine Dannheisser, 1996

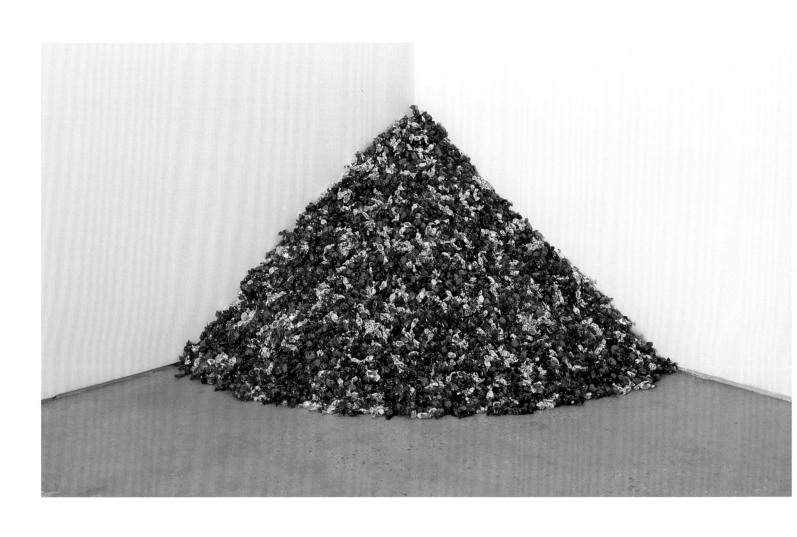

Felix Gonzalez-Torres (American, born Cuba. 1957–1996). *"Untitled" (USA Today)*. 1990.
Candies, individually wrapped in red, silver, and blue cellophane (endless supply), dimensions vary with
installation, with ideal weight 300 lb. (136 kg). Gift of the Dannheisser Foundation, 1996

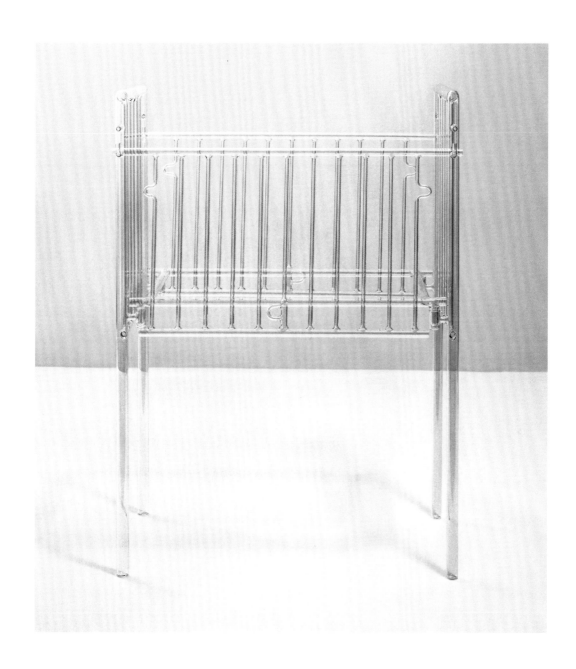

Mona Hatoum (British of Palestinian origin, born Lebanon, 1952). *Silence*. 1994.

Glass, 49⅞ x 36⅞ x 23⅛" (126.6 x 93.7 x 58.7 cm). Robert B. and Emilie W. Betts Foundation Fund, 1995

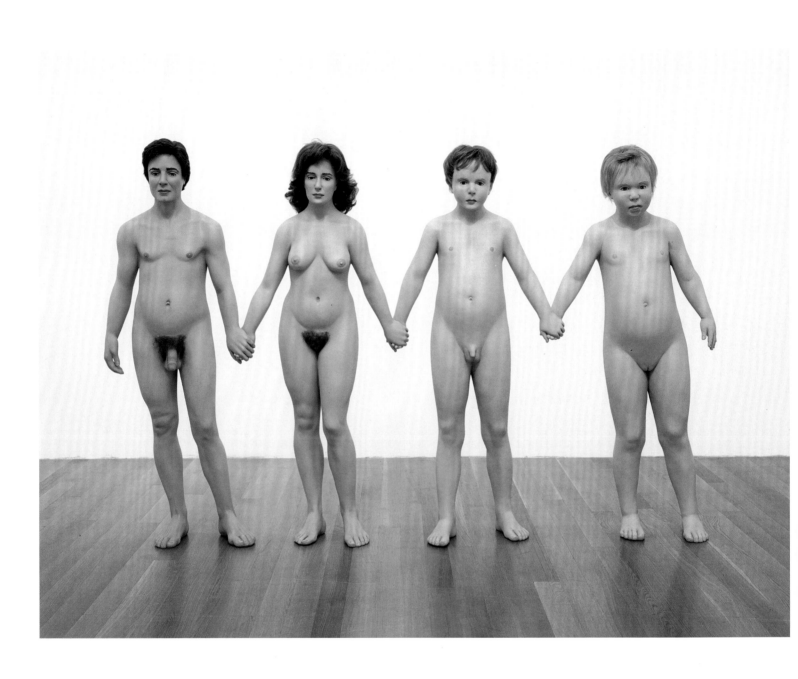

Charles Ray (American, born 1953). *Family Romance*. 1993. Painted fiberglass and synthetic hair, 53" x 7' 1" x 11" (134.6 x 215.9 x 27.9 cm). Gift of The Norton Family Foundation, 1993

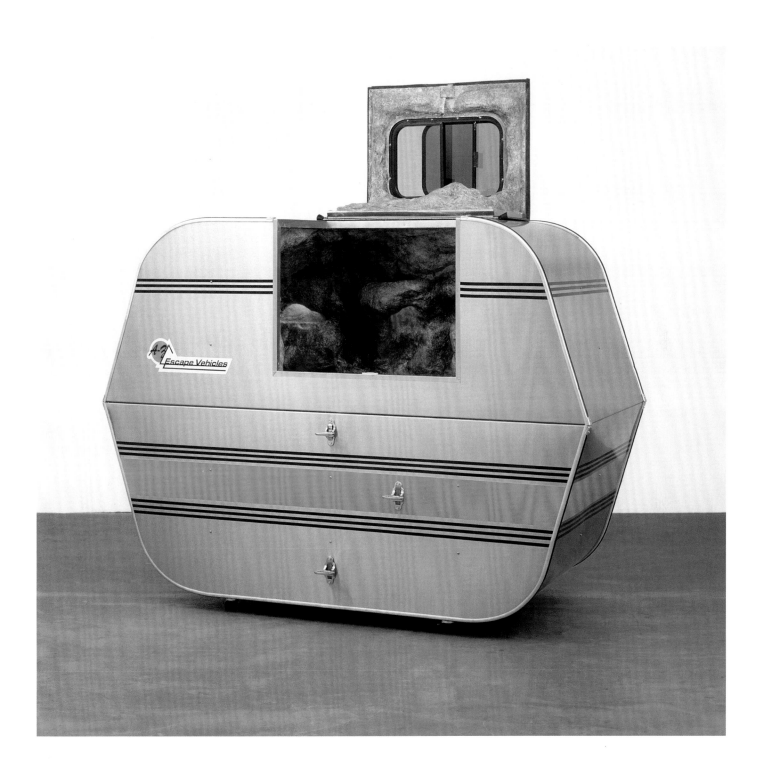

Andrea Zittel (American, born 1965). *A–Z Escape Vehicle: Customized by Andrea Zittel.* 1996. Exterior: steel, insulation, wood, and glass. Interior: colored lights, water, fiberglass, wood, papier-mâché, pebbles, and paint, 62" x 7' x 40" (157.5 x 213.3 x 101.6 cm). The Norman and Rosita Winston Foundation, Inc., Fund and an anonymous fund, 1997

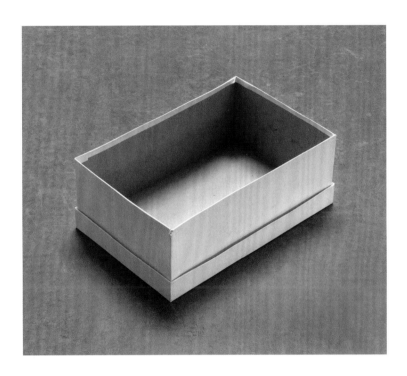

Gabriel Orozco (Mexican, born 1962). *Empty Shoe Box*. 1993.
Shoe box, 4⅞ x 13 x 8½" (12.4 x 33 x 21.6 cm). Nina and Gordon Bunshaft Fund, 2010

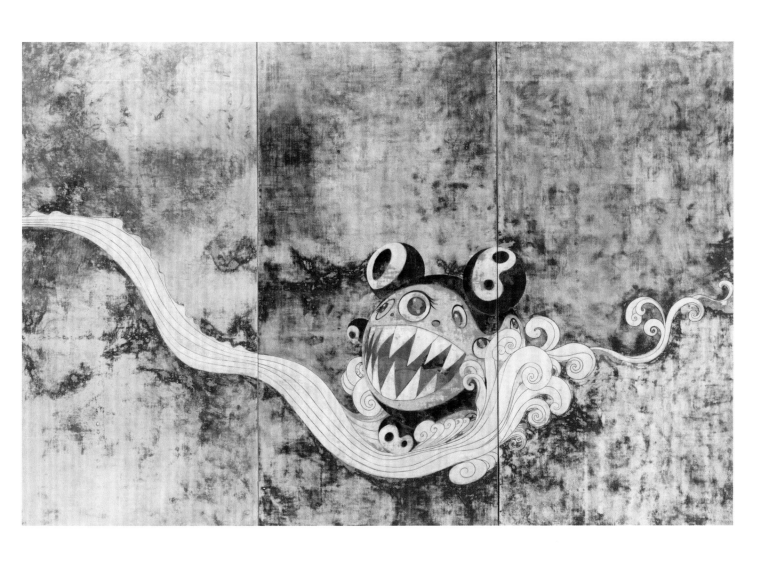

Takashi Murakami (Japanese, born 1962). *727*. 1996. Synthetic polymer paint on canvas board, 9' 10" x 14' 9" (299.7 x 449.6 cm). Gift of David Teiger, 2003

Kara Walker (American, born 1969). *Gone: An Historical Romance of a Civil War as It Occurred b'tween the Dusky Thighs of One Young Negress and Her Heart*. 1994.
Paper, 13 x 50' (396.2 x 1,524 cm). Gift of The Speyer Family Foundation in honor of Marie-Josée Kravis, 2007

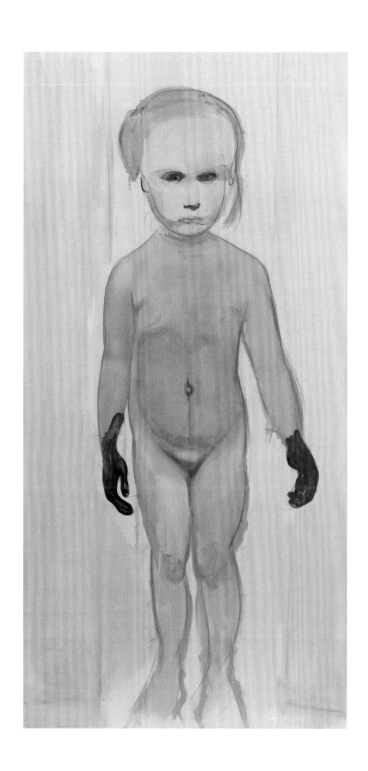

Marlene Dumas (South African, born 1953). *The Painter*. 1994.
Oil on canvas, 6' 7" x 39¼" (200.7 x 99.7 cm). Fractional and promised gift of
Martin and Rebecca Eisenberg, 2005

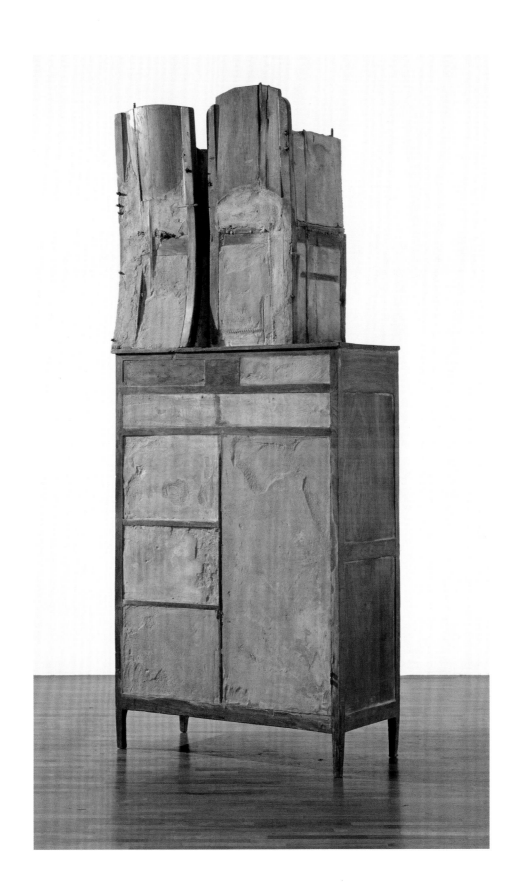

Doris Salcedo (Colombian, born 1958). *Untitled*. 1995. Wood, cement, steel, cloth, and leather, 7' 9" x 41" x 19" (236.2 x 104.1 x 48.2 cm). The Norman and Rosita Winston Foundation, Inc., Fund, 1996

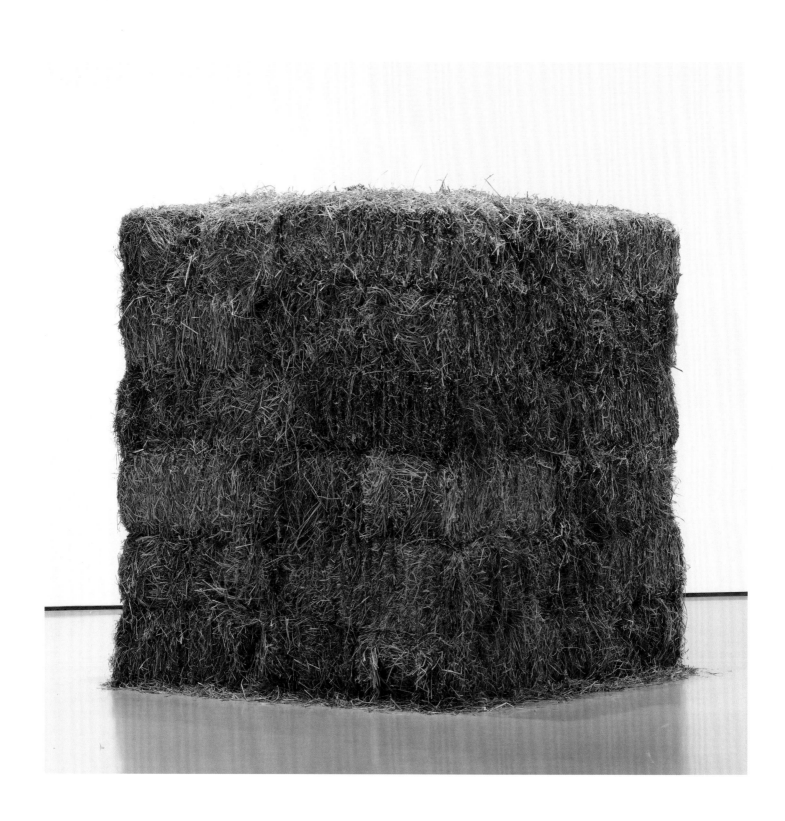

Cildo Meireles (Brazilian, born 1948). *Thread*. 1990–95. Forty-eight bales of
hay, one 18-carat gold needle, 100 meters of gold thread, overall dimensions variable, approx.
7' 1" x 6' 1¹⁄₁₆" x 6' (215.9 x 185.5 x 182.9 cm). Gift of Patricia Phelps de Cisneros, 2001

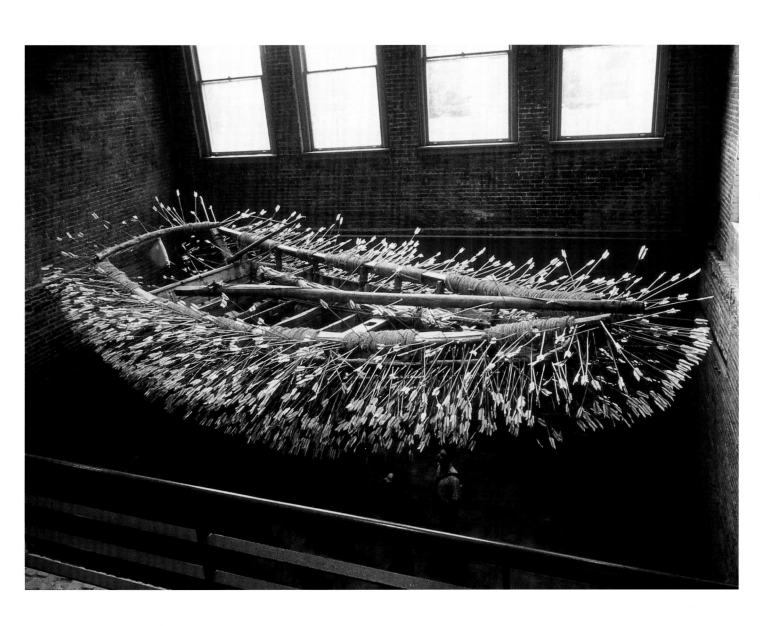

Cai Guo-Qiang (Chinese, born 1957). *Borrowing Your Enemy's Arrows*. 1998. Wooden boat, approx. 60" x 23' 7½" x 7' 6½" (152.4 x 720 x 230 cm); arrows, approx. 24½" (62 cm); canvas sail, metal, rope, Chinese flag, and electric fan. Gift of Patricia Phelps de Cisneros in honor of Glenn D. Lowry, 1999

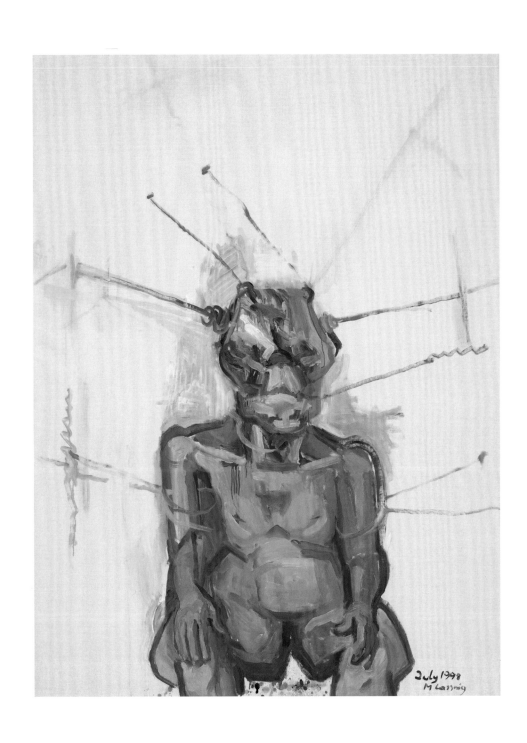

Maria Lassnig (Austrian, 1919–2014). *Sciencia*. 1998. Oil on canvas,
6' 6¾" x 59" (200 x 149.9 cm). Gift of The Ian Woodner Family Collection, bequest
of Richard S. Zeisler, and gift of Thomas McCray (all by exchange), 2014

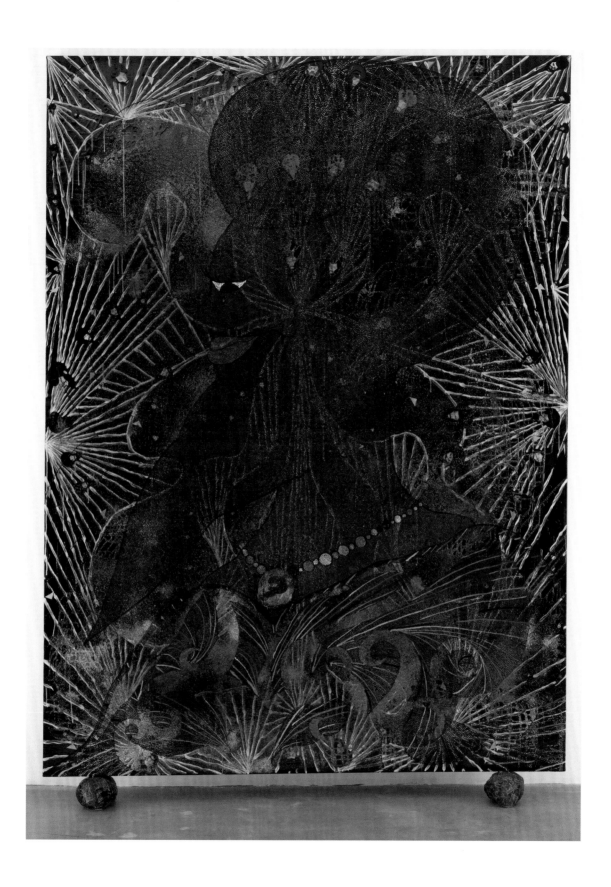

Chris Ofili (British, born 1968). *Prince amongst Thieves*. 1999.
Oil, paper collage, glitter, polyester resin, map pins, and elephant dung on linen,
8 x 6' (243.8 x 182.9 cm). Mimi and Peter Haas Fund, 1999

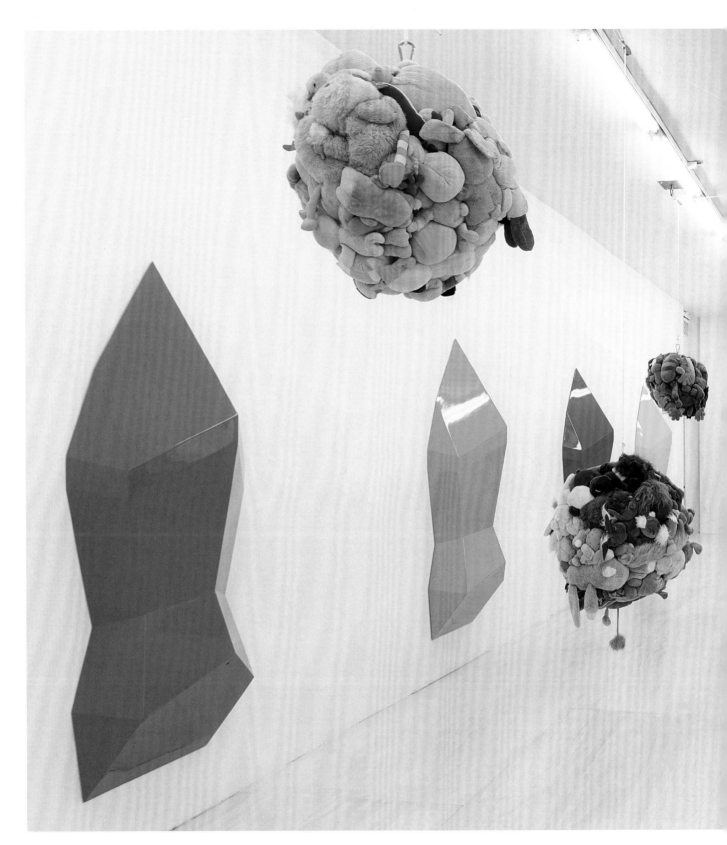

Mike Kelley (American, 1954–2012). *Deodorized Central Mass with Satellites*. 1991/1999.
Plush toys sewn over wood and wire frames with styrofoam packing material, nylon rope, pulleys, steel hardware and
hanging plates, fiberglass, car paint, and disinfectant, overall dimensions variable. Partial gift of Peter M. Brant, courtesy
the Brant Foundation, Inc., and gift of The Sidney and Harriet Janis Collection (by exchange), Mary Sisler Bequest (by
exchange), Mr. and Mrs. Eli Wallach (by exchange), The Jill and Peter Kraus Endowed Fund for Contemporary Acquisitions,
Anne and Joel Ehrenkranz, Mimi Haas, Ninah and Michael Lynne, and Maja Oeri and Hans Bodenmann, 2013

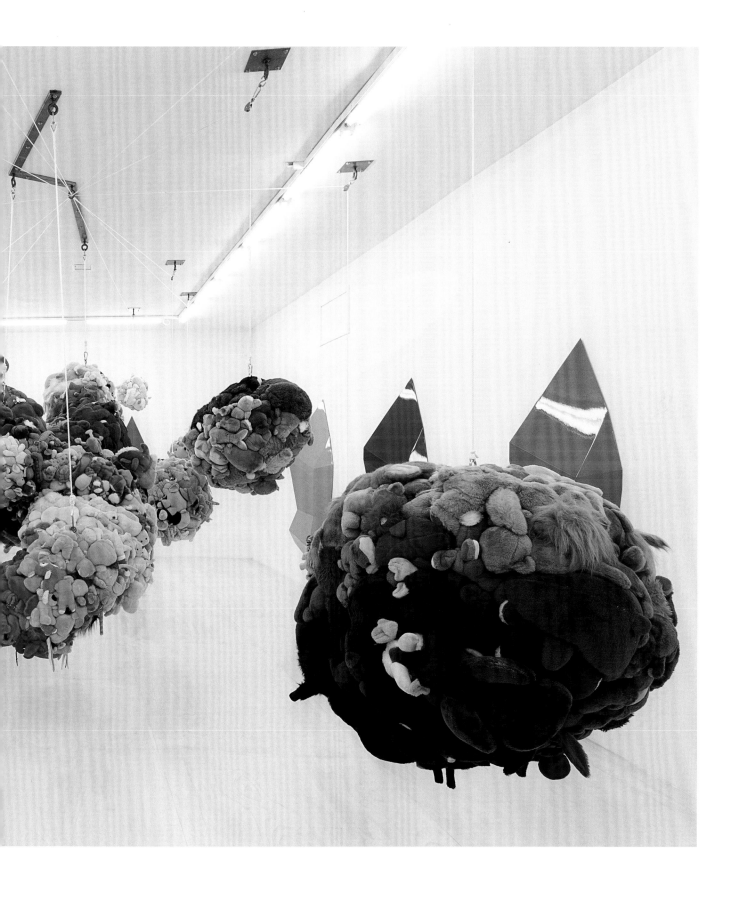

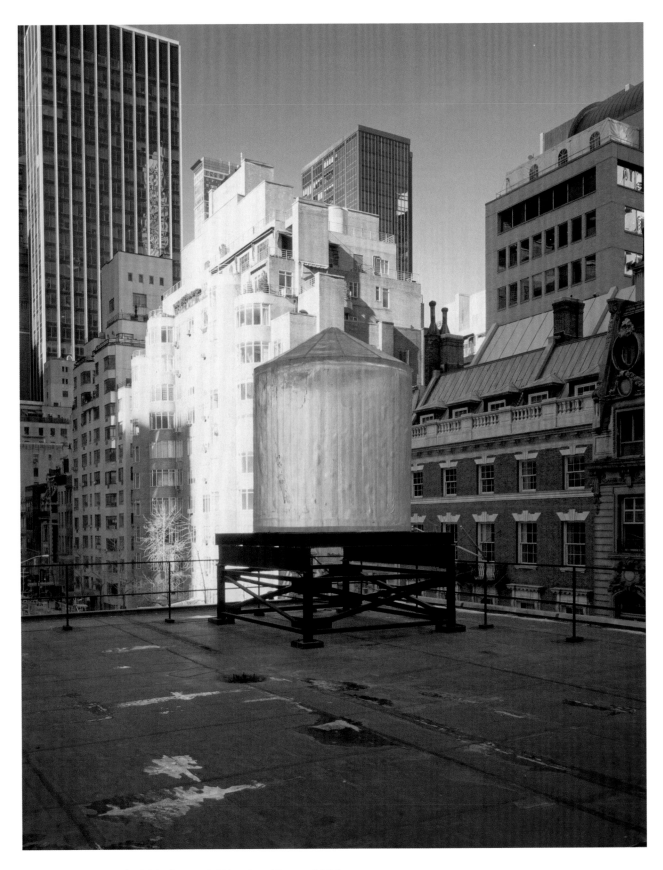

Rachel Whiteread (British, born 1963). *Water Tower*. 1998. Translucent resin and painted steel, 12' 2"
(370.8 cm) high; 9' (274.3 cm) diam. Gift of the Freedman Family in memory of Doris C. and Alan J. Freedman, 1999

Carroll Dunham (American, born 1949). *Ship*. 1997–99. Synthetic polymer paint, urethane paint, and pencil on linen, 10' ⅛" x 13' ⅛" (305.1 x 396.5 cm). Paula Cooper, Donald L. Bryant, Jr., and Andreas C. Dracopoulos Funds, 1999

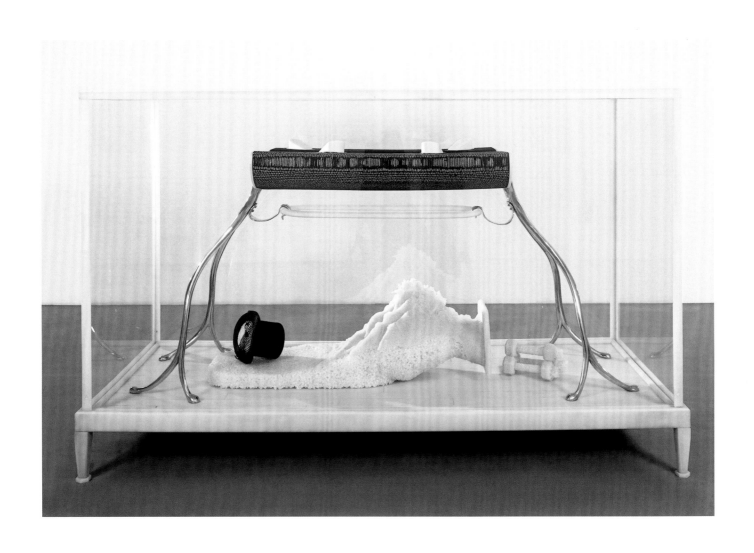

Matthew Barney (American, born 1967). *The Cabinet of Baby Fay La Foe*. 2000. Polycarbonate honeycomb, cast stainless steel, nylon, solar salt cast in epoxy resin, top hat, and beeswax in nylon and Plexiglas vitrine, 59" x 7' 11½" x 38¼" (149.8 x 242.6 x 97.2 cm). Committee on Painting and Sculpture Funds, 2000

Roni Horn (American, born 1955). *Untitled (Aretha)*. 2002–04. Optical glass, 13 x 30 x 30"
(33 x 76.2 x 76.2 cm). Fractional and promised gift of Kathy and Richard S. Fuld, Jr., 2006

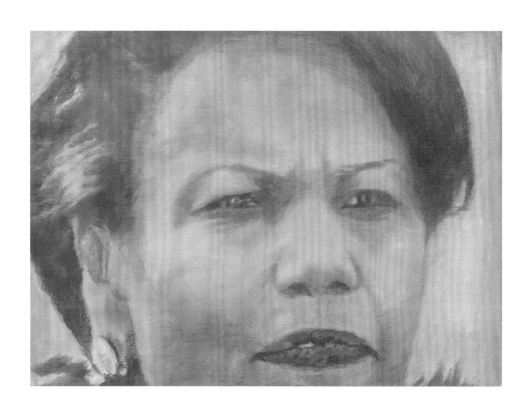

Luc Tuymans (Belgian, born 1958). *The Secretary of State*. 2005. Oil on canvas,
18 x 24⅜" (45.7 x 61.9 cm). Fractional and promised gift of David and Monica Zwirner, 2006

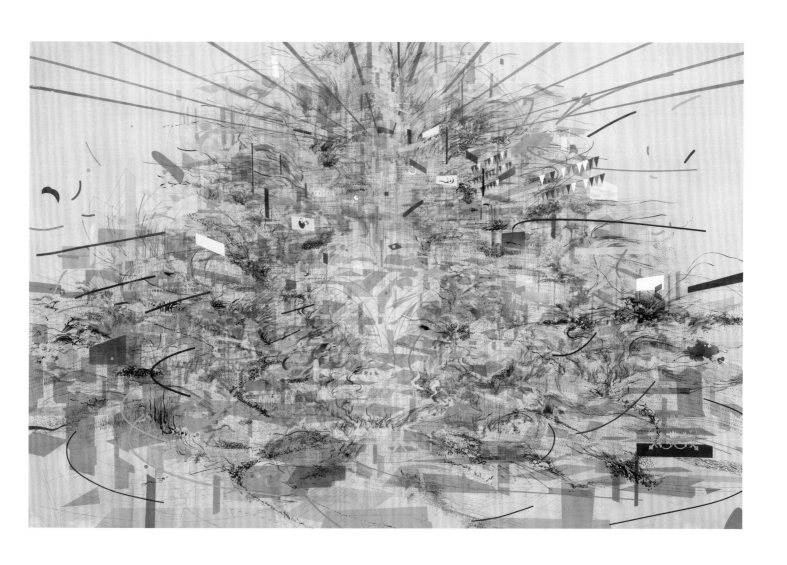

Julie Mehretu (American, born Ethiopia, 1970). *Empirical Construction, Istanbul*. 2003.
Ink and synthetic polymer paint on canvas, 10' x 15' (304.8 x 457.2 cm). Fund for the Twenty-First Century, 2004

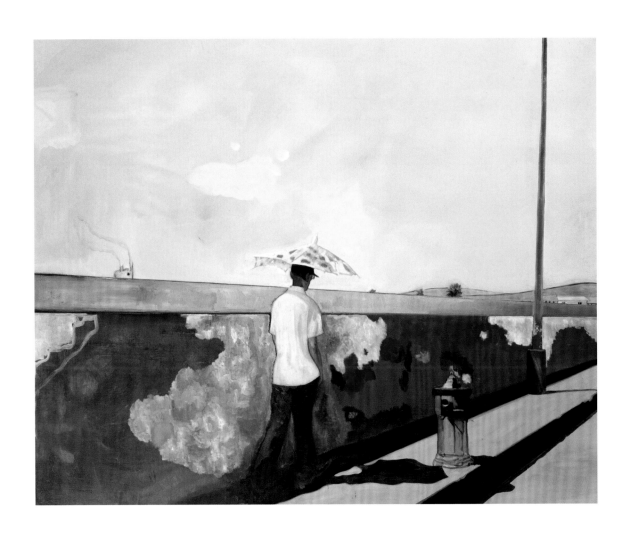

Peter Doig (British, born 1959). *Lapeyrouse Wall*. 2004. Oil on canvas, 6' 6¾" x 8' 2½" (200 x 250.5 cm).

Fractional and promised gift of Anna Marie and Robert F. Shapiro in honor of Kynaston McShine, 2004

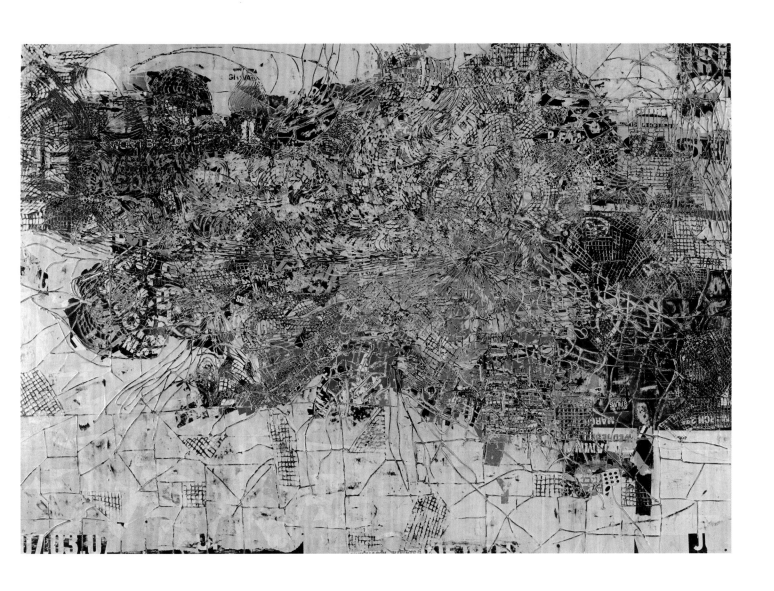

Mark Bradford (American, born 1961). *Giant*. 2007. Torn-and-pasted printed paper on canvas, 8' 5⅞" x 11' 11¾" (258.8 x 363.2 cm). Promised gift of the Ovitz Family Collection, 2008

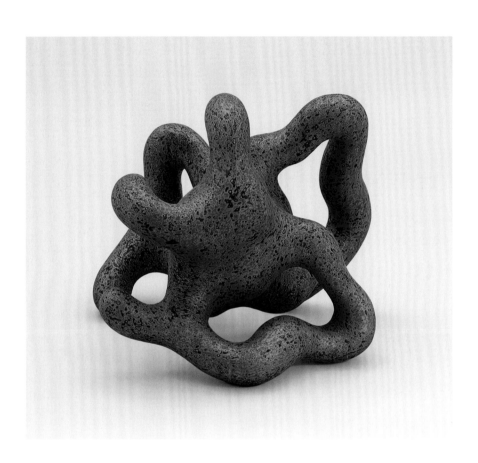

Ken Price (American, 1935–2012). *Red Neck*. 2002. Synthetic polymer paint on fired clay, 9½ x 10 x 11" (24.1 x 25.4 x 27.9 cm). Gift of Edward R. Broida, 2005

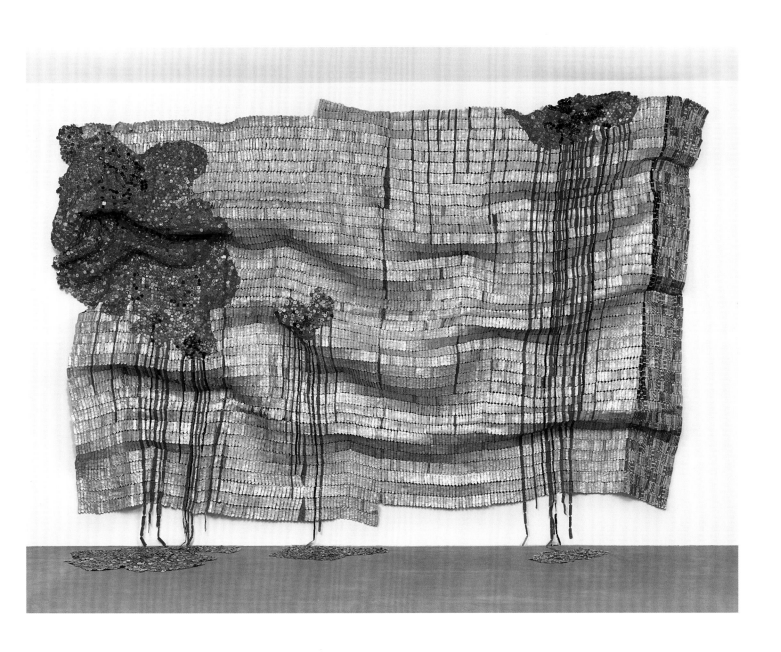

El Anatsui (Ghanaian, born 1944). *Bleeding Takari II*. 2007. Aluminum and copper wire,
12' 11" x 18' 11" (393.7 x 576.6 cm). Gift of Donald L. Bryant, Jr., and Jerry Speyer, 2008

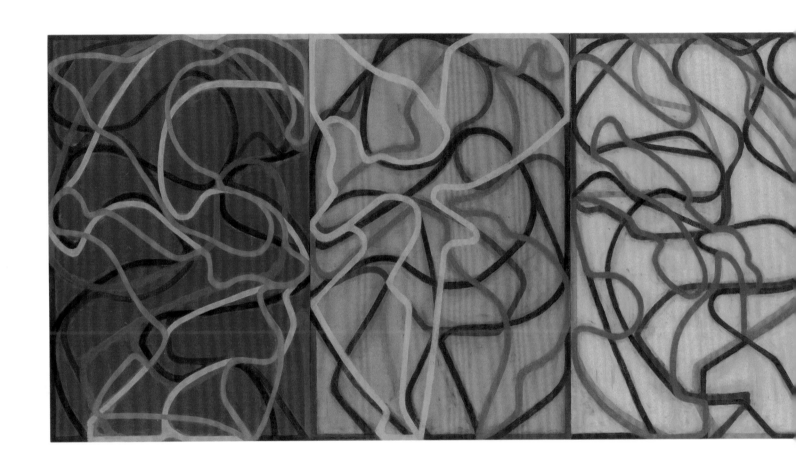

Brice Marden (American, born 1938). *The Propitious Garden of Plane Image, Third Version*. 2000–2006.

Oil on linen, six panels, overall 6 x 24' (182.9 x 731.5 cm). Gift of Donald B. and Catherine C. Marron, 2006

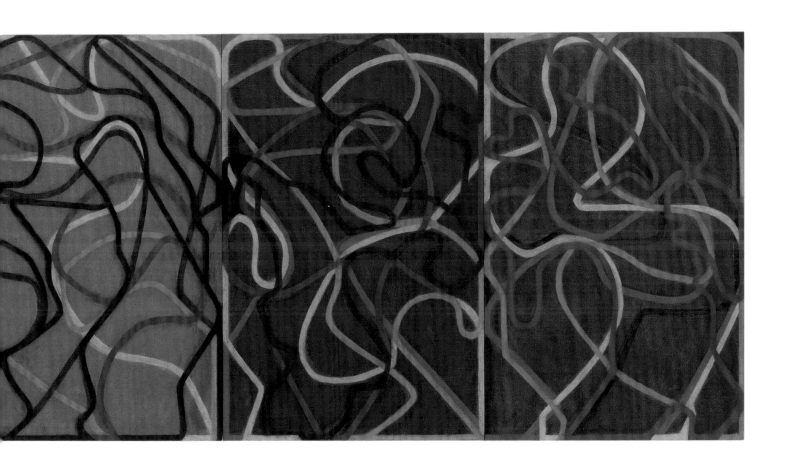

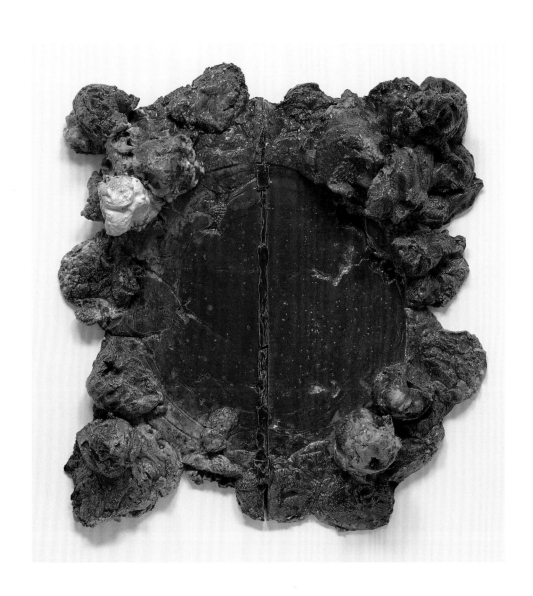

Rosemarie Trockel (German, born 1952). *Violette Beach*. 2010. Glazed ceramic, two parts, overall 49¼ x 47¼ x 13⅞" (125.1 x 120 x 35.2 cm). Scott Burton Fund, 2010

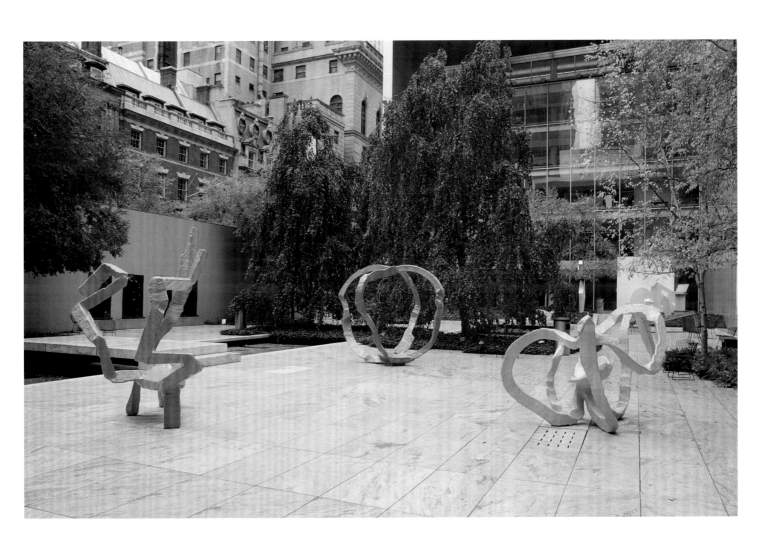

Left to right:

Franz West (Austrian, 1947–2012). *Maya's Dream*. 2006. Polyester, 8' 2⁷⁄₁₆" x 8' 6⅜" x 70⅞" (250 x 260 x 180 cm). Scott Burton Fund, 2007

Franz West. *Untitled (Orange)*. 2006. Polyester, 7' 6½" x 10' x 9' 2¼" (229.9 x 304.8 x 280 cm). Scott Burton Fund, 2007

Franz West. *Lotus*. 2006. Polyester, 65⅜ x 6' 10⅝" x 9' 6⅛" (166 x 210 x 290 cm). Scott Burton Fund, 2007

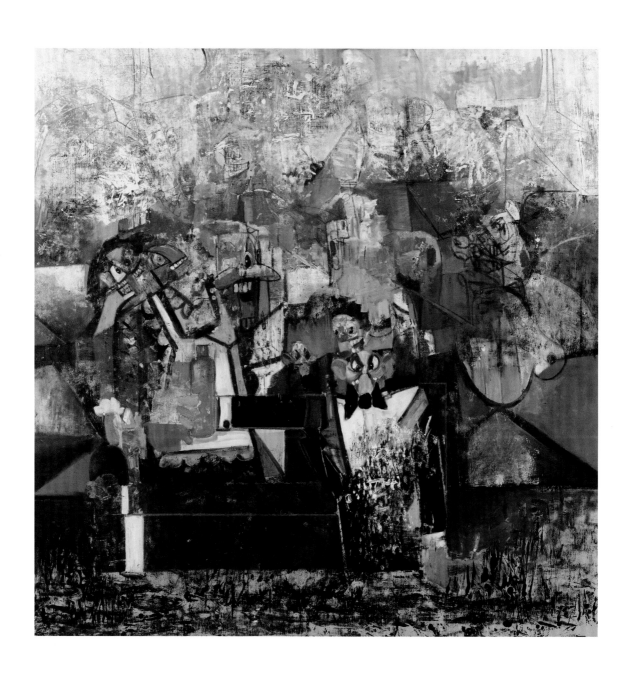

George Condo (American, born 1957). *The Fallen Butler*. 2009.
Oil and pastel on linen, 6' 6" x 6' 4" (198.1 x 193 cm). Gift of Adam Kimmel, 2010

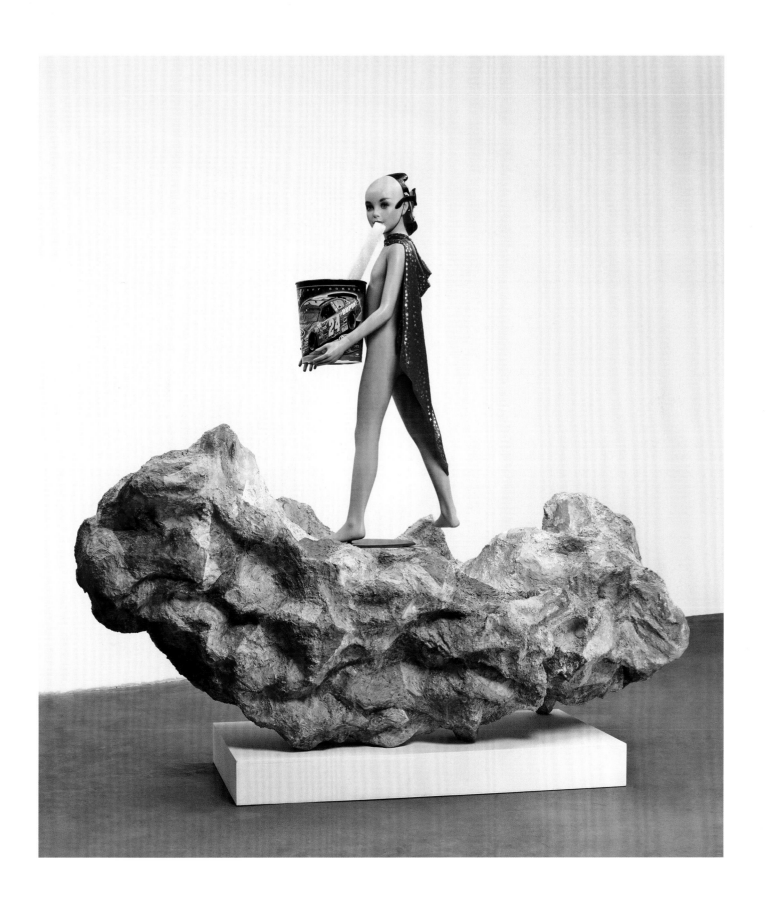

Rachel Harrison (American, born 1966). *Alexander the Great*. 2007. Wood, chicken wire, polystyrene, cement, Parex, acrylic, mannequin, Jeff Gordon waste basket, plastic Abraham Lincoln mask, sunglasses, fabric, necklace, and other materials, 7' 7" x 7' 3" x 40" (231.1 x 221 x 101.6 cm). Committee on Painting and Sculpture Funds, 2007

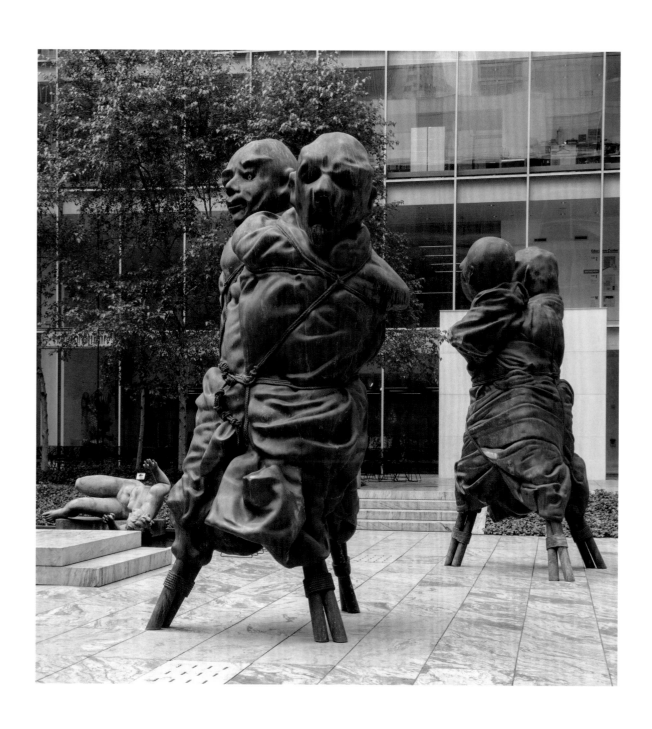

Thomas Schütte (German, born 1954). *United Enemies I*. 2011.
Bronze, two parts, 13' 3" x 6' 8" x 7' 5" (406.4 x 203.2 x 226.1 cm) and
12' 8" x 6' 8¾" x 6' 11" (391.2 x 205.1 x 210.8 cm). Purchase, 2014

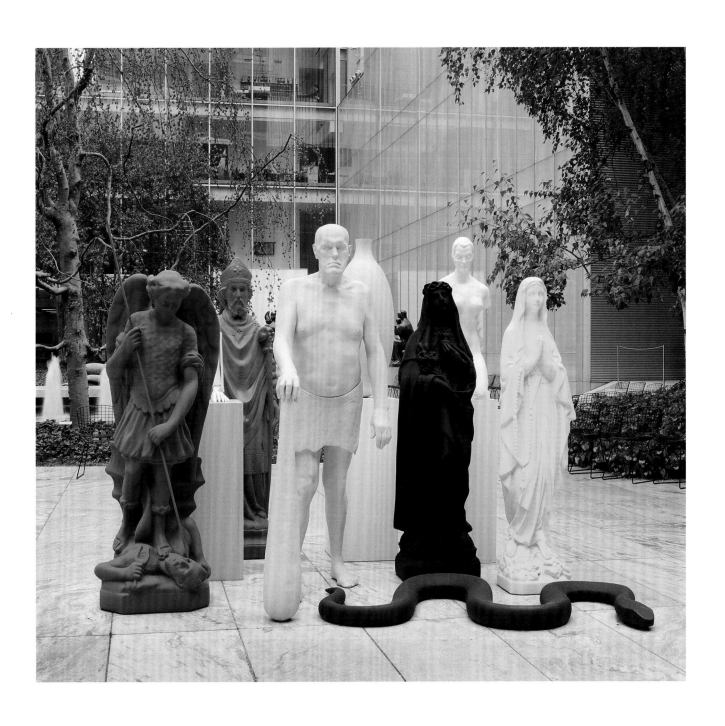

Katharina Fritsch (German, born 1956). *Group of Figures*. 2006–08
(fabricated 2010–11). Bronze, copper, and stainless steel, lacquered, dimensions
variable. Gift of Maja Oeri and Hans Bodenmann (Laurenz Foundation), 2009

Index of Plates